D1359511

MEERA
MUKHERJEE
PURITY OF
VISION

Meera Mukherjee

Essays by Nandini Ghosh • Maitreyi Chatterjee • Shilvanti Pracht
Georg Lechner • Maja von Rosenbladt • Clelia Segieth
Pranabranjan Ray • Geeti Sen • Adip Dutta

Akar Prakar • Mapin Publishing • Raza Foundation • Emami Art

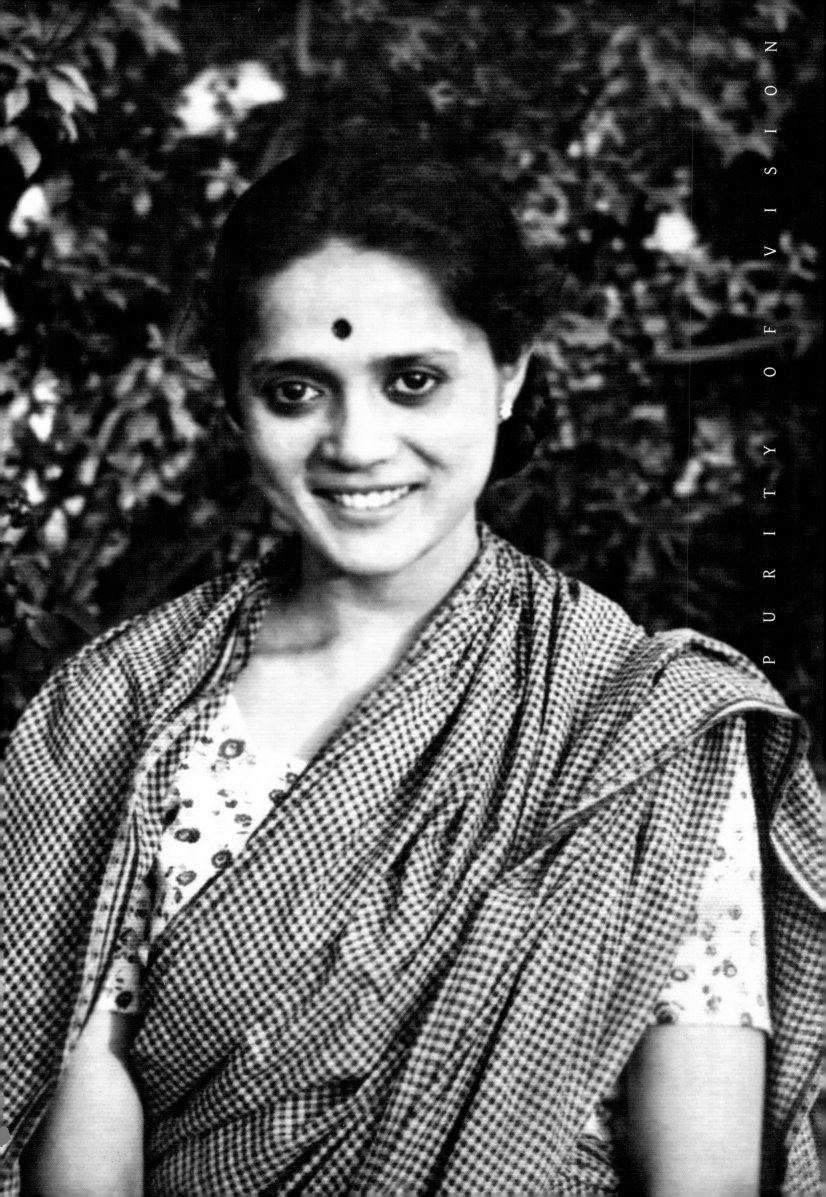

First published in 2018 by
Akar Prakar

in collaboration
with **Emami Art**

supported by
Raza Foundation

in association with
Mapin Publishing

International Distribution
Worldwide (except North America and South Asia)
Prestel Publishing Ltd.
14-17 Wells Street
London W1T 3PD
T: +44 (0)20 7323 5004 • F: +44 (0)20 7323 0271
E: sales@prestel-uk.co.uk

North America
Antique Collectors' Club
T: +1 800 252 5231 • F: +1 413 529 0862
E: ussales@accpublishinggroup.com • www.
accpublishinggroup.com/us

South Asia
Mapin Publishing Pvt. Ltd
706 Kaivanna, Panchvati, Ellisbridge
Ahmedabad 380006 INDIA
T: +91 79 40 228 228 • F: +91 79 40 228 201
E: mapin@mapinpub.com • www.mapinpub.com

Text © Nandini Ghosh, Georg Lechner, Maja von
Rosenbladt, Pranabranjan Ray, Geeti Sen, Adip Dutta,
Akar Prakar for Maitreyi Chatterjee, Shilvanti Pracht,
Clelia Segieth

Photographs © Artist's archive and Akar Prakar unless
otherwise mentioned

All rights reserved under international copyright
conventions. No part of this book may be reproduced
or transmitted in any form or by any means,
electronic or mechanical, including photocopy,
recording or any other information storage and
retrieval system, without prior permission in writing
from the publisher.

The moral rights of Nandini Ghosh, Georg Lechner,
Maja von Rosenbladt, Pranabranjan Ray, Geeti Sen,
Adip Dutta, Maitreyi Chatterjee, Shilvanti Pracht,
Clelia Segieth as author of this work are asserted.

ISBN: 978-93-85360-03-9

Copyediting: Ankona Das / Mapin Publishing

Proofreading: Ankona Das / Mapin Publishing

Editorial support: Akar Prakar and
Neha Manke / Mapin Publishing

Translation of Bengali texts: Shrutakirti Dutta

Archival research: Akar Prakar

Printed at:
Archana Advertising Pvt. Ltd.
New Delhi

Akar Prakar
• P 238 Hindustan Park
Kolkata 700029
T: +91 33 2464 2617

• D43, Defence Colony
New Delhi 110024
T: +91 11 4131 5348
E: info@akarprakar.com
www.akarprakar.com

The Raza Foundation
C-4/139 Lower &Ground Floor
Safdarjung Development Area,
New Delhi110016
T: +91 9810166953
E: razafoundation.delhi@gmail.com

Emami Art
Kolkata Centre for Creativity
777 Anandapur, EM Bypass
Kolkata 700107
T: +91 3366232300
E: contact@emamiart.com

Captions:
Front cover: Ashoka
Bronze, 132 inches
Collection: ITC Ltd.

Facing page: Woman with Pitcher
Bronze, 12.75 x 5.5 x 7.5 inches
Collection: Sanjukta Sarkar

Contents

Foreword

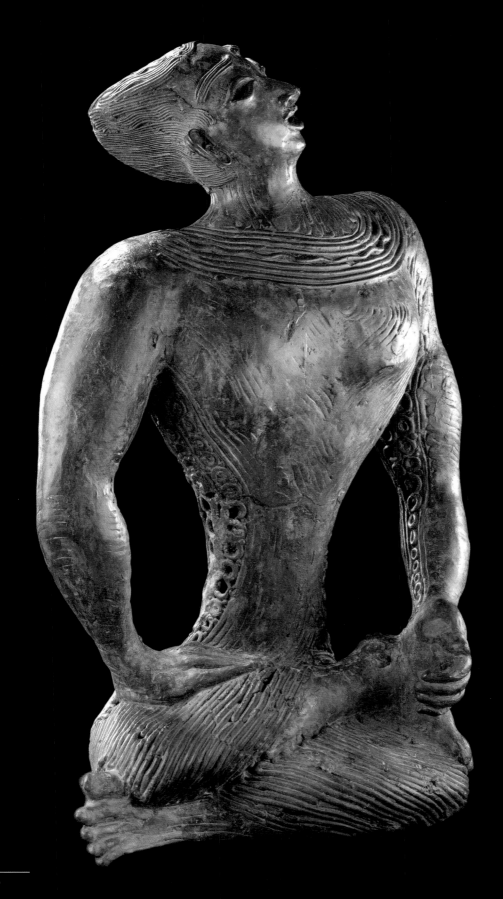

Alaap
Bronze, 23.5 x 14.25 x 7 inches
Collection: The Savara Foundation
for the Arts, New Delhi

Even though we never had the honour of meeting this brilliant artist, we seem woven into her world in mysterious ways, so much so, that for several years now, it has led us to gathering information on her life through family, friends, people and collectors who knew Meera closely, and of course through the many writings and books we found, both by her and by others on her, which form the basis of this book.

The outline of Meera Mukherjee's life that comes alive through various writings and pages from her diary, is a fearful, hidden cry of every artist's self-questioning in the midst of loneliness and despair. Meera is unravelled as "the woman behind the metal", as a woman of flesh and blood, in writings of Maitreyi Chatterjee; readers could well trace the palpability of a fine young girl. In the initial years of trial and toil, instead of shunning herself, she started turning each pebble to a new path and no trouble seemed enough for her at one time; whatever one can know about her, if one brings together the limited learning of her life, the reader finds itself lost in the layers of her personality. Being close to her grandmother, she got drawn to making dolls, and then the festivity and rituals of a regular Bengali household were Meera's first steps towards realising her pursuits towards crafting and painting. For others, while it was just a regular occasion, for Mukherjee it was like a stepping stone to her future endeavours. As a student of art in Delhi, her travel to Germany with scholarship was a rebellious attempt. She discovered that though spoken language differs from one country to other, art is probably the only convergent point where many languages amalgamate into one. She travelled to different parts of Europe, to different museums, and found herself bemused in the rich Greek cultural ethos that found expression in the works of Michelangelo and Picasso. Although Germany for

her was a learning experience, her close observation of their treatment of art became an expression of their authenticity and heritage. The fact that piqued her was that there was so much heritage of India which was still in complete ignorance. This realization was pinned to her head probably on the day her professor Toni Stadler asked her, "Your country is so rich artistically, and yet you work in the style of the West. Why is that?" Her integrity and passion were fired by this questioning. Her training in Germany therefore incorporated the realization that she now has her way in India, where she can discover herself and renew the spirit of art. The experience was cumulative of training, education, exposure which finally culminated into a form of expression which turned into the language of her life.

Meera took up a challenge, which was one of the most pioneering attempts of her time, of bridging the gap between artist and artisans. As reflected on the pages of her diary, she wondered how an artist can alienate itself from the hard work that it is expecting the worker to do. The pages of her diary emote her everyday dedication for her work. She committed herself towards waking up at midnight, watching the flames working endlessly with her failing health, towards perfection. Understanding the use of metal, cultivating the wax and lifting heavy metals all by herself, and often even without a single helper, can only be a testament to the mental strength she possessed. An artist, according to her, has to be someone who takes the initiative to dissolve the boundaries; an artisan has fixed contours but an artist has the universe of endless liberty and experiment.

Meera Mukherjee was a devout Indian, her 'Indian-ness' found expression not only in her personality but also in her art and expression of life. When she

refused her Master's scholarship in Germany, she had already realized how she wanted to channelize her talent. Her visits to the tribal belts of Bastar, to the potter-man's village in south India, and to the outskirts of West Bengal, stood evidence to her zestful efforts to salvage the heritage of traditional art which was losing ground each day. On many accounts we know how she involved herself with educating young girls from the villages around Bengal and revived the tradition of 'kantha', helping them find employment, in spite of her struggle to manage her own finances.

Her work was never incomprehensible or complex, the language of simplicity was always innocent and rhythmic. The sculptures were instantly traditional yet modern, they were replicas of her strength and emotional vulnerability which somewhere unified into a spirit and projected a world where she lived alone, surrounded by an active crowd. In her sculptures her abstraction never really created a distance with what was regular or personal; everything for her viewer was quite identifiable. Her belief in Buddhism took form of her *Buddha*, her swan song, now at Badamtam, Darjeeling, which stands tall, marking her impeccable zeal which made this complete despite her failing health and untimely death. Drawing the genre of everyday life, Meera Mukherjee's work ultimately left nothing undone. From single figure to depiction of scenes, from describing her life and ideals to describing her surroundings, she could just instill 'life' into each and every piece.

Being a private person, as described by many authors who wrote on her, she could question and address very vital social causes concerning art and life. "However, ideas and emotions are only the beginning: to realise them in form calls for sustained physical as well as mental effort", thus bridging the gap between artist and artisan. On another go she brought up the universal question of 'art for art's sake' and refuted the idea of restricting art to gallery display, and limiting it to any cult or target audience. Her art was for the masses and it was from within them. She worked heartily towards keeping alive the deepest traditions which were art to her. She visited those places which upheld these traditions and it pained her to see how convenient and easy usability has been eating up one tradition after another. During her life's last days, this got her more engrossed in efforts to hold on and keep alive the traditions and authenticity—a reason that brought her back to India on the first place.

The word 'Meera' has stayed with Indian culture and ethos for long. 'Meera', the name, is identified with Meerabai, the 16th century mystic poet and devotee of Lord Krishna, and consequently with divinity, music, rhythm and love. Incidentally, the word 'Meera' also means 'light' in Sanskrit. Meera Mukherjee, probably, was a personification of all these aforementioned meanings. She was already a singer and her devotion towards music was praised highly by everyone who had an opportunity to listen to her. As for her devotion, innocence, and her pointed aim like the poet Meerabai, she sings to us the theme which is 'life'.

We hope that you too will find the music of life in her art.

Reena and Abhijit Lath
Akar Prakar

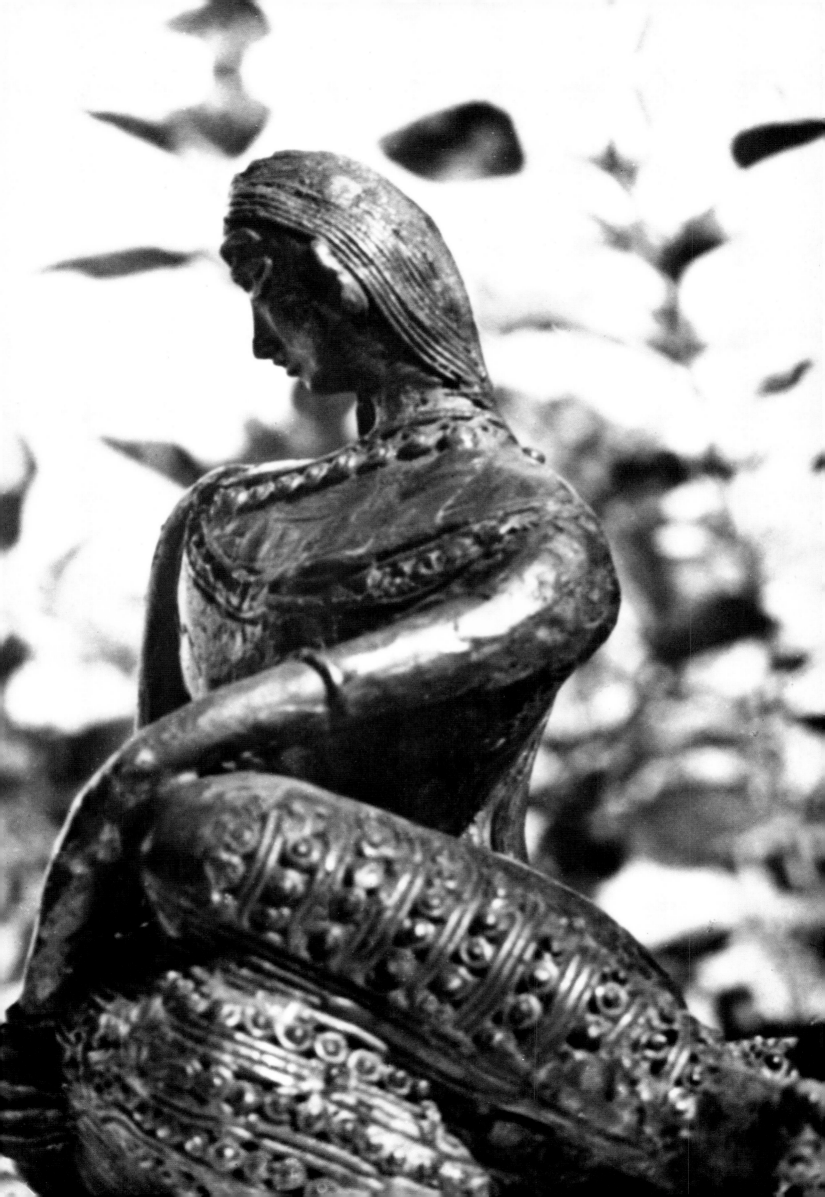

Dr. Nandini Ghosh

Introduction

I n the context of the two decades of 1970s and 1980s, and that of the practice of visual arts in India, Meera Mukherjee holds a position of significance. This can be attributed, on the one hand to her choice of sculpture as the primary mode of expression, and on the other to her sex and gender, that is, her being and identifying herself as a woman. However, this gendered perspective of distinction was never Meera Mukherjee's personal inclination; it is a dimension that we invest into her oeuvre on hindsight and retrospect. In fact, she would personally abhor the exclusive pronouncement of gendered identity as the avowed point of origin for her practice. It is probably from such a position that she distanced herself from the all-woman collective called "The Group", of which she was initially a member in the early '80s. However, it is an art-critical and historical imperative that one locates her artistic practice in the context of the socio-cultural situation of the mid-20th century Bengal, and the overall location of women within the said socio-cultural structure, to be able to arrive at a relatively more grounded analysis of her oeuvre. As a woman engaged in the practice of the visual arts (especially the mode of sculpture) and operating as an artist with a distinctive individual identity and economic independence, her example should be viewed as a truly significant factor in the context of the regional modern.

What also needs to be clarified here is that adopting such a perspective does not intend to isolate her practice with the preferential advantage of gender alone, even a formalist analysis of Meera Mukherjee's visual language reveals layers of fascinating interest to the viewer. While the lyrical and the rhythmic may seem to be the dominant qualities in Meera Mukherjee's sculptural expression, what is significant is the fact that her

Facing page:
Meera in her early days

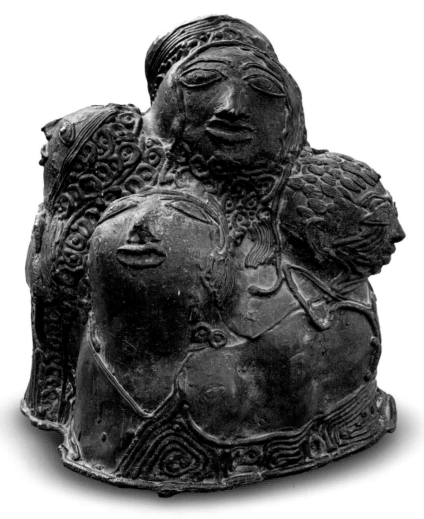

Cluster of Women
Bronze, 13.75 x 13 x 13 inches
Collection: Gurucharan Das

creations provide the viewer with a simultaneous experience of the real and the fantastic, the stable and the dynamic, the momentary and the eternal'—all at the same time, she emerges as a narrator as well as a philosopher, and it is this productive, dynamic pull of apparent opposites that characterize her language of expression, making the artist a noteworthy figure in the modern Indian art scenario.

Meera Mukherjee's career as a sculptor began from the mid 1950s. Her favoured medium was bronze. If faced with the unfortunate circumstance of unavailability, her second choice would be clay, also extended, occasionally, to the medium of ceramic. All of these are a pointer to the fact that Meera Mukherjee's world of sculptural forms constituted the mode of building up tactile, fluid, modelled volumes, rather than the subtractive mode of cutting away from a block of stone or wood to reveal the form trapped within. As such, there is inherently an organic quality in the formal characteristics of her sculptures—and one is not speaking in a constricted notion about the organic visible in the forms or their constituent parts, but an overall sense of organic 'breath' or rhythm that informs the whole of a sculptural construction—one could think of this along the lines of the Chinese *qi*, the Vedantic *prana* or the Tibetan *lung*, all of which are references to the essential life-force within—all of the inner pulse that animates what we see as the outer form.

Beyond the media of the third dimension, Meera Mukherjee also excelled in drawings, and paintings, the latter not too commonly discussed in art-critical circuits. These chromatic exercises effectively employ the formal equivalents of embroidery stitches, subtly blending two different worlds into one. Thereby, as an artist, Meera Mukherjee united the intimacy of the 'home' with open statements uttered in the 'world'. The home–world polarity gains in another sense when we learn how she was ready to leave her home and family when faced with the choice of dedicating herself entirely to her practice; in the context of the 1970s and more specifically in the context of Bengal as a location, such a choice of "bohemian" dedication to the cause of creative expression was a considerably remarkable characterizing feature for an artist, and may thus be perceived as an index to Meera's frame of mind and life-philosophy, as well as a proof of

the intensity of her engagement with the world of visual art.

Meera Mukherjee's creative endeavour, whether sculptural, or painted or drawn, are qualified by the essence of spontaneity, by their rootedness in life and a direct engagement with the same. From her own recollections it becomes evident that this has been a nearly silent and imperceptible process where she picked up the art–life interconnection from the otherwise apparently mundane rhythm of daily existence—for instance, although executing the *alpana* was an ordinary household affair for a Purba Bangla (East Bengal) family, Meera's observation of her mother making it helped her pick up from all the characteristic essence of creative expression that it had, probably even without a conscious primacy of considering it as a 'work of art'. She also recalled that though her mother's *alpana* was not exactly identical to the iconic *alpana* forms and patterned rhythms

evolved and practiced in Santiniketan, and were not meant to echo them either, the designs were guided by the essential prerequisite of spontaneity and effortlessness. It is this inherent quality that she cherished—it is this that she learnt from her mother—maturing from childhood into adult life, effortless spontaneity continued as an internalized philosophy of life and creative expression.

And since this philosophy of life was so integral to her being and existence, her art is not determined by any conscious posturing, or an artificially adopted intellectual position. Her practice did not assume the buttressing support of a theoretical vantage-point; it naturally proceeded from an inner core of sincere conviction, which was intimately connected to the necessity in a close contact with one's roots. That explains her admiration of craftsman's art, as much as it qualifies her critical position on prevalent art education, whether in India, or abroad. She had expressed

Untitled
Ink on paper
Collection: Private

her dissatisfaction with the school that began from Abanindranath Tagore as much as with her experience at the Delhi Polytechnic. Her opinion, that the pure practice of precise calculation was insufficient as a mode of inculcating an 'eye' for the visually creative, is significant. Such technical expertise lacked in the individual's training towards an awareness of the element of mood, and the philosophy behind the same, a consideration which never held a status of significant importance within art-school pedagogy. In contradistinction to the art-school pedagogy, she admired her Indonesian mentor Affandi Koesoema, for he showed her how to 'look', and how to lose oneself into the rhythm of nature.

Meera Mukherjee appreciated the self-critical attitude in European student-artists, but was equally disturbed by their over-ambitious and over-conscious efforts to 'become an artist'. She in contrast remained rooted and wrote,

If I am unable to become an intellectual […] if I do not become an artist, nobody can turn me into one by force. If I am an ordinary human being, then I will continue to do the ordinary chores, and remain satisfied and happy with it. I did not have an enormous ambition; I did not wish to become a great artist. Whatever be my standard as a human being, I will only desire that which I feel good about.

It is from the continual search for a connection with the roots of indigenous art practice, especially the craft traditions of India, that Meera Mukherjee set out for Madhya Pradesh, where she came into contact with the local artisan community, and which in turn initiated her larger search for craftsmen-artisan communities from all over India,

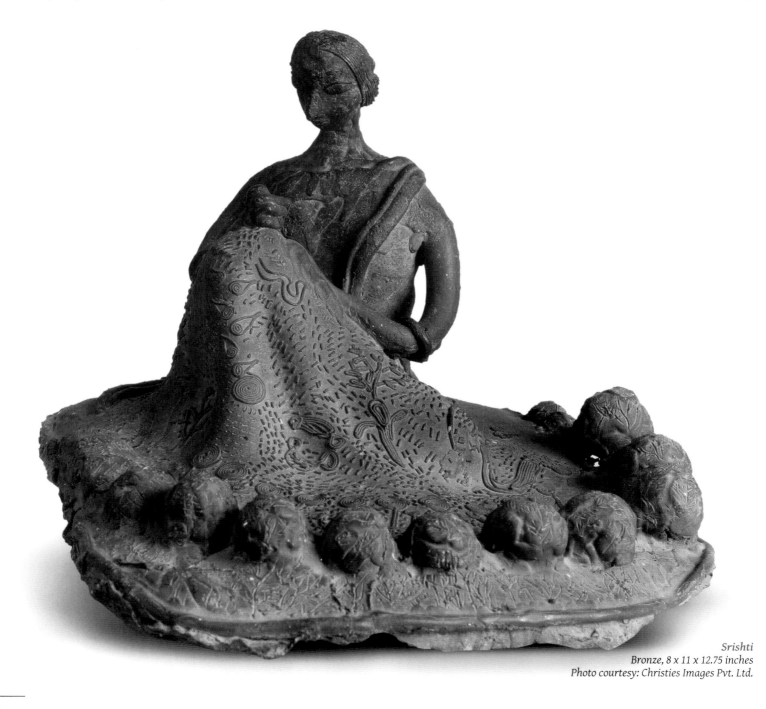

Srishti
Bronze, 8 x 11 x 12.75 inches
Photo courtesy: Christies Images Pvt. Ltd.

including Bengal and South India. "I have learned from them—their life and craft—their craft entirely embraces and encompasses their life", she wrote. In Meera Mukherjee's opinion, an artist primarily aspires for recognition and status as an 'artist'; an artisan aspires to link life and art into one inseparable entity; this distinction was an essential and integral part of Meera Mukherjee's vision, and formed the basis of her conviction.

In the context of the narrative of an evolving modern in Indian art, Meera Mukherjee appears to be one of the few artists active in the 1970s who held on to a distinct approach to the categories of art and craft. In a bid to re-connect to the roots and to regenerate the visual practices with authenticity, she aimed to bring together the mainstream and the folk in her own practice. Her role in this respect was not merely that of an urban modern artist who parasitically sought for motifs and structures from the folk practices; she had an active and dynamic engagement with the circuit, and worked in close harmony such that the relationship was in effect symbiotic. Since she had been trained abroad, she could be expected to have been aware of the trend within modern art identified as 'primitivism', but her adoption of the marginal cultural expressions from her own national culture, for instance the *dhokra* metal casting and the *kantha* quilting process should probably be distinguished from the same. Although the aspiration remains modernist at its base, with an intention of introducing the cultural expressions of non-mainstream cultures into modern visual expression, her adoption of the craft techniques in both instance was effected from a wider social encounter. It should suffice to recall, for example, that she made it possible to engage with the women of the community whereby the quilting practice received a mutual impetus for both parties engaged in the encounter.

From a more theoretical perspective, the significance of Meera Mukherjee in the context of the period of her activity would be her distinctiveness as a modernist individual. As an artist, and more specifically as a sculptor, she reveals a strong leaning for individualism. It is here that the dynamics of the collective and the personal intertwine such that her extremely personal linguistic structure is actually often harnessed to voice contemporary social context and lived reality. The trend in Indian modern

Meera with her early work

Below and facing page:
Cosmic Dance
Bronze, 18.11 x 13.78 x 13 inches
Collection: R. Pal Choudhury

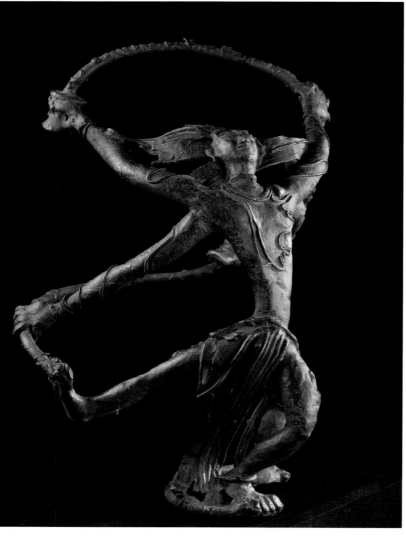

Analysts of Meera Mukherjee's practice often indicate her thematic engagement with aspects of daily life. Such a thematic preference produces a vast range of moments culled out of everyday existence, some of which are depicted in absolute humility of scale, while others are rendered in truly majestic proportions. However, in both these diametrically opposed ways of rendering, the majesty does not overpower into the monumental just as the humble does not disintegrate into insignificance. Such an acute balance is a matter of immense poise and grace. It is this grace and poise that find their most succinct expression where Meera Mukherjee addresses gendered labour. The domestic and the commonplace do get elevated in significance, but in her quiet though rhythmic language they do not become declamatory statements; on the contrary, they make us ponder on the dignity of labour – even more so when it is performed by women.

It is the same duality of the grand and the simple that characterizes Meera Mukherjee's approach to myth as a constitutive thematic element in her visual expression. For her it turns out to be a process of 'myth-making'—unlike the manner in which myth could grow into an assumed constant, like in the Bengal School context, Meera Mukherjee's reinterpretations redefine the figures and personalities from the past into the framework of contemporary relevance. Even more significantly therefore, her engagement with history (rather than 'myth' per se) should be observed as pertinent, where her *Buddha* or her *Ashoka* emerge as historic personalities from the past but carry resonances of eternal questions that concern humanity as constants even in the present. When she depicts the eternal cosmic dance through her sculptural rendering, her primary goal is not so much the invocation of an iconographic

during the decade of the 1970s was inclined towards a concentrated focus on the immediate and the contextual. Meera Mukherjee, as an integral part of that ambience, evolved a personal diction whereby she could concentrate on the immediate locale, both thematically as the subject, as well as in formal terms of the visual object. The flip-side of the local-locale dimension would be the necessity to locate the phenomenon of Meera Mukherjee simultaneously in the global context of a rising interest in the folk among mainstream practices.

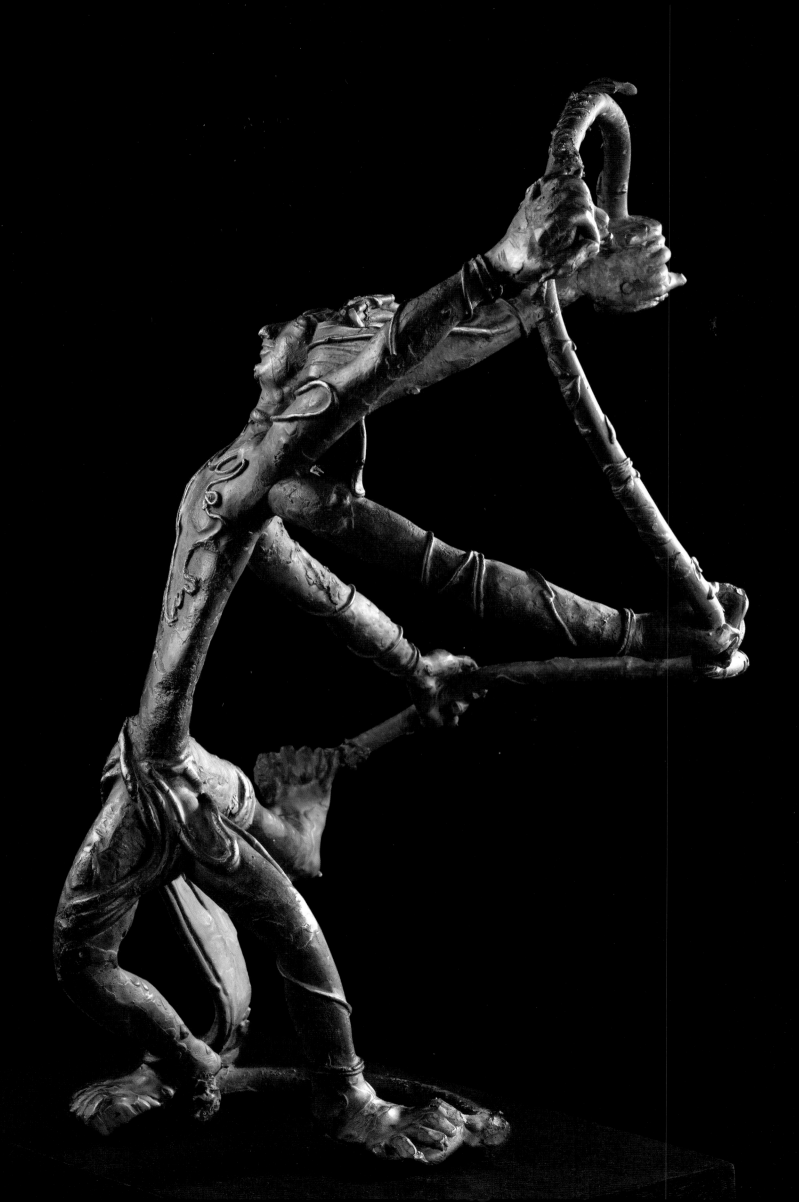

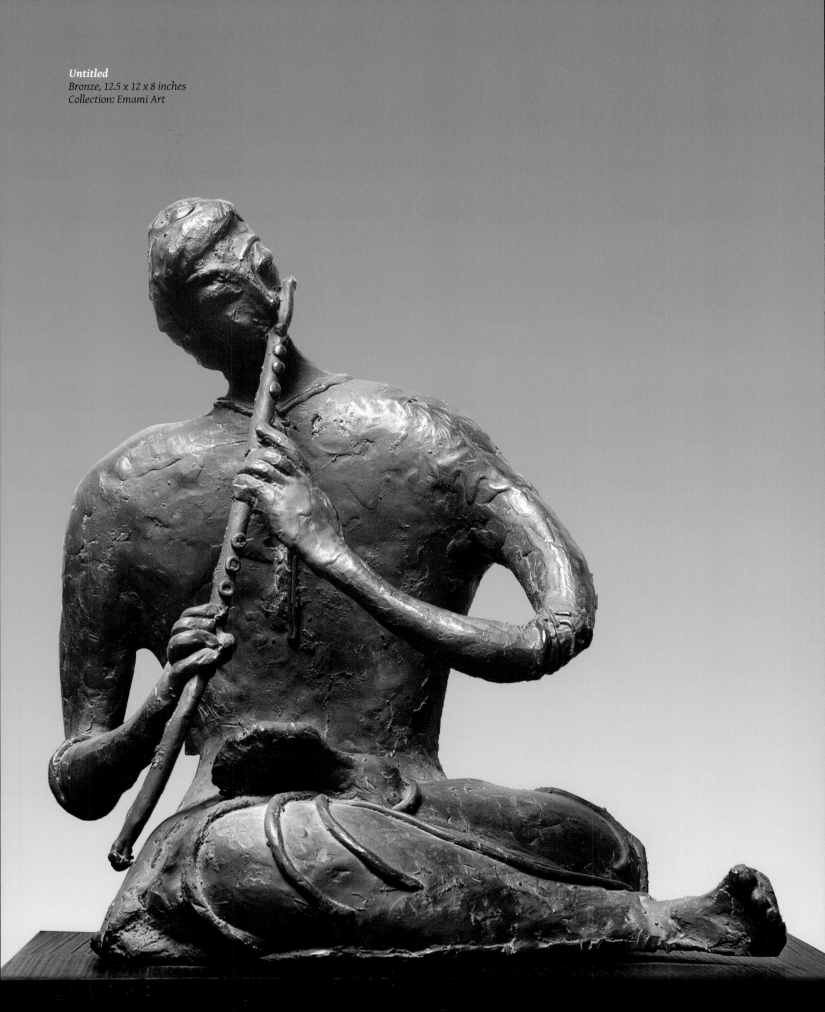

Untitled
Bronze, 12.5 x 12 x 8 inches
Collection: Emami Art

feature from classical past as a revivalist gesture, but the process of a continual re-interpretation of one's historic past which generates new myths in the process. It is probably here that her choice and technical preference for the *dhokra* method of metal casting moves beyond its mere technical possibilities of novelty or the question of subsumptive adoption or accommodation of the 'folk' within 'contemporary' visual practice—the free-flowing flux of the forms that the process permits and facilitates, merges imperceptively with the specific perspective of the artist's perception of the theme. The organic, unsmooth though rhythmic nature of the surface and the contours reveals a fundamental authenticity in translation of feeling into form. Time, past and present, recall and the immediate, history and the contemporaneous, defies segregation into polar categories.

Perhaps one of the elemental routes towards this goal is achieved through Meera Mukherjee's responsiveness to music. The rhythmic and the musical, the lyrical and the fluid, could possibly be shared points of intersection between her visual practice and her love and involvement with music. Over and above the other modes that she personally took instructions in, it is well known that her heart lay in the songs of Rabindranath Tagore—*rabindra sangeet* was a common zone of love and solace, as it has indeed been to all within the Bangla-speaking community. As Tagore celebrated nature and the seasons through his basket of songs, the community learnt to respond in tandem, and *rabindra sangeet* has turned out to be an inseparable aspect of the Bengali consciousness. Moreover, in the musical history of the region, Tagore's unique formulations have long since been acknowledged as significant statements of the modern within the song-tradition of Bengal. That Meera Mukherjee should share an intense

personal affiliation to Tagore's songs, may be considered another index to the formation of her expressive self.

The above prefatory statements introduce this compilation as an anthology. As a publication intending to reveal the artist on a wide horizon, the anthology is a collection of articles and recollections on the sculptor, an album of images representative of the oeuvre of Meera Mukherjee, as well as excerpts from her own literary works. Although her primary identity may have been that of a sculptor, there are fascinating drawings and paintings from the artist which indicate that she had a holistic view towards the visual arts and the felicity of expressing herself in both two and

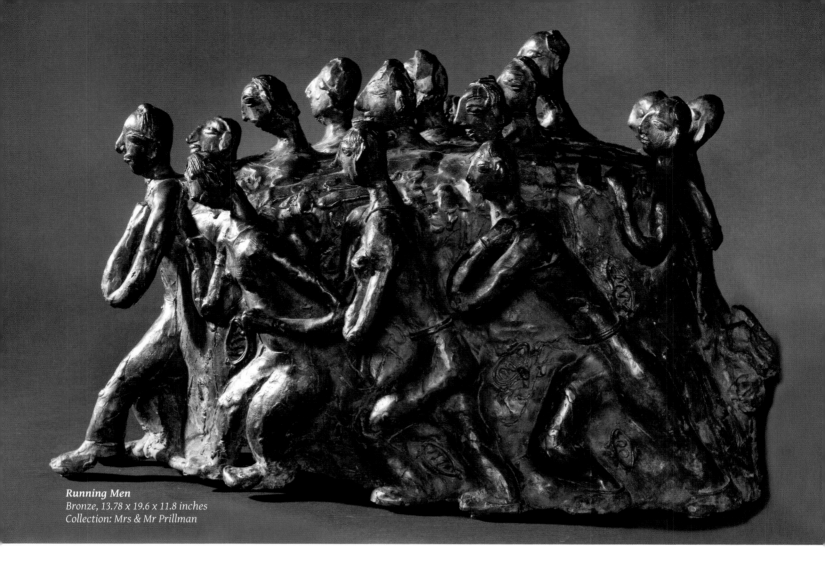

Running Men
Bronze, 13.78 x 19.6 x 11.8 inches
Collection: Mrs & Mr Prillman

three dimensional media. Taken together, it is this dimension of Meera Mukherjee as a 'complete' artist which is so significant, and it is the diverse aspects of this dimension which the various essays in this collection seek to explore and analyse.

The essays have been arranged in three broadly thematic categories. The editorial introduction serves as a key-note on Meera Mukherjee, viewing the artist from the construct of modernism; it is proposed that we perceive the artist as a modernist who locates her work vis-a-vis the national-regional dual paradigm; this is also intimately tied up with the goal of formulating a distinctive individual identity through a characteristic personal language and expression. Following this introduction, the first and second set of essays have been categorized under the captions of "Recalling Meera as a Person" and "On Meera's Art: the Artist and her Language". The compilation ends with the section titled "Meera on Art", which contains selected sections from her own writings that are expected to reveal the persona and her personality.

The first section, "Recalling Meera as a Person", contains an essay by, Maitreyi Chatterjee and Shilvanti Pracht.

Maitreyi Chatterjee in her essay "A Purity of Vision" provides a relatively intimate account of the artist, which gains credibility from her direct experience of Meera Mukherjee as an individual and as a creative artist. On the one hand she focuses on the fact that Meera Mukherjee has concentrated on manifestations of daily labour as themes of glorious relevance fit to be presented on the panorama of visual art making in an elevated, monumental, and grand proportion. On the other hand she provides a feminist dimension to the analysis of the sculptures whereby the acts of husking, quilt making etc., become significant statements about gendered labour and experience.

Shilvanti Pracht travelled to Munich where she was a co-student of Meera Mukherjee; her account traces Meera Mukherjee from that perspective of familiarity. She addresses Meera Mukherjee as an artist and human being. Her account therefore complements the reminiscences of Maitreyi Chatterjee by providing a different shade and dimension to an interpersonal account.

Essays by Georg Lechner, Maja von Rosenbladt, Pranabranjan Ray, Geeti Sen, Adip Dutta, and Clelia Segieth have been put together in the second

section titled "On Meera's Art: The Artist and her Language". These essays address the individual from the academic perspective of visual practice. Despite her significant contribution to the Indian modern, Meera Mukherjee had maintained a low public profile. And yet, critics and historians have analysed and discussed the diverse aspects of her work in profound detail.

In Georg Lechner's essay titled "Notes from Germany" we are given a brief insight into the artist's connection to Germany, the evolving German art scene, and the influence that the nation and her European tutors, like Toni Stadler, had on her.

Maja von Rosenbladt, having known Meera Mukherjee personally and through her artistic practice, authored her essay from the vantage point of art and social practice. Acquainted first hand with the Dhankhet Bidyalaya project that the sculptor was associated with along with her partner Nirmal Sengupta, Rosenbladt explores in the essay Meera

Fisher Women
Bronze, 13 x 9 x 9 inches
Collection: Mrs & Mr Prillman

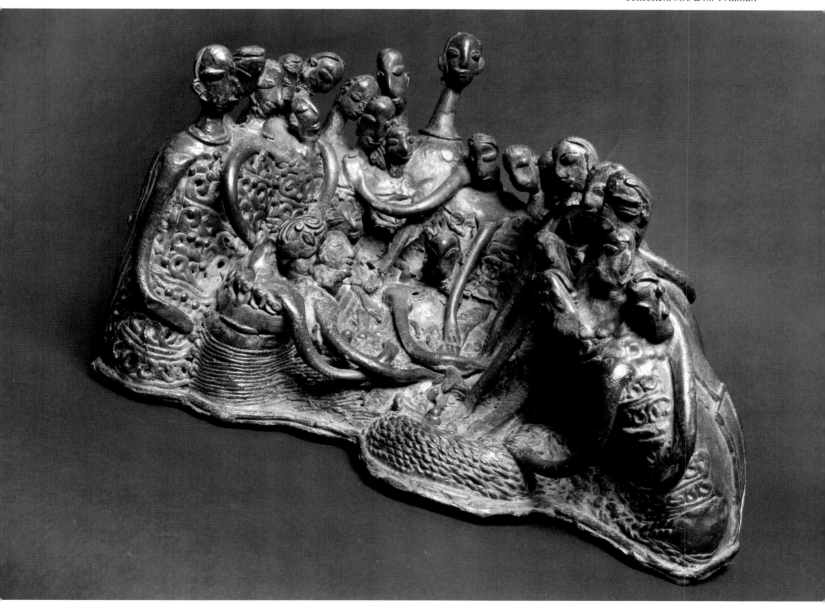

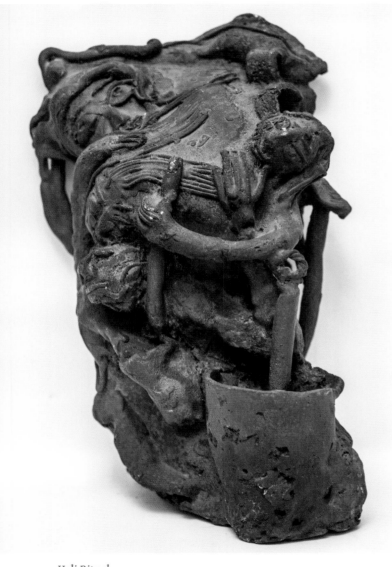

Holi Ritual
Bronze
Collection: G. Ghosh

Mukherjee's involvement with the people from whom her sources of stylistic and mediumistic inspiration arose. The essay delves into the art-craft issue in the context of a contemporary artist's quest for personal expression and situates it in the context of her larger involvement with the community.

Pranabranjan Ray addresses Meera Mukherjee from the art historian's perspective, discussing her work in terms of its aesthetics, process, philosophy, and thereby her development as an artist with a distinctive visual language. In the process he has come up with illuminating art-critical analysis of some of her significant works.

Geeti Sen addresses the two iconic sculptures of the *Buddha* and *Ashoka at Kalinga* in her proposition on "Meera's Journey to the Himalayas". This essay seeks to contextualize the relevance of Buddhist ideas through the two sculptures, and proposes the metaphor of the journey in terms of the inspirational impulse and its return in the form of the sculpture of the Buddha back to the pristine mountains. Poetically narrated, the essay provides a much relevant perspective for viewing the visual practice of the sculptor against the inseparable component of its thematic content.

Adip Dutta's essay focuses on another dimension of the creative persona in Meera Mukherjee; he explores the artist's involvement with non-urban traditions of visual expression, namely the *kantha,* home-embroidered quilts, and locates an interaction between the *kantha* and child art where Meera Mukherjee's role as an informed mediator had significant catalytic impact towards community expressions.

Left:
Bhulu-II
Watercolour on paper, 11.25 x 15.25 inches
Collection: Private

Below:
Bhulu-I,
Watercolour on paper, 8 x 10 inches
Collection: Private

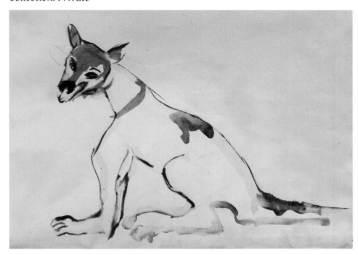

Clelia Segieth explores Meera Mukherjee through the event of an exhibition at the Buchheim Museum. Emphasizing an East-West interaction and relying on the element of movement and dynamism inherent in Meera Mukherjee's sculptural expression, this essay draws parallels that situate the sculptor in a broader international perspective.

And finally, the last section of the compilation, titled "Meera on Art", presents excerpts from Meera Mukherjee's literary works with the intention to bring to light the artist in her own words.

Not only did she excel as a visual artist, but she wielded the tools equally effortlessly in the domain of literature—Meera Mukherjee as a writer expressed herself in lucid clarity through extremely simple language. Besides her essays and personal accounts on art practice, she also wrote illustrated books for children, which reveal another dimension of her creative persona. Books produced and intended for children are inherently distinct from the isolation of intellectual pursuit; they do not suffer the obligation to align with mainstream trajectories associated with modernism. Besides the innocuous sensitivity in the illustrations, the text of the narrative in Meera Mukherjee's books for children is characterized by an equivalent evocative picturesque characteristic that immediately appeals to the sensory perception of vision. For instance, in "Their friend the smoke person" (published in English translation, 2000), the faculty of visual imagination is incited in the mind of a prospective young reader, through the vivid though simple description of the young protagonists Bhulo and Sukho-didi who 'see' animated figures rising up in the smoke as their grandmother fanned the wood-

oven. Recasting abstract forms into identifiable likeness is as much the faculty of mature visual imagination as it is a common phenomenon with children who are innately endowed with dreaming up a vast plethora of visuals from the mundane daily experience; it is precisely here that imagination crosses over the divide between adult visual practice and child's world of wonder. Similarly in the story titled "Quilt", Khoka—the child protagonist, joins the cotton carders who produce quilts, in bridging the segregation between the realm of the real and the imaginary, when the cotton stuffed within the quilt and the fluffy autumn clouds in the sky tend to merge as identical in their shared likeness. The child's innocent query, "And what if it starts raining inside the quilts?" transports the reader into a universal childhood where a cloud-stuffed quilt could be a completely convincing possibility. From there on, the imaginative takes absolute wings, and the cotton-carders lead the protagonist into a remarkable journey into the domain of cloud animals and cloud people, the description of which is flooded with a distinctive visual flavour. The visuals accompanying the text are simple calligraphic renditions, sometimes employing zones of textured

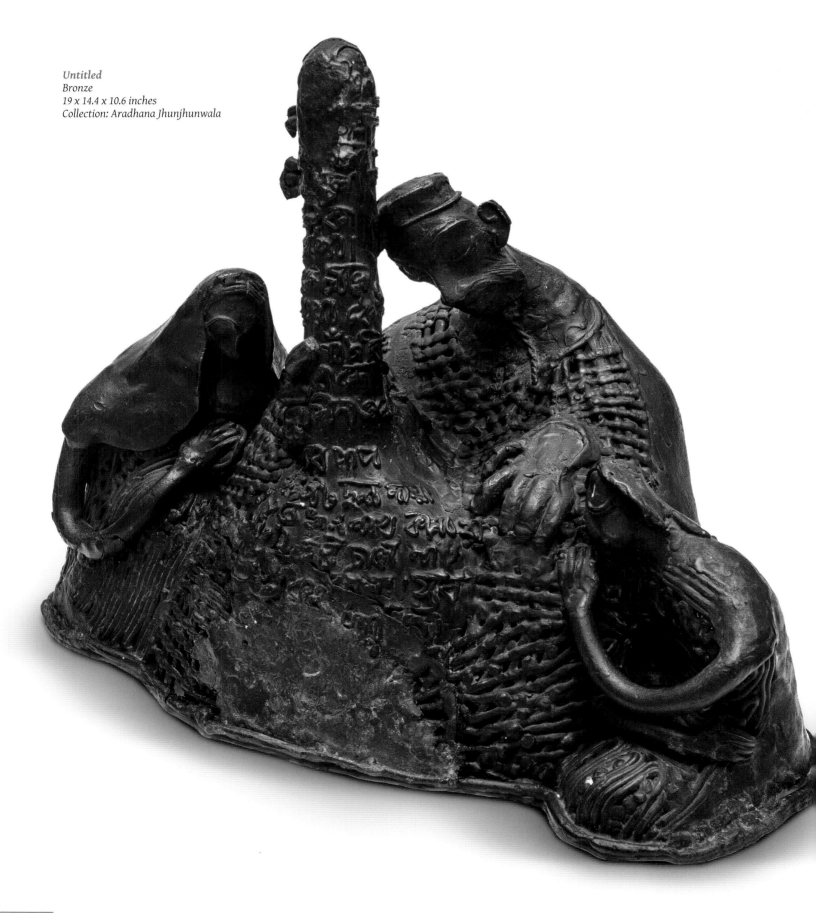

Untitled
Bronze
19 x 14.4 x 10.6 inches
Collection: Aradhana Jhunjhunwala

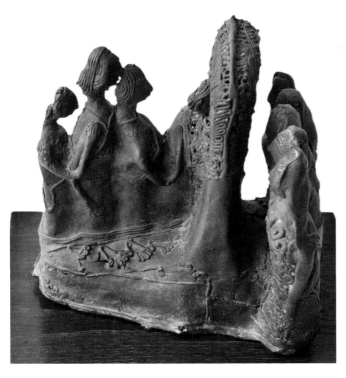

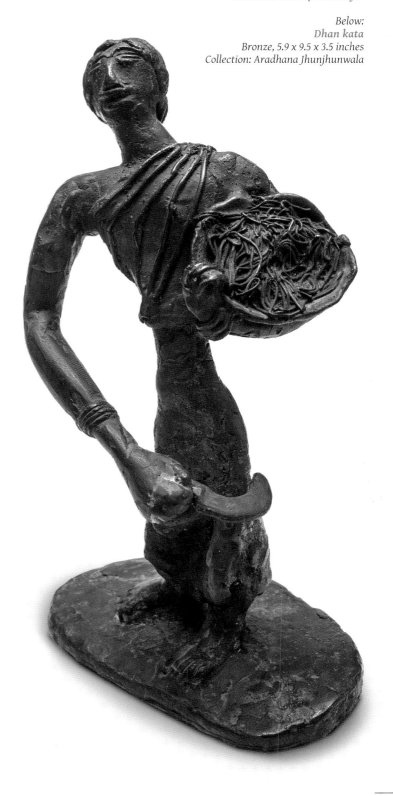

Above left:
Gateway
Bronze, 10 x 11 x 10.6 inches
Collection: Swarup Mukherjee

Below:
Dhan kata
Bronze, 5.9 x 9.5 x 3.5 inches
Collection: Aradhana Jhunjhunwala

network of lines to achieve tonal variation. Such images combine the element of simplicity that would immediately appeal to young minds, with the evocative yet subtle formal sophistication that is a mark of a mature visual artist. The resultant combination of text-and-visuals thereby does not limit itself to being merely storybooks for children, but evokes equal interest in responsive adult as well.

Although she did not personally execute them, Meera Mukherjee was involved in a project on redesign and development of the traditional Bengali home-sewn *kantha* quilts. While on the one hand this is a proof of her activities in the capacity of a designer, working with the women of the village who executed the *kantha*s, on the other it is also an evidence of the symbiotic relationship between Meera Mukherjee as a modern artist and the artists and artisans from the rural sector. What is fore grounded in such an endeavour is the artist's conviction in the community as a collective. The anthology contains photographs of some of these *kantha*s.

To sum up, the present publication intends to explore various dimensions and aspects of Meera Mukherjee as an artist so as to arrive at a total picture of the person and her mode of practice. To do so, the various authors concentrate on the aspects that they consider to be of primacy, and in this way, the diversity of foci serves to cumulatively build up the complete persona that was Meera Mukherjee.

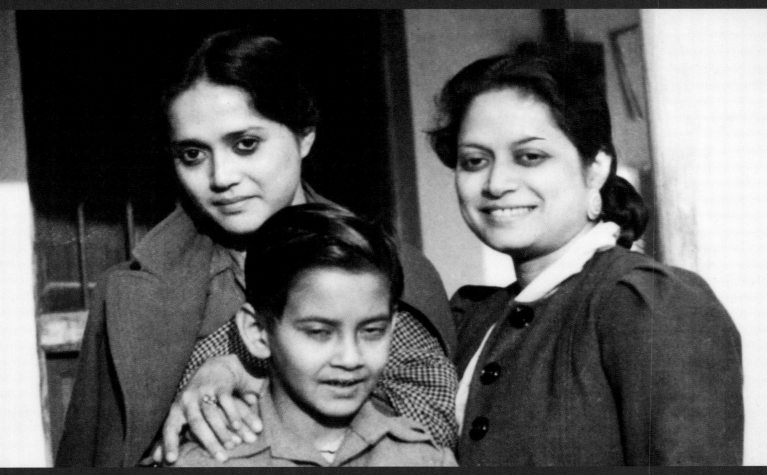

Recalling Meera
as a Person

Purity of Vision

The sculptures of Meera Mukherjee have always been a tremendously moving experience for the viewer. The rare and instinctive quality of romanticism is irrevocably reinforced by technical brilliance and expressive artistry. From the 1960s to the 1990s, her journey has been a saga of courage, boldness and commitment to emotional candour. This has guided her in charting a path in search of the right idea, the right dimension, to build characters in metal. The artistic energy and devastating intensity have made familiar subjects, like Ernest Hemingway's *Old Man and the Sea*, emotionally resonant. The ordinary men and women, the toiling masses are now a part of the well-recognized Meera Mukherjee signature. Looking beyond traditional methods of shape, she has created a richly detailed portrait of life around her.

An intensely private person, jealously guarding her personal life, afraid of any intrusions, she has been putting flesh on bare bones as a poignant solitary but not a recluse. The visually arresting group sculptures of men laying cables, people strap-hanging in public buses, the railway ticket counter, men asleep on a city pavement, an elephant being bathed by its keeper, are brought forth in uniquely diverse subjects. The extraordinary details, the style and finish in the expression of ideas indicate passionate involvement with life. Her works, although possessing the enduring sculptural values as weight, form, and balance, are rooted in another tradition. It is possible for her to be serious and pure, yet not scornful of the playful. Her many pieces like *Mocha, Cat, Bhulu the Dog*, and *Playing ball with a pariah dog* are shiny, fragmentary images. They are full of naïve charm and delightful harmony.

In the context of the violence surrounding us, her decision to embark on the massive statue of Ashoka demolishes any notion about her being naïve about

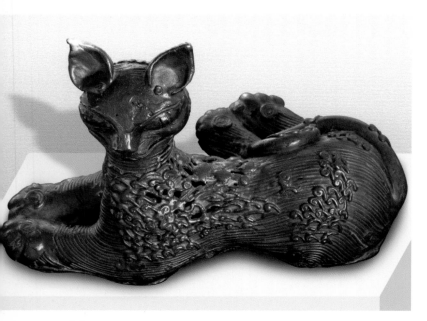

Cat
Bronze, 6 x 11.02 x 7.08 inches
Collection: Helma Bels

violence. The political violence towards the end of the '60s created in her the impetus for this work. It was a clear-sighted confrontation with the forces of hatred, and yet not merely bleak realism. It is suffused with sadness, full of insight, quietly determined to shake up society's values. This nearly nine-feet work is vigorous and compelling, astute and perceptive. It is Ashoka after the death and destruction of Kalinga, where legend says the river turned into blood. She has put the haze of passion into focus to make the emperor's tragedy an expression of hope in a world scarred by much misery and sadness.

The solitary pursuit of sculpting in her life has been to reclaim "the old idea that there is light outside". Her work shows the "inner light to make us see the light outside". She has also made it a goal in her life never to exclude the masses from culture. She has created that magic in her work which attracts the lay person as well as the connoisseur because she realizes that for art to be effective, it needs to be controlled; avoiding both sentimentality and oppressive solemnity. No matter how ephemeral the subject (grandmother recounting a fairy tale to her grandchild, women poised in the doorway of their homes, women fetching water), they bear the stamp of enraptured attentiveness and a subtlety of observation. Her themes, both rural and urban, have urgency because the vision is never stark or impersonal. *Ihokal* (This life) is not only a woman weaving at the loom; it is the wrap and weft of life's struggle. This large work encases the entire body of the woman in a loom in precise detail. Here, Meera Mukherjee is at her most tender and powerful best. These are works that do not date but remain bitter sweet experiences for all seasons.

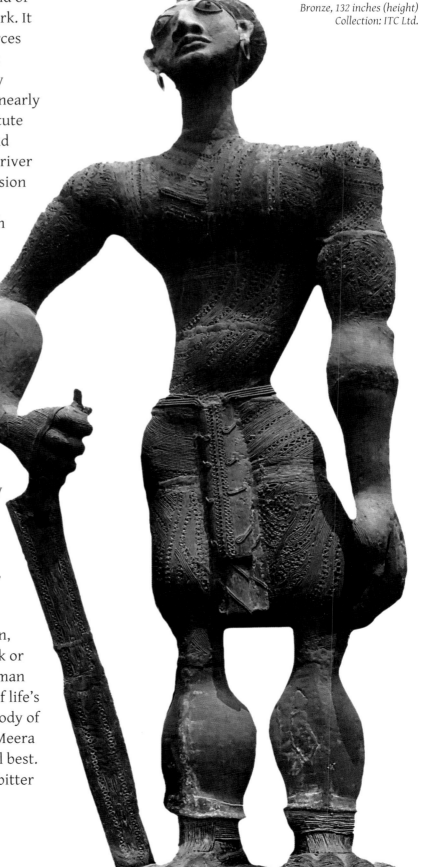

Ashoka
Bronze, 132 inches (height)
Collection: ITC Ltd.

Carpet Weavers
Bronze, 8 x 11.5 x 6.5 inches
Collection: Piramal Art Foundation

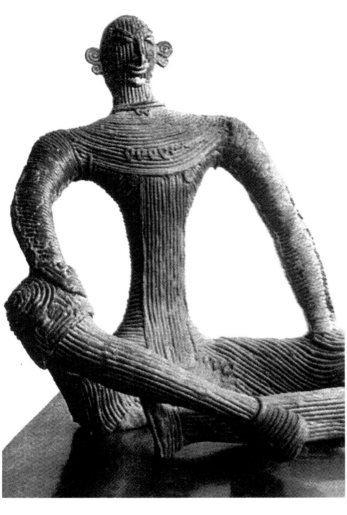

Left: *Guru, bronze*
Collection: M. Chatterjee

Below: **He Who Saw**
Bronze, 65 x 26 inches
Collection: Abhishek Poddar

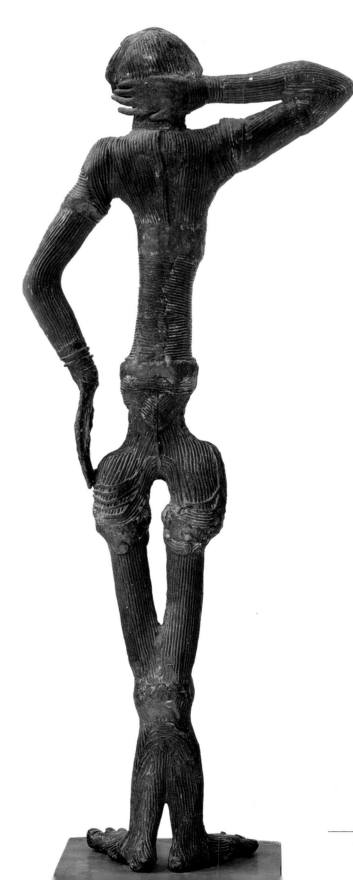

The cult of volume, of size, came to her in the mid-'60s and she regards it as an important turn. The three pieces were the *Guru*, *He who saw*, and the *Baman Avatar* followed by the *Archer*. All the three pieces possessed a strong sense of the physical as well as the emotional, indicating an unerring ability to move through ranges of emotions in one facial expression or a posture. The *Guru* charts a personality of authority, the *Archer* holds the sky with the birds, *Baman Avatar* explores form and *He who saw* conveys a sense of time, place and movement. The technique was the lost wax method which the metal craftsmen of India had been using for centuries. But the size was never on the scale as done by Meera Mukherjee. The *Gharua*s of Bastar, the *Dhokra*s of West Bengal and the *Malhar*s of tribal Bihar inspired her to extend an important art-historical tradition. Stella Kramrisch, the art historian, pointed it out to her that so far, this technique had not been used for creating large works of sculpture. This began the evolution of an

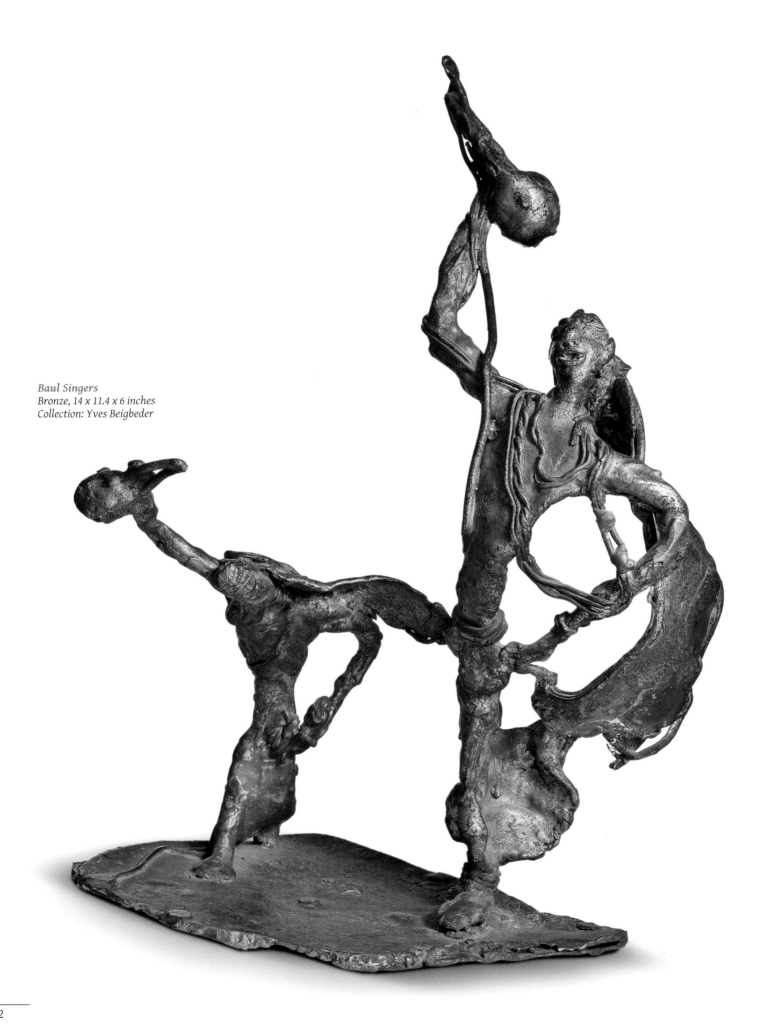

Baul Singers
Bronze, 14 x 11.4 x 6 inches
Collection: Yves Beigbeder

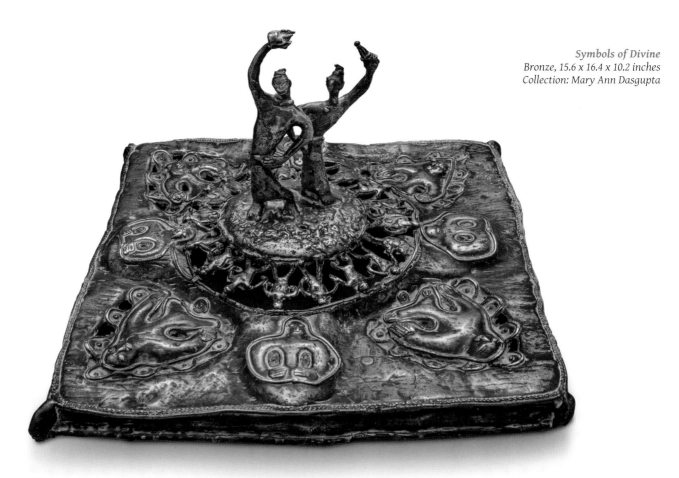

Symbols of Divine
Bronze, 15.6 x 16.4 x 10.2 inches
Collection: Mary Ann Dasgupta

entire art form that over the years had been shaped by social and political changes around her.

The language of Meera Mukherjee's art is admirably simple. She avoids jargon and lucidly summarizes the ups and downs of life, holding together realities and fantasies. There are no extravagant elaborations but exacting idioms. Each piece is like a story told with beauty. It is like a book that creates lovely evocative pictures with an absolute economy of text, whether it is men in sport with jostling *lathis*, or the massive sitting Buddha; each creates its own world and seems illuminated from within. Her homage to her music teacher Bimalaprasad Chattopadhayay is a grave and calm image which simply cannot fail to impress. The bust of a friend, Nirmal Sengupta, is a sharply observed portrait. *Mohan* is Meera Mukherjee's tribute to the village teenager who was devoted to the welfare of the villages around him but died a brutal death; it is an emotional vignette where the village has been created on two upraised palms. It is a life expertly and deftly told.

All the three pieces, aforementioned, radiate innocent charisma.

Meera Mukherjee has taken traditional elements and made them her own. But unlike lesser artists, her work is challenging and stimulating. One glance

is not sufficient. The way it engages the emotions is transparently spontaneous. Combining popular appeal with real artistic quality and purity of vision, she has emerged as India's Dickens of sculpture. Her art is immediately accessible, diverting yet intellectually demanding; her creations are anecdotal, nostalgic, sentimental and reassuring, spanning the timeless and the trivial.

If her works could be categorized then they would encompass three worlds—the all-pervasive presence of daily activities, the world of music full of subtle expressions and elemental passions, and the third world of abstract sculpture possessing philosophical powers. The common thread that runs through all of them is the rare intuitive relationship between the sculptor and her themes. In the first group would be the fishermen, the women repairing nets, stitching quilts, sitting at the loom, gathering *shapla* (a variety of water lily that is edible). Sculptures like *Repose* and *Thought* are an enrichment of life. Her mother figures are original variations on a traditional theme. The various music sculptures—*Alaap, Dhrupad, Shruti, Folk Singers from Mandu* and *Bauls,* provide both convincing atmosphere and strong characters.

She combines, myths, folklore and peasant art to create new art — expressive of the complexity, unease, and psychological darkness of the modern age. *The Storm* series and the *River of Life* are good

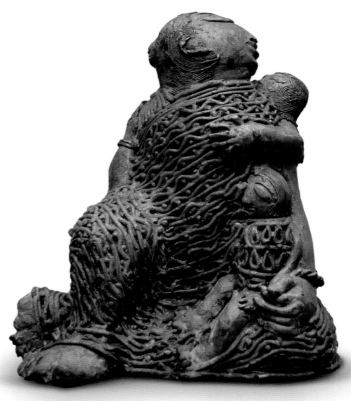

Right:
Mother with Children
Bronze, 14 x 11.5 x 11 inches
Collection: Dr Choubey

Below:
Mother and Child
Bronze, 14.5 x 7 x 6.5 inches
Collection: A. Dutta

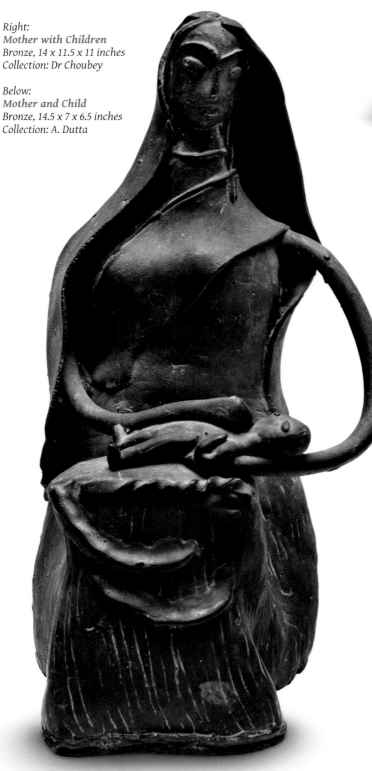

examples. The lines and quotations that she uses are never simply a matter of embellishment, nor merely a matter of style. They provide much food for thought.

Meera Mukherjee does not believe in coasting serenely along on her past glories. Her artistic personality has been moulded by a stormy burst of ideas. Her work is a visual diary of how an artist's growth is documented as she weaves in and out of the lives of people who create the ferment of ideas in her mind. *The Spirit of Work* (now in the National Gallery of Art in Delhi) throbs and bustles with life and feeling. *Give and Take* is an extraordinary exposition of life's cycle inspired by the apparently simple act of a woman worker passing on the load to a male worker who will continue the chain. This work too smells of life. Her figures are tight, incisive, muscular, articulating and exaggerating the contours. Drawing on the devastations of the 1978 floods, she created a memorable twosome. In *Bhopal '84,* the smoke in the chimney carries dead figures. Art here was designed to cope with the fact of death and destruction. *The Emergency* created two icons of protest, expressions of authentic powerful feelings.

The compassionate collection of works over the last two years is not only well crafted but also diverse in themes. She has, in the pieces, abandoned herself

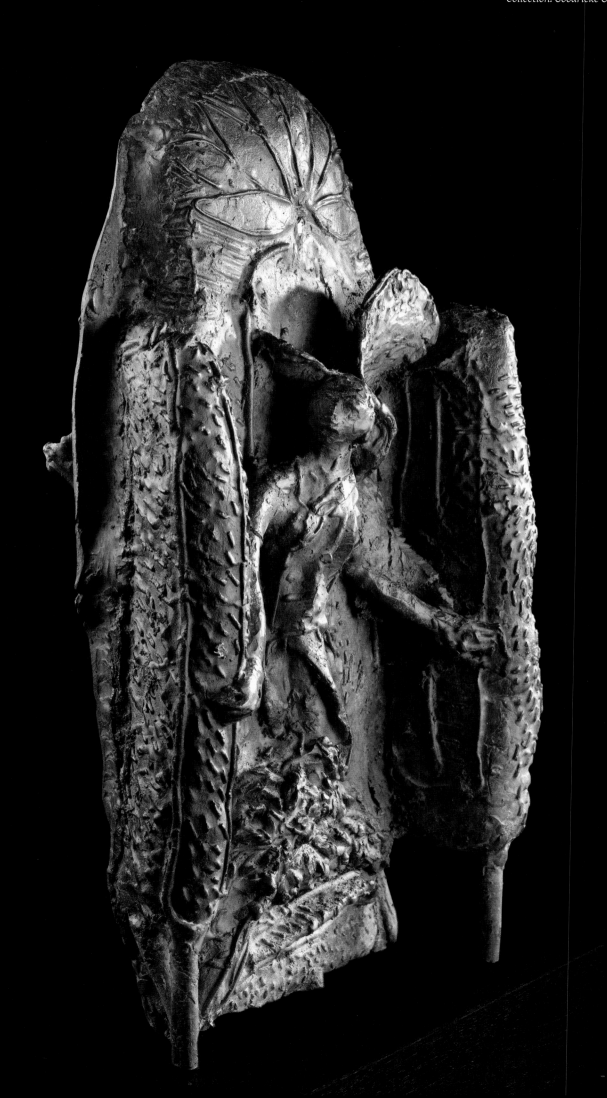

Storm
Bronze, 19 x 10.6 x 4 inches
Collection: Goodricke Group Ltd.

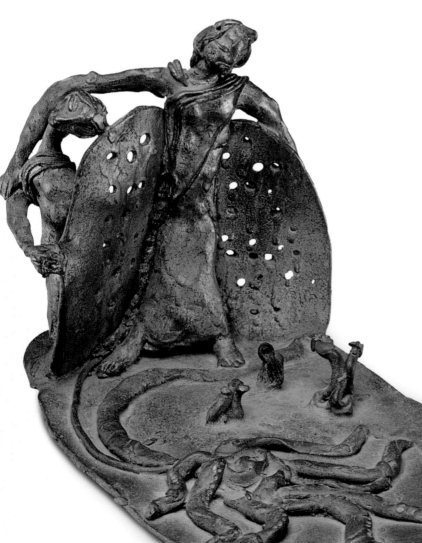

Untitled
Bronze, 8 x 7 x 12.5 inches
Photo courtesy: Christies Images Pvt. Ltd.

to her creation, oblivious to her surroundings. Her natural absorption in her art remains unrestrained by political correctness. *Dharampuja* goes back to an ancient ritual of tree worship. The intricate casting is demanding and difficult. *Benaras Ghat*, a poignant recreation of a period and place, indicates patience and determination. In the *Railway Station*, the name of the station is "Marta hoite Swarge" (from earth to heaven). A gamut of expressions—love, ambition, disappointment, arguments have wormed their way into the imagination. *Ekka Dokka,* a form of simple play among girls has inspired in Meera Mukherjee flights of fancy. *Behula* is a triumph of form, as she dances for the pleasure of Yama who is conveyed rather originally through small, flat eyes. In *Expectation*, the fishermen unfolding the net are in no error of anticipation but the quest of gold at the rainbow's end. Qualities of delicacy and restraint make caress (*Mother and Child*) a little minute of happiness. The kite (*Kite flying within a kite*) is not just a bland and mechanical application of technical skill. Here the artist uses sculptures as a vehicle for emotions and ideas. The work is subtle and complex without any glib effects. In a difficult piece like this mistakes can rarely be corrected. The seemingly effortless spontaneity has been achieved through confidence and discipline. A herd of buffaloes positioned against trees is as deceptively simple as *Kope* (hacking a tree). *Festival* (during Tusu worship) sheds new light on a hackneyed theme. *Bhokatta* (a full throated cry when an airborne kite snaps) and *Fishermen* running forth in the rain for fish and justice convey a sensuous feel for material. Metal here has the freedom of pulse. The theme of music is revealed in startling beauty making an impact that lingers long in the memory.

Earth to heaven (back and front)
Bronze, 7 x 16 x 12 inches
Collection: The Savara Foundation
for the Arts, New Delhi

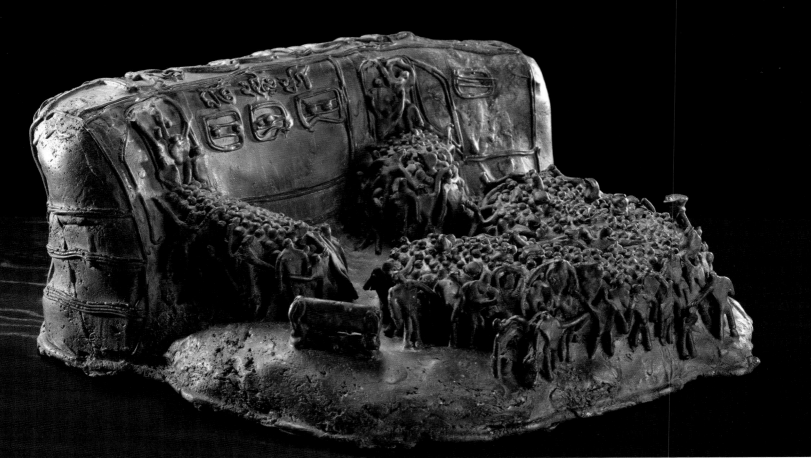

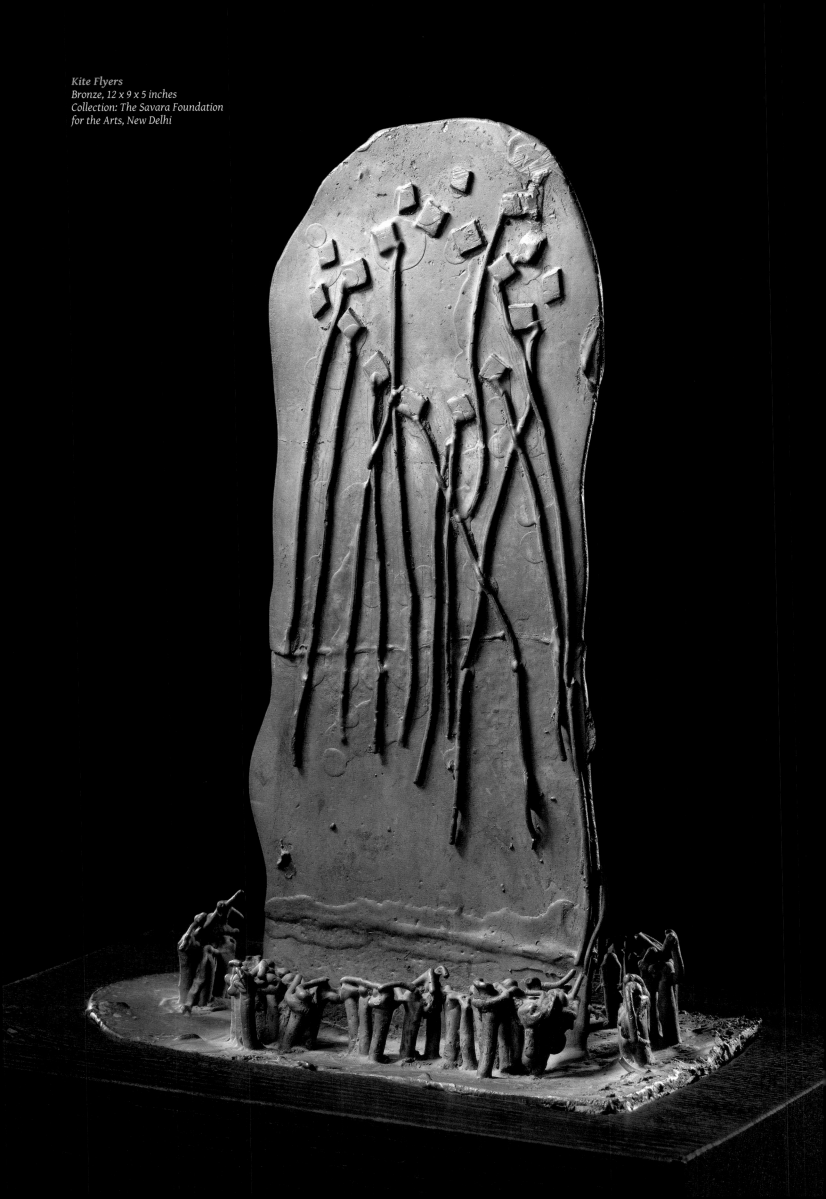

Kite Flyers
Bronze, 12 x 9 x 5 inches
Collection: The Savara Foundation
for the Arts, New Delhi

Top: *Festive Mood*
Bronze, 8.5 x 12 x 7.25 inches
Collection: S. Raja

Bottom: *Boatmen*
Bronze, 12.20 x 5.51 x 3.74 inches
Collection: Private

Puppets on a String is a sculpture on war. Meera Mukherjee is not a part of the drama of alienation. There has been a tendency to put her into comfortable pigeonholes like an artist using the folk idiom in classical form. The tormented aspect of the art of creation is vividly documented in these works. The surface for her is never more important than form, that part never more telling than the whole. She is formally innovative and daring in her development of complex forms in the round, a three dimensional conception, the essence of all authentic sculpture. It is not the manual dexterity involved in the technicalities, but the vision that creates that ecstasy of communication. Her sculpture always gives the impression of the whole thing driven as though by a single creative impulse. Her work is not so much an escape from the world of 'what we have to do' as to the world of 'what we would like to do'.

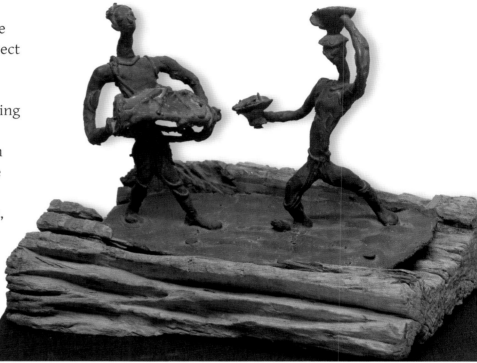

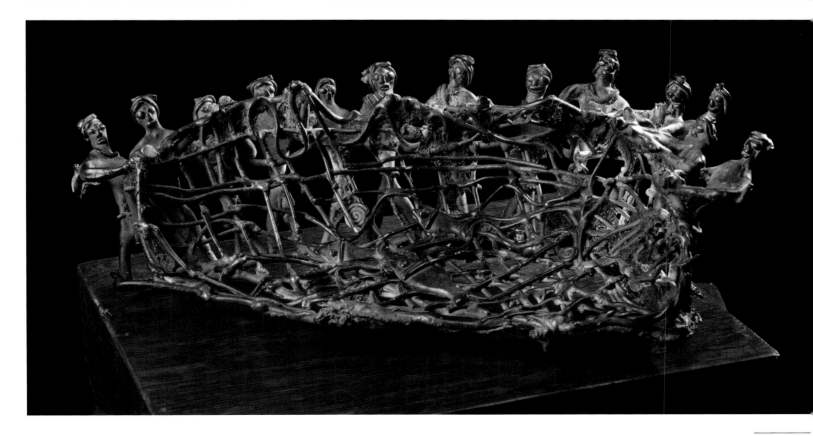

My Friend Meera

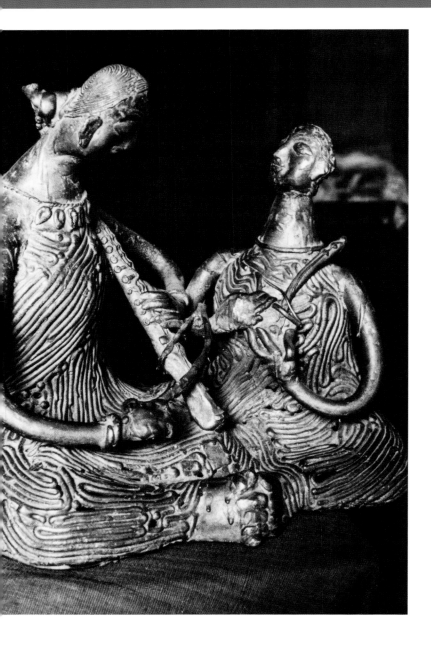

On a cold November evening, soon after my arrival in Munich (1953), an acquaintance of mine asked me if I would like to meet the only other Indian lady student, who studied at the Art Academy. I was only too happy to agree. So we set off for the Studentinnen Heim at Kaulbach-Strasse, where she lived. On knocking, the door was opened and there stood Meera. We were introduced and she welcomed me with her warm smile. I was pleased to see that she was dressed similarly, but she could give me little time that evening. She asked me to come again.

I remember a small and neat room with a bed done up like a sofa with a bolster at the back. A table and a chair or two in a corner, and a gramophone somewhere filled the rest of the room. The most striking feature was a huge poster of a Sur Sundari from Konarak on top of the cupboard. I think she enjoyed the reaction of her friends and visitors who concluded that Indian art was erotic, and long conversations would take place on this theme. She was of the view that art was an expression of the artist's experience of life and beauty, and there were no negative nuances associated with eroticism in Indian Art, nor was eroticism alone the sole intent of an Indian artist.

The next time I met Meera she introduced me to her close friends Josef from America and Ray from England, both studying Germanistik at the University. We all seemed to be attuned to each other, so it became a practice to meet in Meera's room, especially on weekends. Fortunately, my office (where I worked as a trainee) was within walking distance, so I would often drop in for a short while in the evenings during the week, before I took the tram home. Home, however, was an hour's distance, so these visits had to be really

short, unless we had planned to go to a concert. All of us were very fond of music and eager to learn more of German classical music. Whenever possible, we would listen to records together and lively discussions would follow thereafter, often leading on to other subjects like art, philosophy and famous personalities. Meera had been brought up in a Brahmin family and was more conversant with Indian mythology and legends. She would tell many stories which I had never heard. I think her favourite was about Maitreyi, the wife of Yajnavalkya, who when asked by him whether she would prefer his worldly goods or spiritual knowledge, opted for the latter without a moment's hesitation.

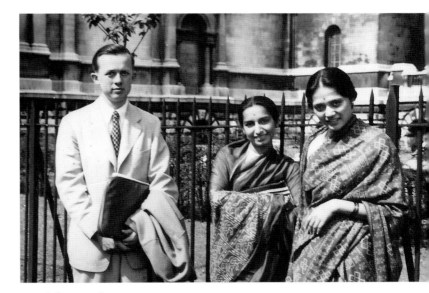

From left: Mr Josef,
Shilvanti Pracht and Meera Mukherjee
Courtesy: Surjit Singh

Many years later at Surjit's place in Chandigarh, when we were looking at one of her works titled *Maitreyi*, Meera explained that she had given the figure the form of a question mark to indicate Maitreyi's quest of knowledge. The figure is about 1.5-feet high and is done entirely in the wax wiring method, a strong reminder of Bastar art.

However, at the beginning I did have trouble understanding Meera. She seemed to be made up of so many moods, happy, sad, and teasing, like a naughty child, then again thoroughly depressed, agitated, worried, and superstitious. I could not imagine how she would be next time we met; sometimes relaxed and laughing, at other times extremely disturbed and agitated. At such times I did not know how to calm her. Only Josef seemed to find the right words. Sometimes she would ask us to leave her alone for an hour or so, and on our return we would find that she had gathered herself and had put her worries aside for the time being at least. She did tell us about her broken marriage and how her husband had asked her to leave the house. But I did not think that she was very unhappy

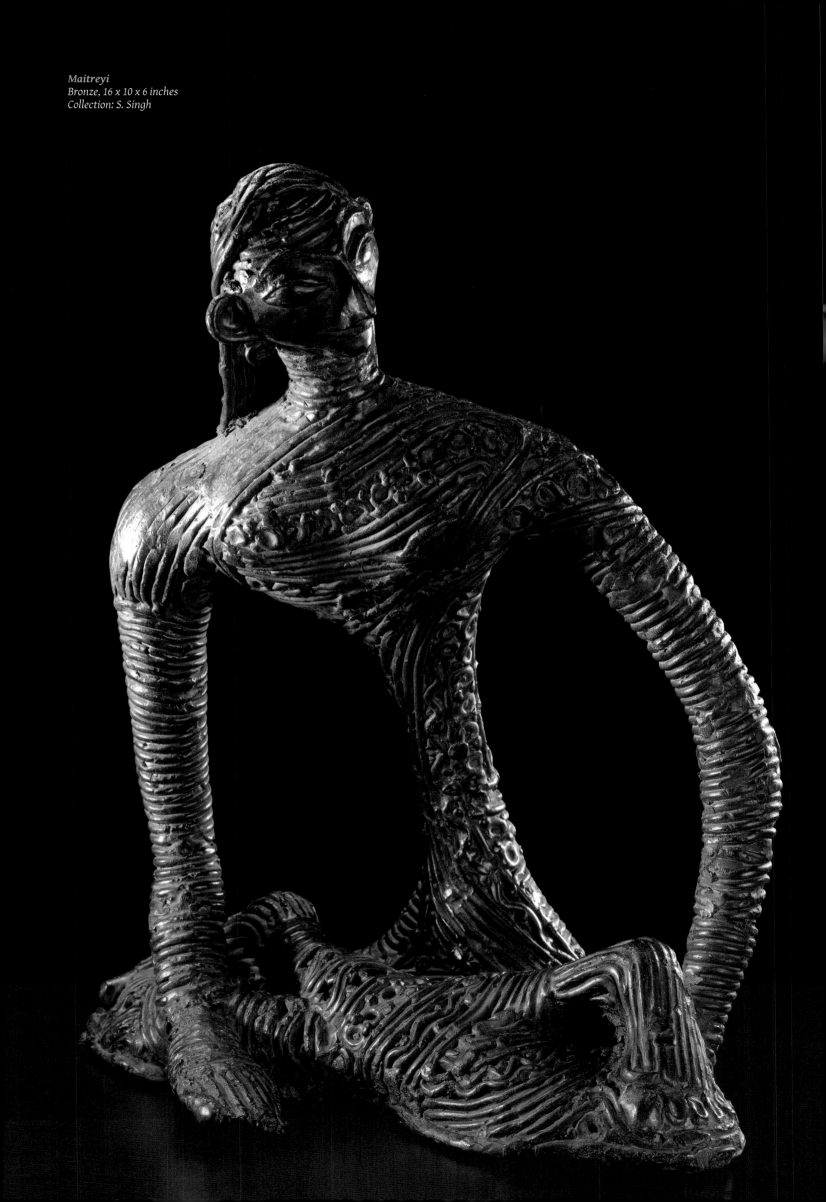

Maitreyi
Bronze, 16 x 10 x 6 inches
Collection: S. Singh

about that after so many years nor was she very clear at that stage of what direction her art would take. Her concern was of what was waiting for her in the future and whether she would succeed as an artist and achieve recognition. She was extremely devoted to her teacher—Prof. Stadler, and learned eagerly. He in turn seemed to understand her sorrow and her need to express herself in art. One day she quoted a few lines that he had spoken to her while she was working: "The blue of the sky wishes to meet the green of the trees...The wind blows and sighs alas, alas".

She was really happy working with him and absorbing whatever he had to teach.

Once I found her looking pensively at a large wooden bowl that she had just finished. I could not take my eyes off it. It had one of the most beautiful shapes that I have beheld. It reminded me of a *diya* (a small clay lamp), but with its mouth at an angle. It was at least 50 cm across with rounded edges about 2 cm thick, its sides moulded out smooth and the centre hewn out roughly. I could not find words to express my feelings, but somehow I never asked her later what had become of it. And yet, to this day, I remember with joy its perfect form.

One day, Meera said she had been assigned to do her first metal work–a masque–and would like me to sit for her. We met for several sessions in the evening at the Art Academy. There was no one around, so it was very quiet in the room. We sat opposite each other at a little distance. Neither of us wished to disturb the still calmness. She worked silently at the clay model while I watched or was lost in thought. After an hour or so she would finish for the day and we would go back to her room, to meet again some evenings later. She was pleased with the result when she cast the clay model in bronze, but

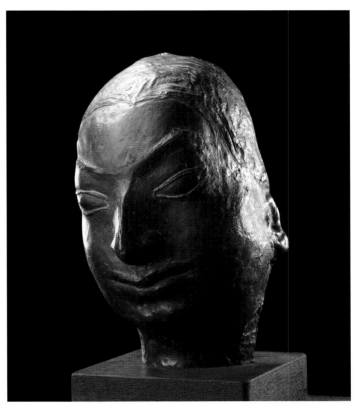

Shilvanti
Bronze, 9.44 x 5.5 x 3.39 inches
Collection: The Savara Foundation
for the Arts, New Delhi

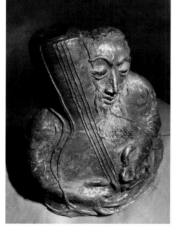

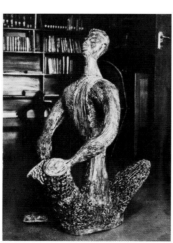

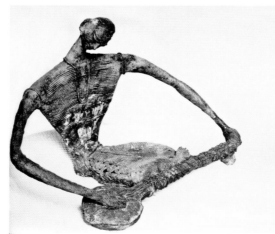

disappointed that she had been unable to catch the expression of the eyes and had thereafter resorted to closing the eyes. Years later she brought the piece to Chandigarh and presented it to me. I was, of course, quite thrilled and still cherish it.

As spring and summer came, the days became longer and our outings increased. On fine days we would all opt for a walk through the Englische Garten which was very close to Meera's hostel. We would pause at a small bridge over a narrow stream and ponder upon life while watching the water flow beneath. There was a kiosk at one end of the garden where we bought coated peanuts. And then of course, there was the new Art Gallery, Haus der Kunst, where we went as often as we could to visit the many art exhibitions. Sometimes, when we felt rich, we would stop at the Chinesischer Turm (Chinese Tower built like a pagoda) for a cup of coffee and cake. Those were carefree moments, and before we knew it, the afternoon was over. One day, quite unexpectedly Meera burst into a song, while we came upon a fountain. The first time was a joyful surprise but thereafter I realized that singing came very easily to her when she was particularly happy or sad. My favourite song was "Tarana arana se ranjat dharma navalochan hai lal".

Her repertoire of Bengali songs seemed to be endless. And the best part of it was that she translated all the songs for us, thus adding to our joy, and binding me closer to home.

Here I would like to mention Meera's own uncanny sixth sense for other people's feelings and emotions. She seemed to know one's problems without being told about them. Sometimes she sensed my nervousness and one day she taught me one of Tagore's songs, *"Na nago na /Koro na bhabona"*. She felt it would give me courage and an inner strength,

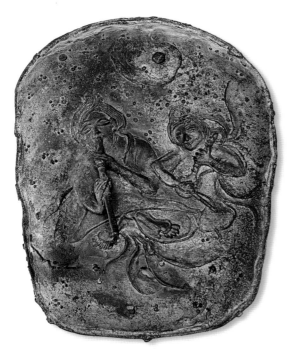

Left: Melody
Bronze, 15.4 x 12.2 inches
Collection: Abhishek Poddar

Below: Untitled
Bronze, 23 x 15 inches
Collection: Private

and I think remembering the song has helped me in many weak moments.

Meera often spoke of her friends Surjit, Kulwant, and his brother Laljee who were all studying art in London. They were friends from her Polytechnic days in Delhi and she was extremely fond of them. She was very eager to meet them and to know how they were getting along. So the three of us, Meera, Josef, and I, decided to take a trip to London that June, stopping on the way in Bonn and Aachen.

But for Meera and Surjit, I don't think I could have enjoyed seeing the artworks in London as much as I did. Seeing a work of art with Meera was an experience in itself. She would become completely absorbed with what she witnessed, her face transparent with an inner joy. She seemed to identify herself with the artist's feelings and was able to convey these to us quite convincingly, even in her broken German or English. If she saw something that really touched her, like Henry Moore's open air works in which the spaces between solids also seemed to take forms, she was transported with joy.

Indian art held a special place in her heart. In London there was plenty of opportunity to view Indian art at the British Museum and the Victoria and Albert Museum, and we spent hours in both. At the British Museum there was a slab from Amravati Stupa placed against the wall at floor level. We all just sat on the floor to take a closer look at the

procession of people depicted in relief on the slab. It was then that Meera pointed out that movement was an essential element in Indian sculpture, whether done in temple or caves or open air. In the case of the Amravati slab, all the figures were shown performing different actions, but together they formed a harmonious whole. Later one could notice this element in Meera's work itself. We have a small sculpture of fishermen drawing a net with fish, done in the wax-wire style which shows exactly this harmony in movement.

Another thing that Meera was very proud of was the way the Indian artists of the past identified themselves with the artisan. In fact, the traditional notion of an artist and an artisan appears to have

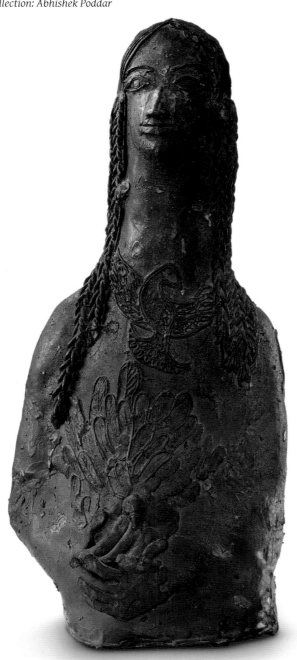

Girl with Pigeon
Bronze, 22.4 x 11.8 inches
Collection: Abhishek Poddar

been identical and overlapping when in the employment of a patron or a king, and thus they never left their names on their works of art for posterity. Meera herself admired and followed this tradition and refused to sign her name on her works, maintaining that the work would speak for itself.

Most of the theatres in London were closed for summer holidays, but we did have an opportunity to see a Japanese 'Noh' play and Pirandello's *Six Characters in Search of an Author*, which we enjoyed very much, and as usual spent the rest of the evening discussing its deeper points. For me this holiday came to an end all too soon, but Meera and Josef stayed on for an extended period.

Meera had a characteristic way of smiling when she had something secretive and interesting to reveal. So on her return from London: "You know, Shilvanti"— a long pause —"You know," till she had my full attention, and then in a burst "we met Henry Moore!" Josef had managed to fix an appointment on telephone for Meera to meet Henry Moore at his country house. They were received most graciously and Meera could talk freely with him on his works, and his views on art. This was, of course, the highlight of her visit to London.

Soon after our return from London some Indian students suggested we should put up a small cultural show on Independence Day. Meera knew I had learned the rudiments of Indian classical dancing in Bombay, and much against my doubts felt that we could present one or two items with her singing and me dancing. The only Bengali song we both knew was *"Nirmala kanta namo he namo"*. Fortunately I loved dancing to this song, and with Meera singing I soon gained confidence

Meera Mukherjee and Henry Moore, London, 1955. Photo courtesy: Surjit Singh

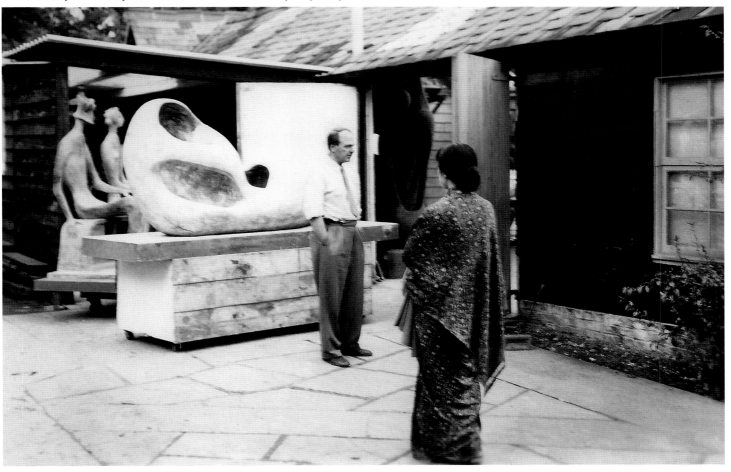

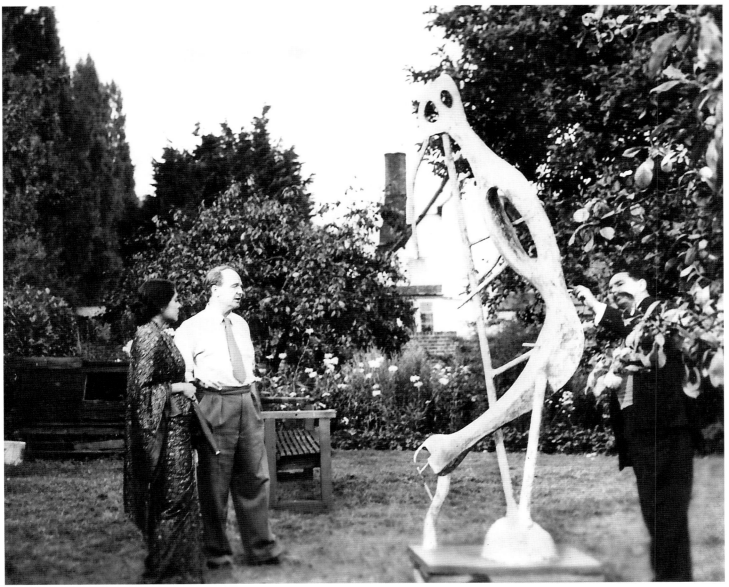

and practised with her in the evenings, till she felt that the item was presentable.

Then came the surprise I was not prepared for. She said if I tried hard enough we could put together another dance to a song I had never heard before. This was *"Mor Bina"*, a song expressing sheer joy. This was a real challenge because we had to fit in whatever dance steps I knew to the rhythm of the song.

The day came when we had to present the songs and dance before the other students for a final rehearsal of the whole performance. All went well till the last step of the second song, when Meera suddenly said that this lacked the liveliness it required. Till then we had been practicing in her room, but, now, in a bigger hall, the end of the dance seemed too static. She insisted I do something about it right away. I tried all kinds of versions but could not satisfy her aesthetic sense. Finally, in despair, I repeated the same step several times in a large circle and that suddenly brought approval all around, and I could breathe again.

In November I moved to a room close to Meera's hostel. There after we met almost every evening

Maestro
Bronze, 20.5 x 32.2 x 19.6 inches
Collection: National Gallery of Modern Art

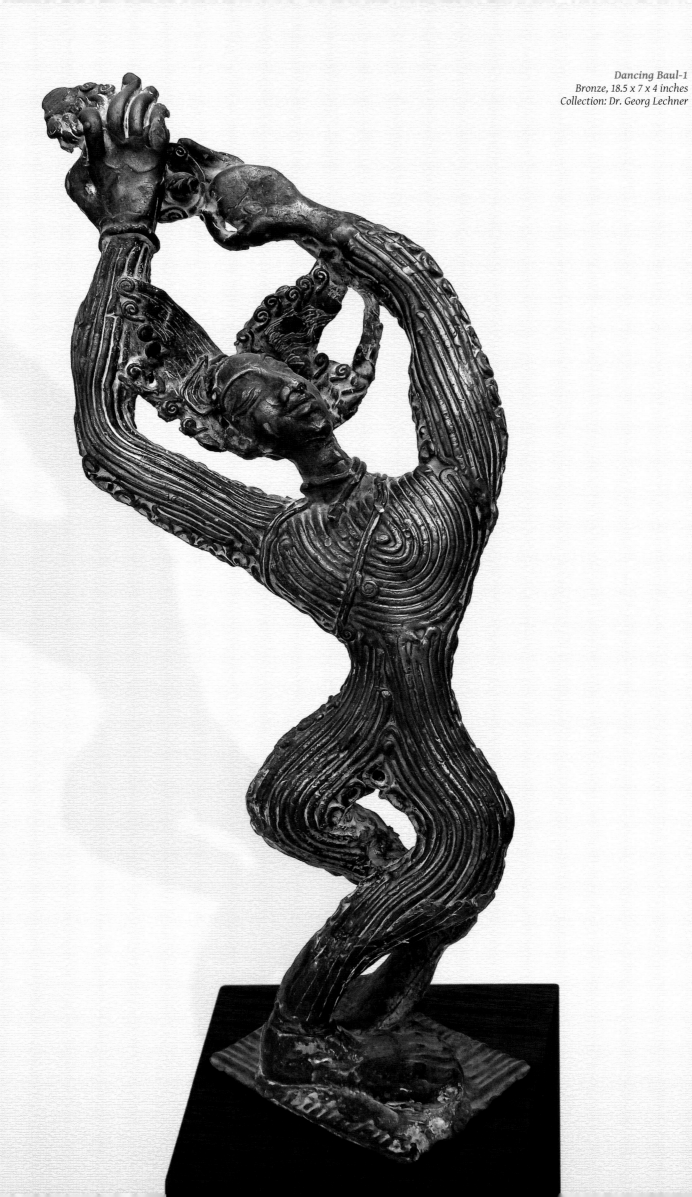

Dancing Baul-1
Bronze, 18.5 x 7 x 4 inches
Collection: Dr. Georg Lechner

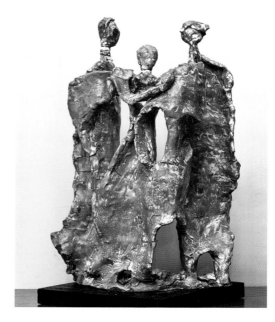

Below and right:
Encounter *(front and back)*
Ceramic, 14.75 x 8.5 x 6.75 inches
*Collection: The Savara Foundation
for the Arts, New Delhi*

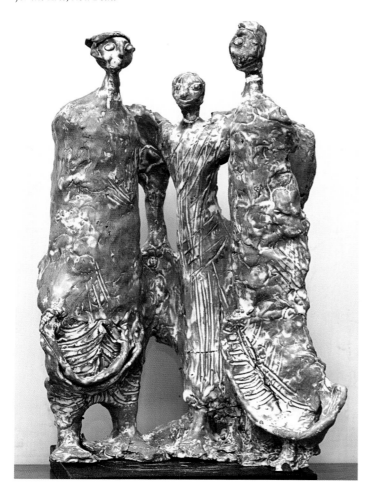

in her room. It was winter again and cold, so we spent most of our time indoors with Josef and other friends joining us.

I found student life in Germany most interesting. The young people seemed to know much more than students in Bombay; at any rate they were capable of holding long discussions on any subject on earth. So time passed on very fast. We celebrated Christmas and New Year together and before I knew it, it was time to say goodbye and leave for India, uncertain when and where we would meet again.

After Meera's return to India we met in Bombay and later in Calcutta and Kurseong (1958), where she had taken up a teaching assignment. Then somehow we lost touch, until the day I read in a newspaper in Delhi that she was having an exhibition of her works at AIFACS. I hastened to meet her there. It was like old times, and there was also a reunion with Surjit. After that we met quite often, whenever Meera came to Delhi to visit her sister.

In 1971 Karl and I moved to Chandigarh. Meera came to visit us and was very happy to see our new house. When she came next, the house was in the midst of being painted. I was struggling with the painters to get the right clay colour, which I wanted on one wall. She succeeded in finding us the correct mixture of paints. Later, when the house and garden were quite ready and the flowers, especially the "golden shower", were blooming, she complimented us on the romantic surroundings created.

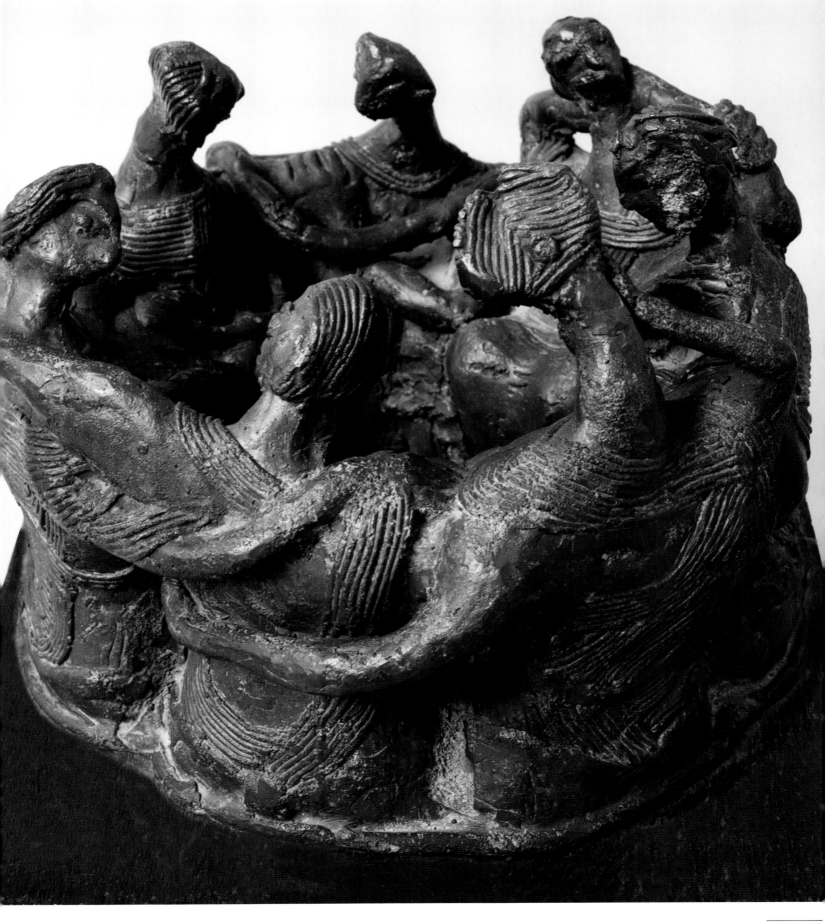

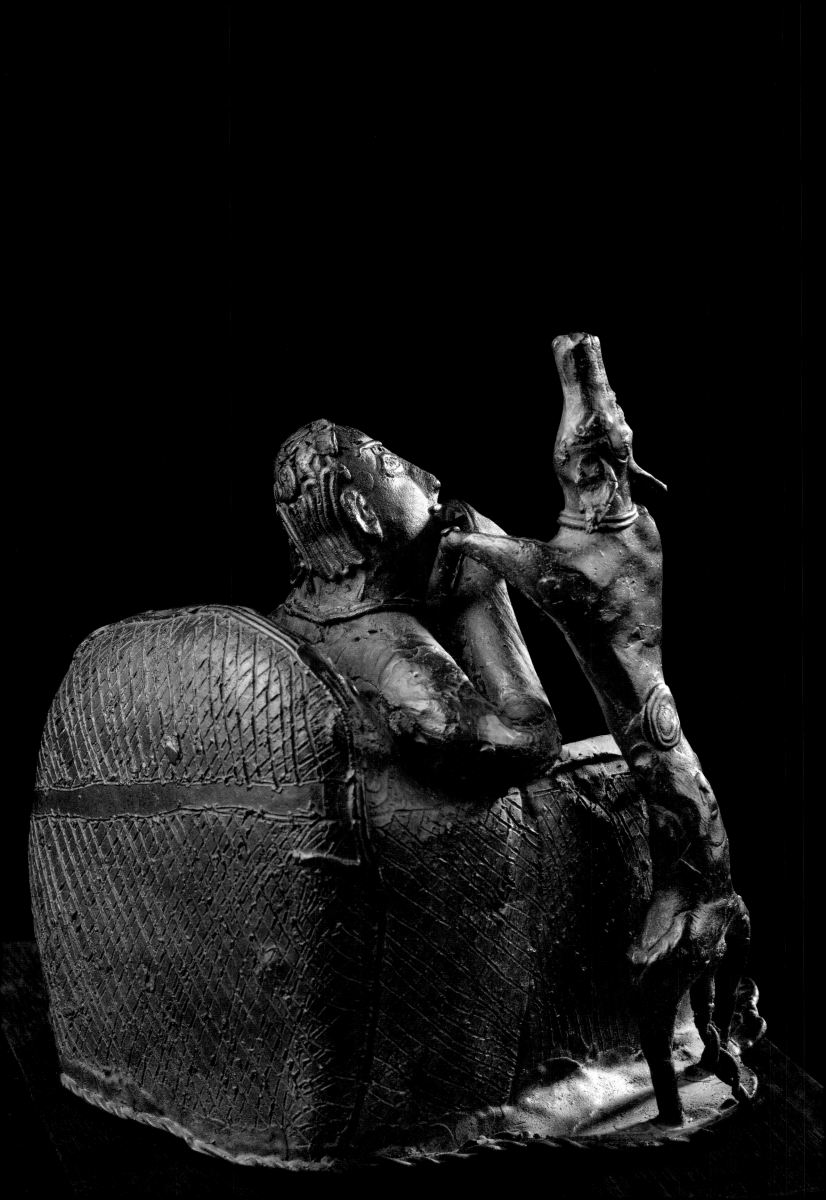

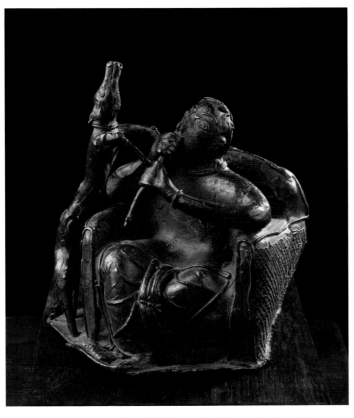

Facing page and left:
Man with his pet
Bronze, 8 x 6 x 6 inches
Collection: Abrajit Mitra

Below:
Couple
Bronze, 9 x 13 x 12 inches
Collection: Swarup Mukherjee

During the years that followed, till we left India (1994), she visited us every third or fourth year. It was a restful change for her after a busy period of creative activity in Calcutta. She often spoke of her work and the changes she had developed over the years. She was always full of ideas of what she intended on doing next – people at work, dancing figures, singers and so on. She was very happy when her Ashoka found a place in Delhi.

The days would pass very fast going out in the mornings and afternoons, listening to music in the evenings and just chatting. Meera knew, from our days in Germany, that I enjoyed her cooking. So when in Chandigarh, once in a while, she would cook some exotic Bengali dish. We had banana trees in the garden, so, one day she gave us a creation from banana blossoms. One day, when we were feeding our dogs, she spied some dog biscuits. Curious, as always, she wanted to taste one. We tried to stop her with warnings about the ingredients, but, being Meera, she had her way, insisting what was good for the dogs was good enough for her! That evening was spent in much laughter.

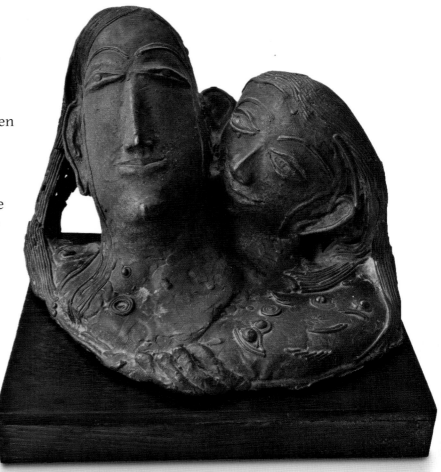

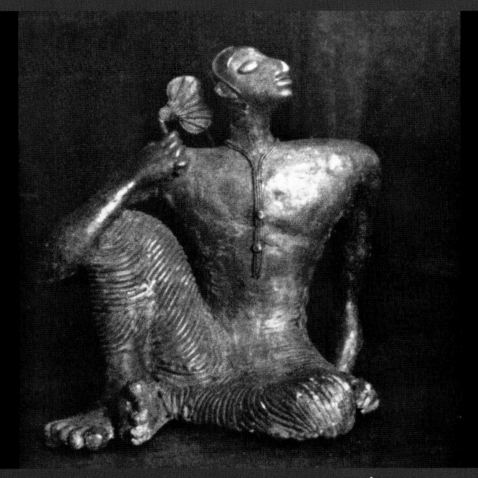

Part II

On Meera's Art:
The Artist and Her Language

Notes from Germany

Meera Mukherjee – then Meera Goswami – came to Germany in 1953 and enrolled as a scholarship holder and student of sculpture at the Academy of Fine Arts, today's Hochschule für Bildende Künste, in Munich. She stayed at the Students' Hostel of Kaulbachstraße that still exists today. Following the European orientation of the German sculptural scene of the time, over the years she developed a taste for the art in France and England. In Munich, her main instructor, Professor Toni Stadler, had become Vice President of the Academy in 1953; Stadler had studied under the famous French sculptor Aristide Maillol in 1925-1926 and had also won a much coveted scholarship for a one-year study at the Villa Massimo of Rome in 1959. In the same year, Toni Stadler was also chosen, along with Professor Heinrich Kirchner (who also taught Meera at the Academy) to participate in the famed international art event "Documenta" at Kassel. By this time, Meera Mukherjee had already returned to her native Calcutta, after spending four years in Munich and had taken home the impact of a rich European tradition of modern sculpture from Wilhelm Lehmbruck and Ernst Barlach of Germany, to Henry Moore of England and Auguste Rodin of France.

At the Munich Academy, during and after Meera's period of apprenticeship, sculpture was taught by important names like Theodor Georgii, Hermann Hahn, Ludwig Kasper, Hans Wimmer and Martin Mayer, in addition to Toni Stadler and Heinrich Kirchner.[1]

It is worth noting that Toni Stadler had acquainted himself with the "lost wax" technique of bronze casting, which Meera was to subsequently study with the craftsmen and image

Queuing before the passport office
Bronze, 16.5 x 13 inches
Collection: Abhishek Poddar

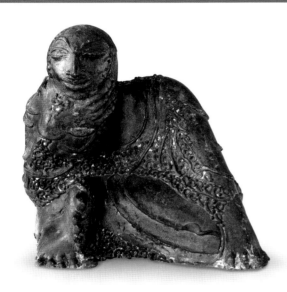

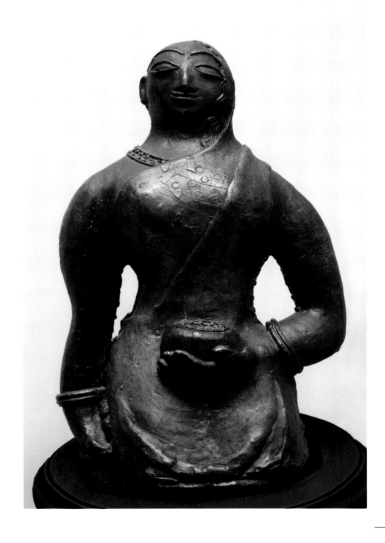

Left: *The Thinker*
Bronze, 12.6 x 11.8 inches
Collection: Abhishek Poddar

Below: *Annapurna*
Bronze, 15.75 x 11 x 6.75 inches
Collection: Rohit Singh

makers of Bastar in Madhya Pradesh and was
to adopt as her favourite technique. Certainly,
there was a common bond from the beginning.
The influence of Toni Stadler on Meera's artistic
development may be classified as more indirect
rather than direct. Although it is true that Meera's
artistic inclinations had been well served by the
expressive character of Stadler and the German art
scene of the period (recall German Expressionism
and the painters Nolde, Kirchner, Marc or
Kandinsky), significant impact from the field of
sculpture, would be the memorable examples: *Der
singende Mann* (The Singing Man) 1928, *Der Bettler*
(The Beggar) 1936, *Der lachende Alte* (The laughing
old man) 1937, all by Ernst Barlach; or *Stehende
Frau* (Standing Woman) 1938-1941, *Sitzende* (Seated
Woman) 1954, *Aglaia* 1961 or *Mädchen aus Anacapri*
(Girl from Anacapri) 1966 , all by Toni Stadler.
Meera Mukherjee's later works like *Seated Woman*,
Blind Companion, or *The Guru* could be seen as
carrying the impact of the German art scene.

In the second half of the fifties, during the years
Meera stayed in Munich and the period immediately
following it, her teacher Toni Stadler was at the
height of his creative effort and acquired several
honours to his credit. But with all his outer success,

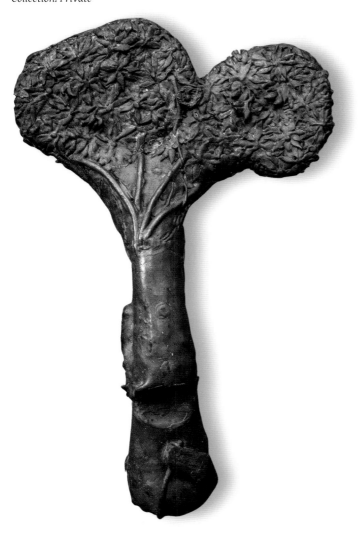

Tree of Life
Bronze, 27 x 16.75 x 5.5 inches
Collection: Private

only to come somewhat nearer to her final vision of a sculpture. There were even moments before the opening of an exhibition when she was so self-critical that she was inclined to give them away for free, should anybody care to have them. Her quiet and unassuming manner and her shyness are reminders of the modesty common between her and her German teacher. Besides these, one could recall the Asian idea of perfection to be gained only through a never ending journey, the *tao* being the goal and destination itself. In East Asia for instance, drawing a horse or a bamboo has been a life-long exercise and calls for *das übendes Dasein* (being as repeating and rehearsing) as the philosopher Peter Sloterdijk put it. Meera sometimes called it the artist's "prayer", because her work took on an almost religious dimension at this level. Faced with the aesthetic vision of beauty and harmony in classical Greek and Roman sculpture, in the depth and the exuberance of Indian temple sculpture, as well as in modern and post-modern explosion of artistic expression and materials, Meera Mukherjee had to negotiate her very own way without faltering for direction. In her own words:

he was increasingly ridden by self-doubt that questioned his belief in the perfect piece of art, the dichotomy between idea and execution, the ideal and the real in art. Armin Zweite, later director of the Lenbach Gallery in Munich, spoke of Stadler's *bestechender Redlichkeit* (pithing), his fascinating sincerity that prevented him from subscribing to any premature solutions and easy answers in his oeuvre. The well-known German art critic Werner Haftmann even went further by speaking of a "tragic chain of voluntarily accepted defeats throughout his creative life". From 1956 onwards, Toni Stadler often renounced detailed anatomical precision in favour of the overall impression; he also began to favour the torso as a valid artistic form. The connection with Meera Mukherjee here is twofold. The self-doubt of Toni Stadler was also the permanent companion of Meera's creative process. I remember many an occasion when I was witness to her never-ending questioning of a given form, her willingness to alter an angle or a surface,

Untitled, Sketch

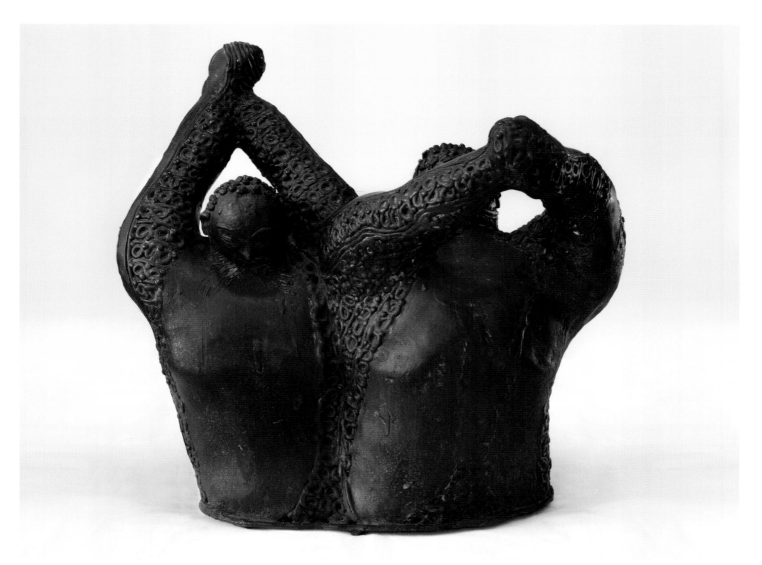

Workers
Bronze, 16.5 x 15 inches
Collection: Abhishek Poddar

I belonged to a country which also had a great tradition of its own. It was the heritage which had in a thousand ways folded me. And, so though I was at the moment living, learning and growing in the West, I should still find my own way to myself, rooted in the great Indian tradition.[2]

But Meera was also aware of the heavy price which an artist has to pay, through the constant striving that is necessary in order to gain possession of that tradition. While in Germany she would have certainly remembered Goethe's statement, "Was du ererbt von deinen Vätern, erwirb' es, um es zu besitzen", reminding us that any heritage has to be individually acquired to be possessed. And I am inclined to quote Goethe once more, who has Faust say, "Wer immer strebend sich bemüht, den können wir erlösen", meaning that unending effort, the constant striving alone can redeem. Meera often referred to the Indian intuition about the self and the universe, the *atman* and the *brahman* being *advaita*, that is inseparable; she said: "Like an artisan, an artist must learn to work without cease" and added: "Through work, one after another of the barriers within him fall apart, until nothing remains to separate his inner self from the great beyond,

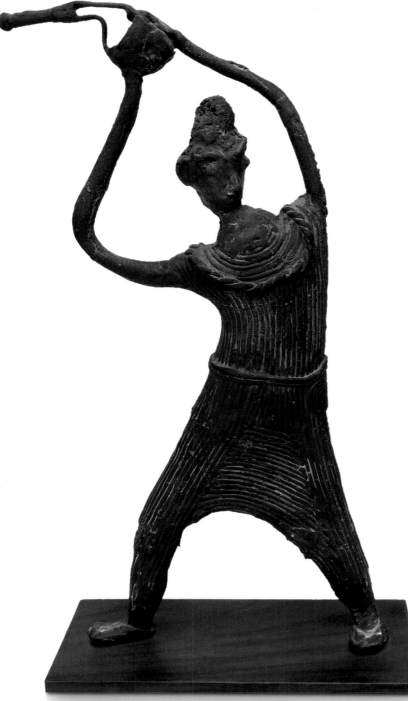

Baul with Ektara
Bronze, 11.8 x 5.51 x 1.4 inches
Collection: Private

and the great power of the universe is within the grasp of his own creative self."[3]

In the best Bengali tradition, Meera Mukherjee had taken the courageous decision for higher studies in Germany and kept up her European connections through friends, all her life. Let this be the place to take stock of her sculptures that have found their permanent home in Germany. To my knowledge, there are at least eleven sculptures of small and medium size and one large sculpture still in Germany, while another four have recently found their way back to India.[4]

With the exception of Hermann Abs who had acquired his collection from the New Delhi exhibition in 1970 during a visit to this city, all the other owners were good friends of the artist and cherished her work along with fond memories of their bonds of friendship. Thematically the *Baul* sculptures take the pride of place, but several others stand out for their own reasons. The bust of Mrs Shilvanti Pracht was the first sculpture to be done by Meera in Munich for her teacher Toni Stadler; the *Seated Woman* was the first German acquisition, and like the *Guru* unique as a seated figure of this size; the *Tribal Girl* is the largest sculpture in German possession; and the *Cat* and *Village Panchayat* stand out for their singularly unique theme. While individual owners will obviously have very special relationships with their respective collections, I have personally developed a singular bond with at least two of these sculptures – the *Seated Woman* and the *Tribal Girl*. I will refer to the *Seated Woman* in the final remarks of this essay and will give a general impression of the *Tribal Girl* here—a sculpture showing a tribal girl (or woman) carrying a water pot on her head. The striking features of this figure are her slender body, long and elongated arms, fingers and

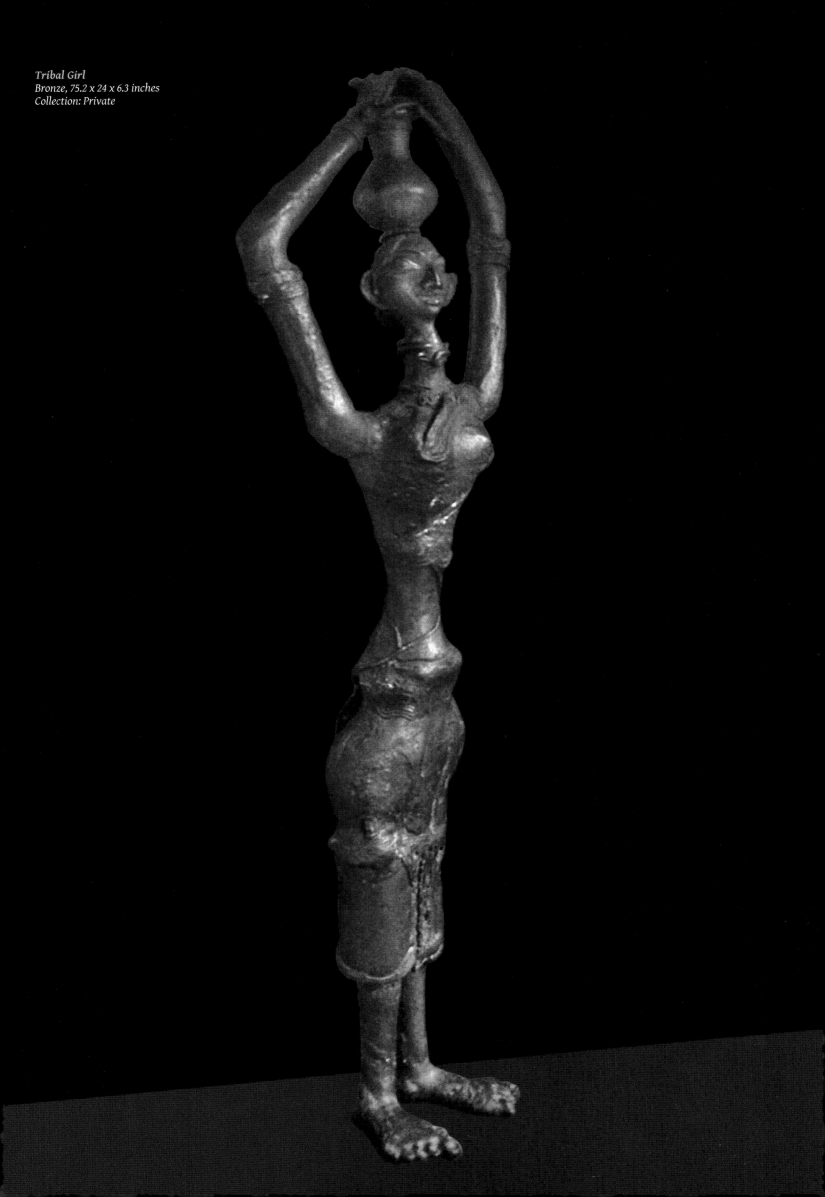

Tribal Girl
Bronze, 75.2 x 24 x 6.3 inches
Collection: Private

Below left: *Earth Carrier*,
Bronze, 109.5 x 50.75 x 16 inches
Collection: Abrajit Mitra

Below right:
Earth Carrier-2, bronze
Collection: Abhishek Poddar

feet, slim waist, broad hips, wide open eyes with an intense, concentrated look, expressive face, simple jewellery and decorative patterns all over the body, light garment, hair knotted at the back, a youthful boosom – indeed a noble figure in all her splendid simplicity. Her act of walking is not really a means to carry water and to reach a goal, but is a goal in itself.

One would assume that Meera's works in Germany have grown a life of their own under the loving care and gaze of their German custodians. And let this also be the moment, to say as an aside that with all the global intercourse and traffic of art between museums and galleries of the world, artworks seem to have, not unlike people and trees, their roots, their *Heimat* (home) in specific places. I am therefore happy to see Meera's *Ashoka*, *Buddha* and the *Earth Carriers* well embedded in the land of their creation where they probably belong forever.

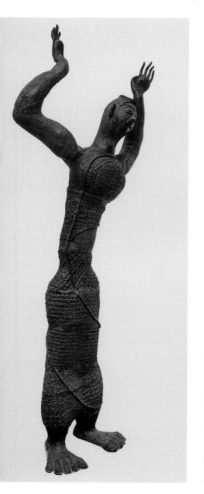

Meera Mukherjee by herself

In the presentation of human figures, sculptors naturally refer to basic positions like the seated, standing or lying figures, male or female. But let us take the example of the Munich Academy and Meera Mukherjee as an instance of a decisive difference. At the Academy, there was a traditional Western preference for the erotic female nude – Martin Mayer being one of its protagonists – while Hans Wimmer's horses still outnumber any other animals amongst the city's public monuments to this day. Meera, on the other hand, has only once cast a horse in bronze—significantly not in any heroic, but in a flying position— and never even once has she chosen a female nude for a model. Instead, the often 'immobile' bronze figures of the Munich Academy change for Meera into incarnations of the dancing Shiva, the *Fiery Nataraj* or the whirling and singing Baul dancers, or into musicians intently listening to their inner music or playing and tuning their instruments, as in *The Vina Player*, *Alaap* or *Dhrupad*, *Group Orchestration* or *Guru* and *Balmiki*, with perfect inner peace emanating from the very posture and from every single line of the body. Music and dance are popular and vital expressions in India, and therefore omnipresent in temples as stone and bronze sculptures. In the West, the Catholic Church had early on banned dance (equated with vitality and lust for life) from the cathedrals and only admitted Gregorian chant or religious music, and the representation of God and the many saints in art for centuries. Accordingly, sculpture had to serve sober and edifying religious ideals in the churches, and assume heroic postures in the worldly spheres. It was only in the Baroque Age that artistic

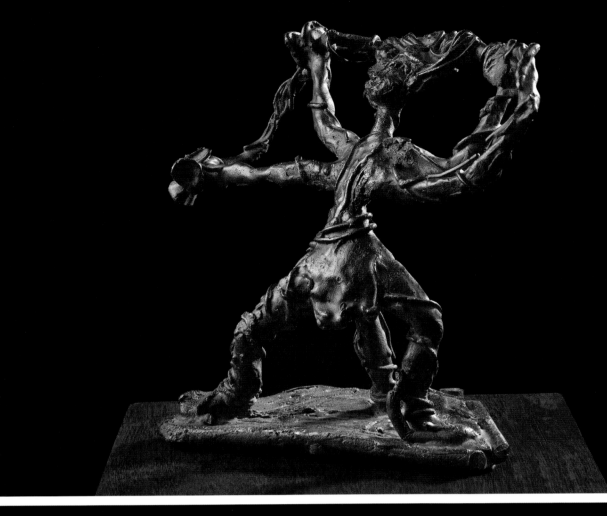

Fiery Nataraj
Bronze, 7 x 8.25 x 4.5 inches
Collection: Raja Pal

Flying Horse, bronze
Collection: The Savara Foundation
for the Arts, New Delhi

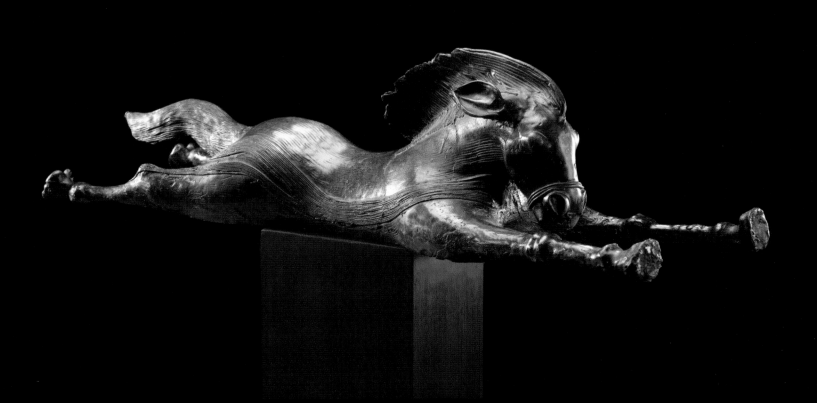

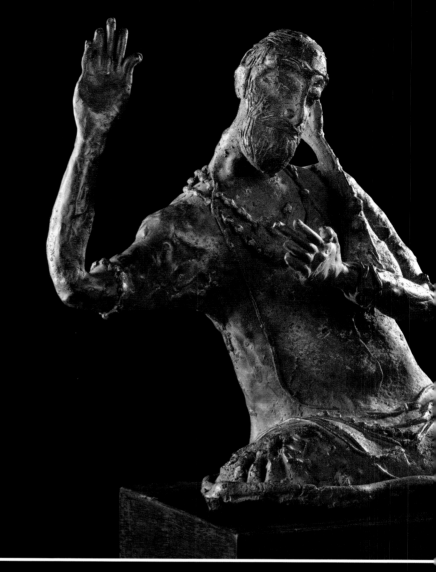

Singing Baul
Bronze, 11 x 9 x 6.5 inches
Collection: Kiran Nadar Museum
of Art, New Delhi

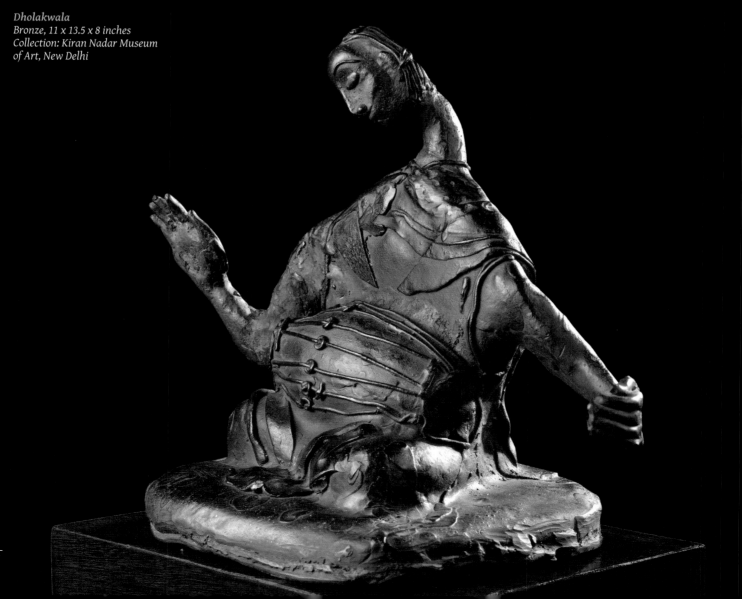

Dholakwala
Bronze, 11 x 13.5 x 8 inches
Collection: Kiran Nadar Museum
of Art, New Delhi

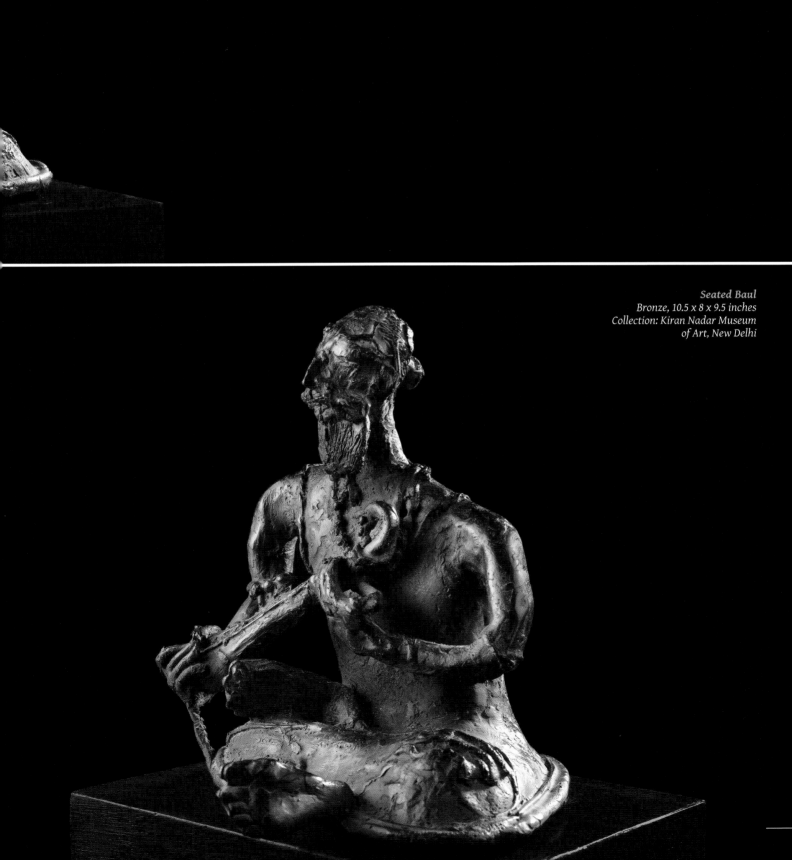

Seated Baul
Bronze, 10.5 x 8 x 9.5 inches
Collection: Kiran Nadar Museum
of Art, New Delhi

exuberance and splendor was allowed to move from the courts into the churches. Meera, in her healthy appetite for human emotions and feelings in their direct and pure state, not distanced by heroic and religious attitudes, very often chose to represent movement, joy, pain, suffering , compassion, and passion of everyday life rather than silence and withdrawal; conversation, laughter and tears rather than silent renouncement; the artisans' and workers' lives and public activities rather than private and idle pastimes; the conviviality of the group and the crowd; and the warmth of the fellow being rather than the remoteness of the hermit. With Meera you will find very few idealized Hindu deities and myths, no Radha and Krishna, Shiva Nataraj and Parvati, Vishnu or Brahma, no Kali, no Rama and Sita, no Hanuman, or Lakshmi, but the wild and throbbing Bauls, the endless patience of the woman waiting in the *Woman in the Balcony* and the *Lady in Sari*, the crowd closing in on one another

Village Panchayat
Bronze, 7.9 x 5.5 x 5.5 inches
Collection: Private

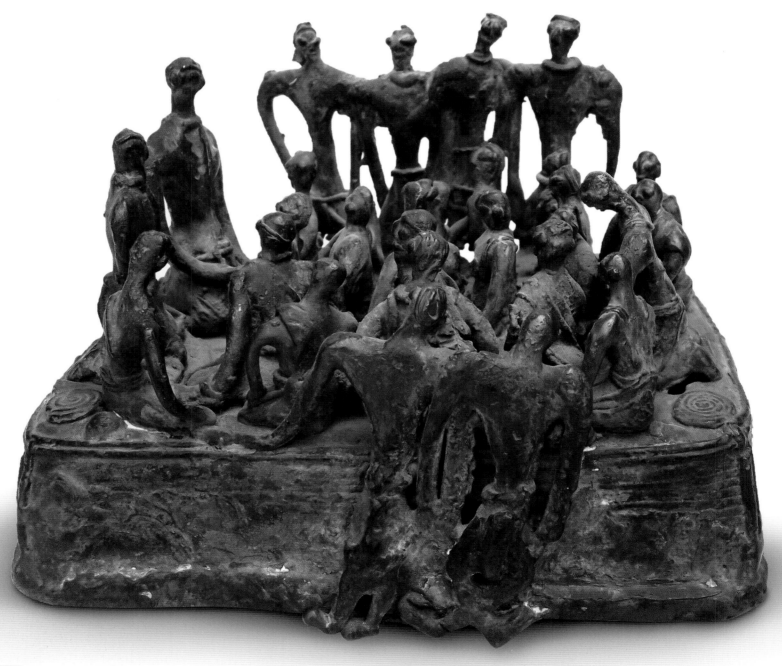

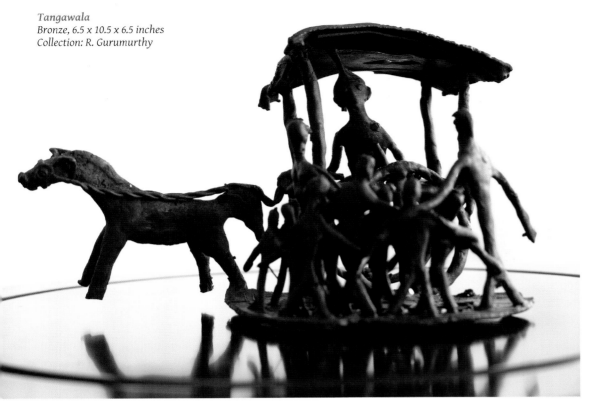

Tangawala
Bronze, 6.5 x 10.5 x 6.5 inches
Collection: R. Gurumurthy

in the cold and drizzling rain, women and children huddling together, women weaving and repairing the fishermen's nets, or the *Lily Gatherer*, the *Man and the Bicycle*, the *River*, the *Winnowing Girl*, the toil and labour of *Three Fishermen* and of *The Cablemen*, the compassion of the blind and the beggar's empty bowl, the quiet affection of a mother and child, the pride of the rower and fisherman, the devotion of the dancing pilgrims, the silent despair of the poor, the innocence of children, the dignity of the grand *Earth Carriers*. Everywhere in her work one finds the joys and sorrows of the common people, their sense of belonging together. Her themes are not to be found in the Vedas, but they are, as it were, around the corner, at the railway station and the ticket counter, they may concern daily activities like that of the toddy tapper, the bathing of the elephant, the rikshaw-wallah, a koolie, a workshop under a tree, a music lesson or a concert, flying kites, climbing, washing or repairing nets, stick players or the hammer-man: as many subjects, as many sculptures. And many of them are in the best tradition of German expressionism, full of empathy and soulful. But with all her appetite for everyday phenomena, her constant dialogue with her fellow beings, there also comes her clear choice against all fashionable trends that would not echo her innermost character: no easy installations or rational concepts; no mere playing with materials so typical of much in contemporary art; sketches and water colours taking a back seat by choice; bronze, brass, and terracotta being her enduring and lasting

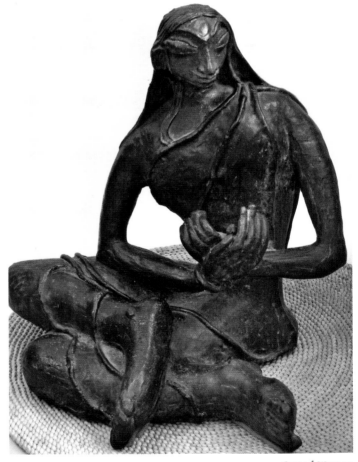

Seated Woman
Bronze, 23.62 x 21.65 x 15.74 inches
Collection: Helma Bels

Siddheswari Devi tuning a veena
Bronze, 24 x 16 x 12 inches
Collection: ICCR, New Delhi

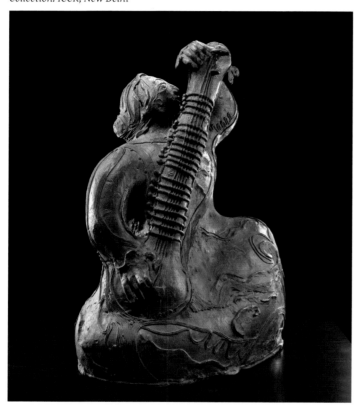

Meera Mukherjee between Asian and European Art and Beyond

material; human relations in all variations her noble and adequate subject, and sometimes even in a classical poise like in *Gargi*.

And then, amongst those hundreds of small and middle-sized bronze figures, Meera occasionally also wants to point to the extraordinary, even the grand and sublime in human existence and it is then that she brushes aside all considerations of time, energy, cost of material or size and reaches out into superhuman dimensions, becomes herself completely—a being out of the ordinary. Then she creates those deliberately monumental sculptures, her gigantic *Ashoka*—involving tonnes of molten bronze, months of casting in 27 different sections, her mysterious *The man who saw*, her moving *Earth Carriers* and the most impressive figures of the seated, standing or reclining Buddha. Then, I suggest, she becomes Meera Mukherjee by herself.

All existence is based on the tension between the uniqueness and singularity of every individual object and moment, and the inborn general law reflecting its essence. The one presupposes the other. No leaf ever resembles any other leaf and yet, without what we can call 'leaf-ness' there would be no leaves at all. For the last 500 years or so European art has chosen to give priority to the individuality of every phenomenon and to invest all its imagination in the detailed representation of what seemed unrepeatable and unique, whereas Asian art, and hence Indian art even today, still charges its vision with the general laws governing the world, with all its intuition and spiritual energy. The self portrait of Albrecht Dürer (1500) and the face of the enlightened Buddha are typical examples of the one and the other art form.

Michelangelo had stressed the importance of the anatomy of the human body for art and ever since Europe had focused on every muscle and fibre, as it were, every grass blade and every cloud – at the other end of this spectrum, for Asian and Indian art, bodies and landscapes continued to thrive on their spiritual energy centres. In other words: European art had over recent centuries seen its salvation in the phenomenal world (Hegel: *Rettung der Phänomene*), while Chinese, Indian or Japanese art had continued to endow human figures and landscapes with a spiritual and even deep cosmic structure. During this period, the West had not only colonized the rest of the world politically, but also set global cultural and artistic trends. In India, artists have not only upheld traditional forms and norms to this day, but also followed international trends and explored totally new areas of experimental art, including installations, land art, socially and politically committed art, adopting synthetic materials and

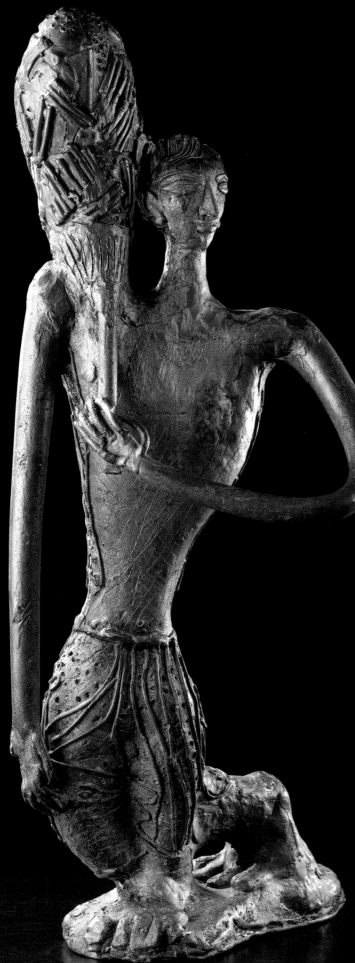

Boy with a bunch of flutes
Bronze, 25.6 x 11.8 x 9 inches
Collection: The Savara Foundation
for the Arts, New Delhi

visual expression. Meera Mukherjee would have been impressed and full of praise for this new generation of artists and the enduring legacy, their imagination, their hopes and despair, their humour and courage. She herself had forcefully reacted to natural catastrophes like floods, the political violence in West Bengal, the industrial exploitation of the workers in Bhopal through her sculptures. But her strong Gandhi-like character and will power would not have allowed her to swerve from her path, expressing her delight in the joys and sorrows of her fellowship with ordinary human beings and their daily lives in ever so many bronze sculptures, without losing sight of the spiritual energies ranging from religion to philosophy, and thereby a deep craving for incarnations like the Buddha. Of course in the end, both the aspects, the events of everyday life and the common people, and the grand aspirations of the great souls are but the two sides of the same coin. Meera's art seems to strike a perfect balance between the two. And here is what she said:

I served a period of apprenticeship under the Bastar artisans. Working with these superb craftsmen, I could not suppress a thrill, to feel that the great Tanjore Bronzes were made by fingers such as theirs, and I was in their company. As I saw their dedicated effort with which they built holy images which men will revere and worship, I asked myself, can we artists, modern artists, not approach the work that we do in the same spirit? What if we, building the figure, not of a god but of more earthly things, not feel in such creation a similar spiritual unfolding? [5]

When she died, the world was getting ready for a new millennium, for new dimensions in life as well as in art. What will be their potential for the future and beyond?

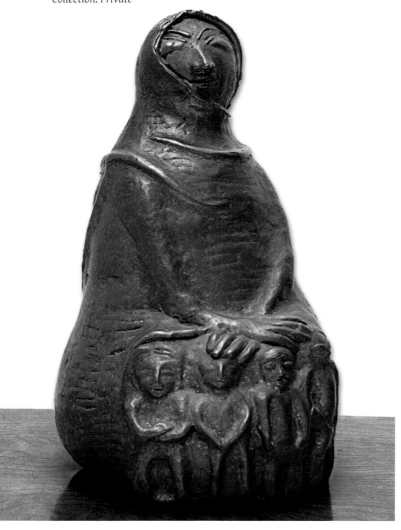

Untitled
bronze
Collection: Private

The German archaeologist Johann Joachim Winckelmann had coined a famous formula and characterized the depth and beauty of Greek classical art as being endowed with "edle Einfalt and stille Größe" (noble simplicity and quiet greatness). In Meera Mukherjee's homeland— India, this beautiful formula would have to be substituted by something like "vibrant with rhythm and charged with vital energy". In Indian art, over the many centuries, the throbbing vitality of the folk art had been allowed to continue and be transformed into the spiritual energy of the classical art forms in a gradual change-over and without ever really disrupting or breaking the chain of the creative process. Meera Mukherjee's best works are part and evidence of this phenomenon, reflecting both the vibrancy of everyday life and the sublime force of their soul, their spiritual energy. The surface

of her sculptures thus becomes pure rhythm whereas their bodily expression breathes their inner strength, often represented by unusual angles and curves or glowing and serene faces. Even in her rather rare representation of animals, like the flying horse and the sitting cat, this union between the individual and unique expression of the living animal and the essence of the 'horse-ness' and the 'cat-ness', the interdependence of the part and the whole, becomes a hallmark of her art. Meera's blending of folk art and classical art also finds a significant expression in the eyes of her figures – reflecting the special place that they occupy in Indian art and philosophy as in the third eye of Shiva. Whereas the eyes of the meditating Buddha in their classical representation remain closed in meditation, with Meera the eyes often remain open, full of expression, but emanating the same concentration from within, reminding of Stanley Kubrick's film *Eyes wide shut* and reducing the usual distinction between folk art and classical art to a mere academic exercise.

Since four decades now her bronze figure, *Seated Woman* (1970), has been my constant companion in changing homes and on different continents, and the throbbing rhythm of her dress and body lines contrasting beautifully with the peace and patience of her face and her posture is an inspiration enough for a lifetime. And then there will be forever her lasting homage to the dignity of untiring labour of the *Earth Carriers*, the overwhelming and monumental *Ashoka*, wherever it will stand on Indian soil, as a powerful symbol of both violence and non-violence within one and the same lifetime. Over the years, the image of the Buddha had turned out to be the noblest challenge for this sculptress. Meera died while working on her last large Buddha image, in search of her own redemption and enlightenment as an artist.

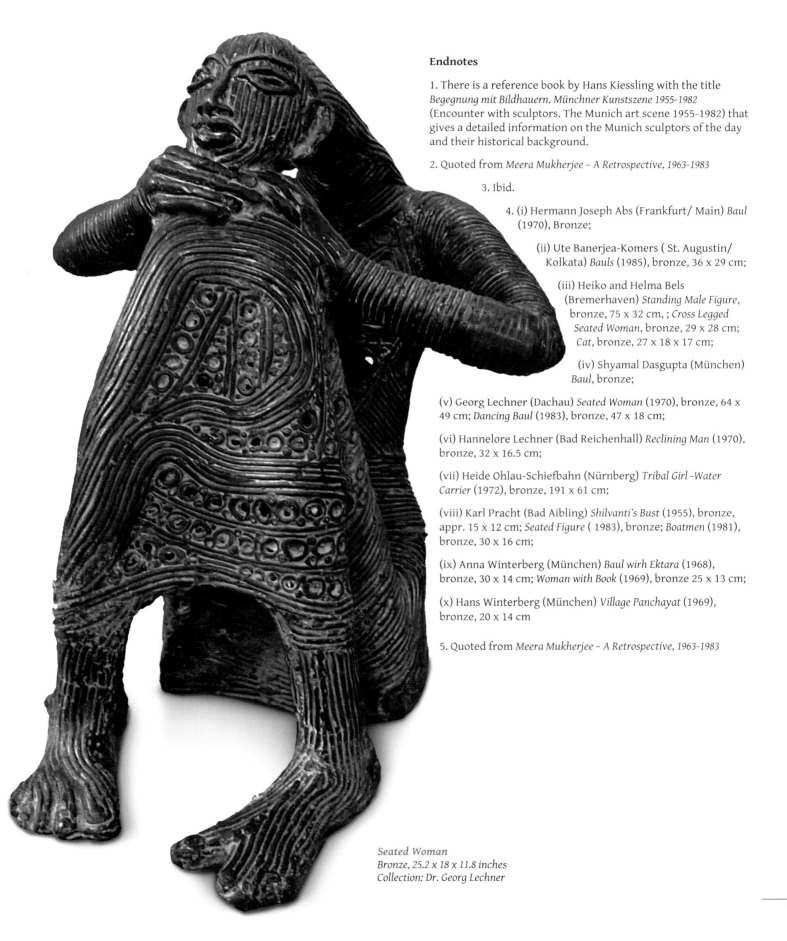

Endnotes

1. There is a reference book by Hans Kiessling with the title *Begegnung mit Bildhauern. Münchner Kunstszene 1955-1982* (Encounter with sculptors. The Munich art scene 1955-1982) that gives a detailed information on the Munich sculptors of the day and their historical background.

2. Quoted from *Meera Mukherjee – A Retrospective, 1963-1983*

3. Ibid.

4. (i) Hermann Joseph Abs (Frankfurt/ Main) *Baul* (1970), Bronze;

(ii) Ute Banerjea-Komers (St. Augustin/ Kolkata) *Bauls* (1985), bronze, 36 x 29 cm;

(iii) Heiko and Helma Bels (Bremerhaven) *Standing Male Figure*, bronze, 75 x 32 cm, ; *Cross Legged Seated Woman*, bronze, 29 x 28 cm; *Cat*, bronze, 27 x 18 x 17 cm;

(iv) Shyamal Dasgupta (München) *Baul*, bronze;

(v) Georg Lechner (Dachau) *Seated Woman* (1970), bronze, 64 x 49 cm; *Dancing Baul* (1983), bronze, 47 x 18 cm;

(vi) Hannelore Lechner (Bad Reichenhall) *Reclining Man* (1970), bronze, 32 x 16.5 cm;

(vii) Heide Ohlau-Schiefbahn (Nürnberg) *Tribal Girl -Water Carrier* (1972), bronze, 191 x 61 cm;

(viii) Karl Pracht (Bad Aibling) *Shilvanti's Bust* (1955), bronze, appr. 15 x 12 cm; *Seated Figure* (1983), bronze; *Boatmen* (1981), bronze, 30 x 16 cm;

(ix) Anna Winterberg (München) *Baul wirh Ektara* (1968), bronze, 30 x 14 cm; *Woman with Book* (1969), bronze 25 x 13 cm;

(x) Hans Winterberg (München) *Village Panchayat* (1969), bronze, 20 x 14 cm

5. Quoted from *Meera Mukherjee – A Retrospective, 1963-1983*

Seated Woman
Bronze, 25.2 x 18 x 11.8 inches
Collection: Dr. Georg Lechner

Maja von Rosenbladt

Art and Social Involvement

When I came to Kolkata for the first time, I had no real idea of what to expect. Meera had warned me, and explained that she lived under very modest conditions, and it was true. The quarter of Kolkata where she lived was by no means rich and elegant, but the lively, noisy Paddapukur Road. Small merchants and craftsmen ran their shops there and created a busy atmosphere. To give her a visit, from the road, one had to pass a dark gateway to reach a silent courtyard, behind which Meera lived in the first floor of a small apartment, comprising a narrow balcony, a kitchen and her studio.

In the balcony, Meera cooked, and did her wax-work. The kitchen, a small dark room where she cooked in the evening (and when it rained), was divided by a curtain, behind which her servant Nimai lived. He gave her a hand with daily chores and at all steps of her working process. In the studio, a well-lit room with a window that reached upto the floor, Meera lived surrounded by books, paintings, photographs and her sculptures. Here she worked, received guests, here she sang, read and slept. In these rooms, only a few square metres in dimension, her wonderful sculptures were created.

Meera Mukherjee's art has a universal appeal. But she was also a person whose generosity and readiness to help touched everybody who met her – but she could not draw from abundance, neither of time nor of money.

On the one hand, to Meera life meant work, creative and hard physical work, which demanded the

My Home
Terracotta, 6 x 6.5 x 2.5 inches
Collection: Neerja & Mukund Lath

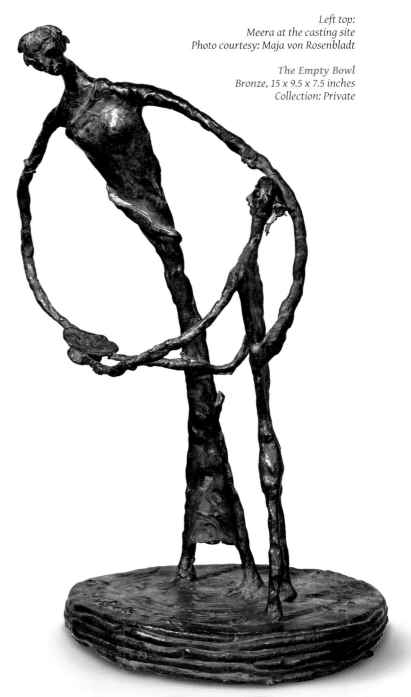

Left top:
Meera at the casting site
Photo courtesy: Maja von Rosenbladt

The Empty Bowl
Bronze, 15 x 9.5 x 7.5 inches
Collection: Private

highest concentration. She detested interruptions, above all during her work, as the process of burning and casting took place in the village of Elachi. The sculptor's work-out, beginning at two o'clock in the morning with the lighting of the furnace, sapped her energy, and when she returned to Kolkata she would be exhausted. But the process of creation was yet to be finished. The process of casting as well as welding together of the pieces for bigger figures demanded her complete physical and mental presence.

On the other hand, she was always struck by financial difficulties. Nirmal Sengupta has described her attitude towards money in these words: "She is interested mainly in the ideas to which she gives form, and only in the amount of money which let her go on doing her work."[1]

And very often, she did not have even that amount of money. In January 1987, almost serenely she wrote to me: "First half of the year I passed through intense economic trouble. When as a student I was studying in München I often called this time 'Geldtraurigkeitzeit' [Meera's creation of a funny, non-existing German word that may be translated as 'money-sadness time']".

Yet, although she was absorbed in her work and her financial means actually did not often allow it,

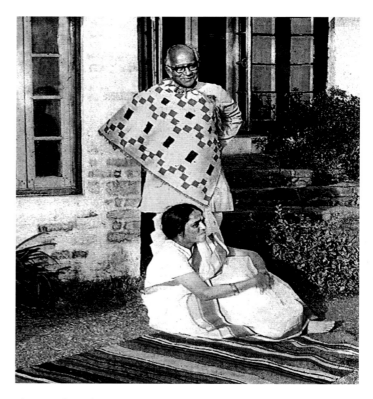

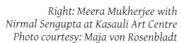

*Right: Meera Mukherjee with
Nirmal Sengupta at Kasauli Art Centre
Photo courtesy: Maja von Rosenbladt*

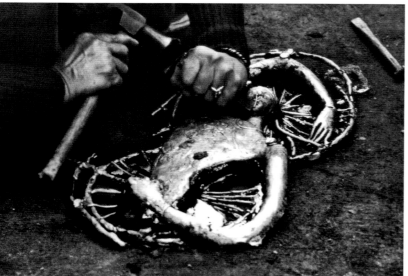

Photo courtesy: Maja von Rosenbladt

she took a deep interest in people around her and helped them whenever she could. For instance, she made it possible for some poor students to pay their school fees, she bought warm clothes for village children during a really freezing cold winter, she offered space in her room at the apartment to people who needed shelter, and she created a network of doctors and therapists who took care, at her request, of children and adults who needed help but could not afford medical treatment.

The frame of many of her activities was Dhanket Bidyalaya, a non-formal school-movement launched by Nirmal Sengupta in a couple of villages south of Calcutta, like Elachigram, Nalgorhat etc.

This grass-root project had begun with Nirmal Sengupta privately tutoring the village children. It developed into a broad literacy movement, involving a floating population of about 600 children. Dhanket Bidyalaya finally consisted of eight school centres, a crèche, a library and a health centre, facilities run by young people who had themselves learnt their alphabet earlier through the same movement.

Nirmal Sengupta's overriding aim was to generate enthusiasm among the children towards learning, and he succeeded. I realized this enthusiasm when I found the children streaming in from all sides to their school at six o'clock in the morning, sleepy, most of them wearing only thin clothes in spite of the cool morning temperature. Outside they sat

down on the concrete floor, full of expectations. They wanted to learn.

More than half of the children coming to Dhanket Bidyalaya were girls. Nirmal Sengupta explained: "This is not surprising. Girls in a backward village like ours have to suffer a dull, dreary and monotonous routine existence. The free atmosphere of Dhanket is like a breath of fresh air to them which they enjoy apart from what they learn there."[2]

Meera contributed an important part to this joy. For many years she went once a week to the village and devoted her attention to the children, all of them sitting on the floor, serene and busy.

One of Meera's projects was "Kantha". She assembled young girls and taught them the old quilt tradition of *Kantha* (hand stitched and embroidered quilt made out of old saris), turning it into a stitching technique to create pictures with an inexhaustible variety of themes and colours. Children from five to ten years drew the motifs, Meera arranged them on the cloth, and in the end grown-up girls stitched them up. She also cared for the carpet weavers whom Dhanket Bidyalaya had helped find jobs in the villages, and supplied with designs that she and the children had developed.

Meera with the students

Meera's sculpture *Mohan* shows her strong emotional involvement in Dhanket Bidyalaya. Mohan, a young man, had been the heart of the movement, helping, teaching, moving on his bicycle from one village to the other, working the whole day for Dhanket Bidyalaya. He was murdered in September 1978 by killers hired by a rich landlord

Left:
Dhanket Bidyalaya
Watercolour on paper, 29.75 x 22 inches
Collection: Piramal Art Foundation

Below:
Untitled
9.75 x 6.75 inches
Collection: Abrajit Mitra

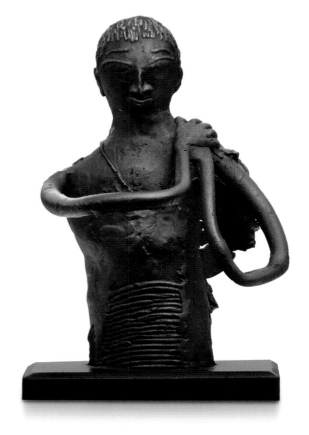

Right:
Bastawala
Bronze, 10 x 7 x 5.5 inches
Collection: Piramal Art Foundation

Below:
Lady with Pigeon
Bronze, 7.5 x 6 x 3.5 inches
Collection: Private

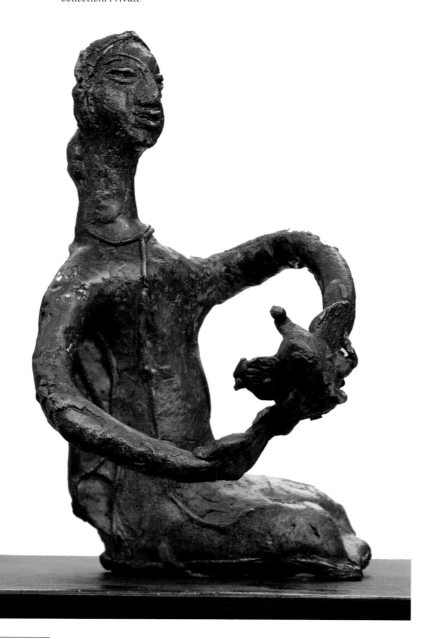

who opposed the literacy movement. With her sculpture showing Mohan and his bicycle, Meera created a moving piece of memory.

The essential effect of her devotion to Dhanket Bidyalaya was that she brought art to poor village children. She provided them with the impulse to draw, paint and do handicrafts. And the children too responded enthusiastically with great concentration and creativity. Art filled their day-to-day lives with colour and joy. Art was something they needed not merely for their physical survival, but for the survival of their souls.

Art as a remedy for the soul: Meera's own experience

If you know Meera only through her serene, positive-minded sculptures it would be difficult to imagine this artist as also often suffering mental distress. Anxieties and panic attacks haunted her time and again. But she was courageous and turned towards life. She lived to work – and worked to live. Through her work, which often was heavy physical labour, her soul found the strength she needed.

Meera's life and convictions, her strength and also her mental distress, were founded on her experience of how painful it could be for a divorced woman of her time and in her country to find her desired path. It had been an extremely difficult

path, and it was taken when Meera was still married.

Maitreyi Chatterjee, in her article "Sculpting for liberation", with a deep understanding of Meera's art and life pointed out that "As familiar tensions increased she [Meera Mukherjee] retreated more and more into her art as an outlet for the anguished, tormented and the scarcely-relieved darkness of her personal life."[3] She understood Meera's life as the consequence of "the trauma of a break-up that society extracts from a woman for deciding to live for art."[4]

Meera had herself explained her shift to sculpturing: "I knew I wanted to involve myself in creation involving hard physical labor. Sculpting was the most natural culmination of this urge".

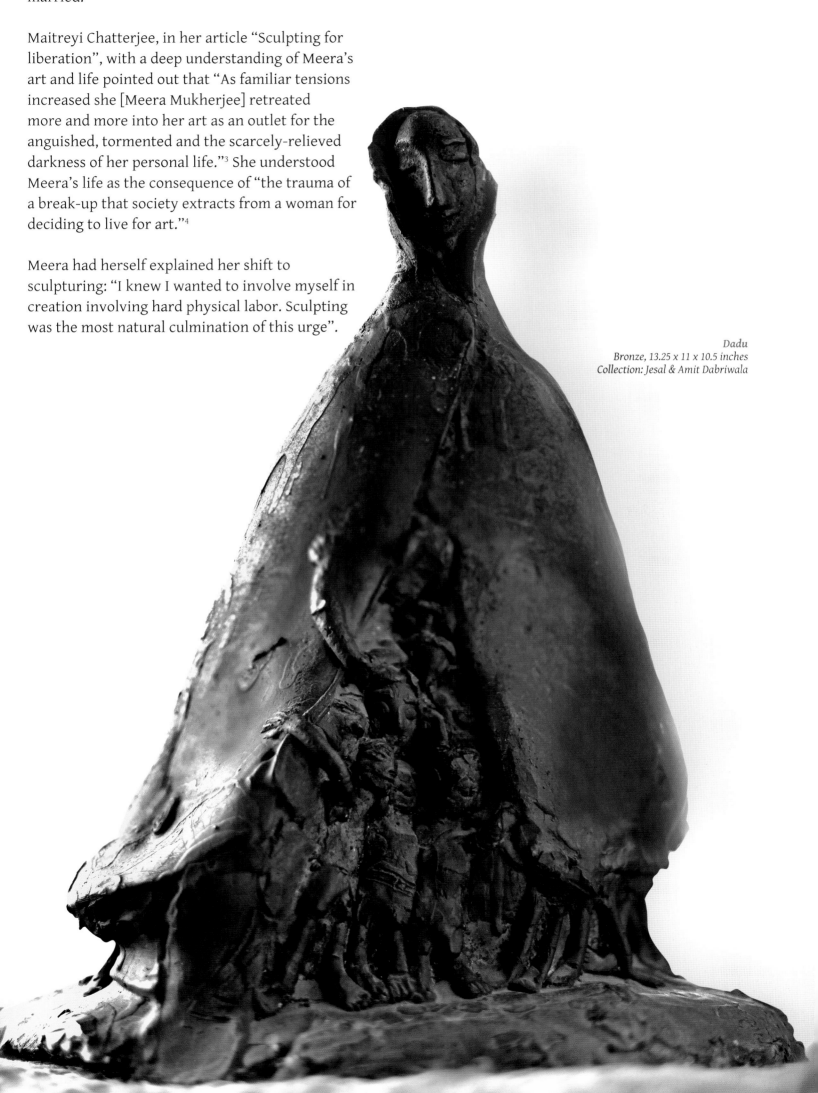

Dadu
Bronze, 13.25 x 11 x 10.5 inches
Collection: Jesal & Amit Dabriwala

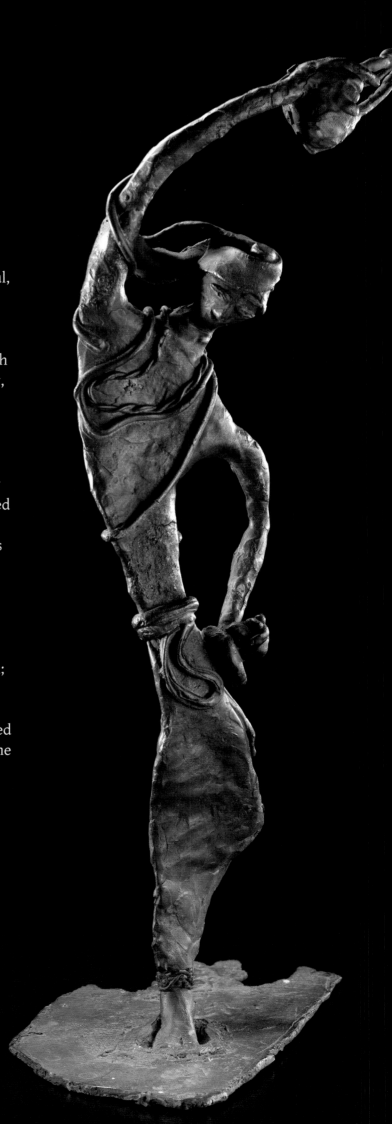

Poised Baul
Bronze, 21 x 8 x 5 inches
Collection: ICCR, New Delhi

Meera did not draw strength only from her work, but also from music. She sang. She had a wonderful, deep and warm voice; singing music unknown to me she bewitched me. The only interruption she allowed herself during the process of casting her sculptures in the village was the music lessons with her teacher and guru Bimal Prasad Chattopadhyay, in Calcutta. I had been fortunate to be present at these sessions, and I watched and listened fascinated with the garlands of tones she formed following the movements of her master's hand. Maitreyi Chatterjee observed: "The special affinity that she has for music is because she has discovered the essential rhythm and tune that lies behind creation. Music for her is not a pastime, rather it is grist to her creative mill."

For Meera the process of sculpting did not imply withdrawing into her inner self. Rather it meant working in cooperation with others. The entire process begun with wax work, supported by Nimai; followed by burning and casting in the village, a heavy work helped by several men and a huge group of children supplying cow-dung cakes needed for the furnace. The process ended with welding the bigger figures together, originally cast in separate pieces, with the cooperation of the metal-workers.

**Meera with the metal workers
in a welding process**

For these craftsmen – in fact for all craftsmen – Meera felt a deep respect. In a letter she wrote:

I am very busy, all the time. Three to four times a week I have to go far away, to a small factory where I work. There are many small and middle factories. Where I work there are fourteen workers. To work with them is something unforgettable for me.[5]

And one feels this respect from her sadness when one of the craftsmen died, made evident in the extract below:

Since last two years I am losing my dear and near ones... last month the master welder who worked with me to join up the pieces for the large sculptures, Kalpu. He died, after joining up all the pieces for the large work. This time nine months I have worked together with him.[6]

Meera herself preferred being regarded as a craftsman. When a group of rural viewers appreciated Meera's *Ashoka at Kalinga* by stroking the statue gently with admiration, pointing to the superb welding job, the woman in her mid fifties standing nearby, her face aglow with joy noted:

This is the most genuine critical acclaim I could ever have. The laboring class who admired the technicalities of my work know the sheer toughness of the job, the physical effort that has gone into erecting the sculpture piece by piece...It's an honor to be a craftsman, the bearer of a long tradition of a life devoted to creating and surviving on that.

Her sense of closeness to craftsmen and common people is reflected in many of her sculpted figures: they show people engaged in work and everyday activities. She had a deep understanding for others, independent of class, status or caste. Social position and hierarchy had no meaning for her.

During her research trips, Meera was able to approach people openly and eagerly for acquiring the knowledge she sought. As a Senior Fellow of the Anthropological Survey of India, she visited the *Dhokra* craftsmen of West Bengal, the untouchable Louhars of tribal Bihar and the Gharuas of Bastar, and this experience brought her close to humble village artisans for whom she had an abiding affection and respect.

Since she had herself struggled hard for self-determination, the rights of women were essential to her, and she fought against violations of these rights whenever possible. This explains the attention she gave to girls and women, be it at Dhanket Bidyalaya or elsewhere.

Several touching moments with Meera are alive in my memory. The strongest ones among these are the morning rituals. During my first visit, *Ashoka* — the huge statue of the ancient king, was still standing in her courtyard. Very early each morning, when I had just blinked with one eye into dawn, Meera would be standing in front of her window, silent, looking down at him. When I could finally open my eyes about one hour later, I would find her still standing by the window. After a while she would turn, smiling, prepared for the day.

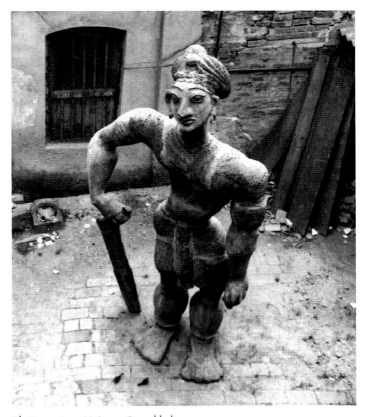

Photo courtesy: Maja von Rosenbladt

Endnotes

1. In a letter to the author, February 1980
2. In a letter to the author, November 1988
3. *The Saturday Statesman*, 9 February 1991
4. Ibid.
5. In a letter to the author, August 1979
6. In a letter to the author, March 1980

A World in Bronze

Bengal has, at least from the 18th century onwards, been engaged in an intense dialogue with the West. Kolkata's colonial architecture, the Tagore family, Keshub Chunder Sen and the Brahmo Samaj movement, Ramakrishna, Shri Aurobindo and Swami Vivekananda are early examples to their successors nearer to our times like Satyajit Ray, Ravi Shankar or Amartya Sen. Meera Mukherjee, with her strong Indian cultural background and her formative years as a student of sculpture at the Munich Academy of Arts, belongs to this intercultural tradition of Bengal. The answer to the main question as to the real character of this East-West encounter and interaction must, however, remain open and must be given individually, rather than generally assuming it. It is in this spirit, that the following article is written.

Meera Mukherjee and the German Art Scene in the 1950s

I would prefer to begin this essay from my experience of having been the Chief Curator at the Buccheim Museum, Munich, which hosted a Meera Mukherjee exhibition under the Fesitval of India in 2012. Lothar-Guenther Buchheim was a painter, artisan, publisher, and author of art books and fiction, as well as a collector with an intellectual openness and freedom that is unrivalled. Buchheim had travelled to India, but he did not touch West Bengal and the cultural capital Kolkata for a meeting to happen between him and Meera Mukherjee. However, if Meera and Buchheim could meet, which might actually have been possible in Munich where she studied under the sculptor Toni Stadler at the Munich Kunstakademie between 1953 and 1957, one might have discovered many common characteristics: for instance, the unreserved passion for art, the self-forgetful abandonment to artistic work, the special liking

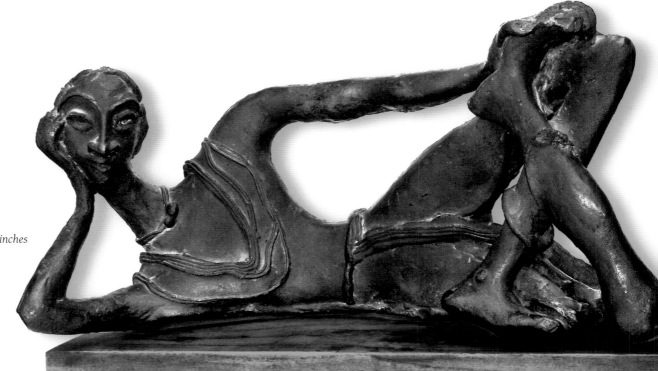

Reclining Man
Bronze, 12.6 x 6.5 x 5.1 inches
Collection: Private

for graphic and expressive tendencies, and the love of folk art, arts, and crafts. In fact, the African yellow-cast figures which he had purchased during postwar times and in the 1970s in Benin were made in a similar *cire perdue* procedure as was followed by Meera. Buchheim would also have shown interest in the development process of her bronze sculptures from wax model to casting.

Meera Mukherjee and Buchheim would have met as two strong and self-willed artists who both did not obey the mainstream, but listened to their intuition and inner voice, consequently and strictly followed their own artistic path. That she did not become a party to the defenders of abstraction, which was at that time en vogue in Europe and considered to be the 'global language', but learnt instead the solid craft of bronze casting from Toni Stadler, who worked figuratively, connects her also with Buchheim's attitude. After 1945, he too as a painter remained bound to the object, and in addition put together in the 1950s, his now world-famous collection of works by the artist community 'Brücke' (1905-1913) — Ernst Ludwig Kirchner, Erich Heckel, Karl Schmidt-Rottluff, Otto Mueller — whose works marked the beginning of the modern prevailing trends and Expressionism in Germany.

East meets West — Art across Borders

The specialty of Meera's expressive ability, her talent and the dialogue between her Indian way of looking at things and the European art of sculpture has had a productive effect on both. This becomes evident with the first sculpture she made during her studies in Munich. As the portrait head of her friend Shilvanti brings to mind, she used suggestions by Stadler who understood the sculpture as a movement, from inside-out driven

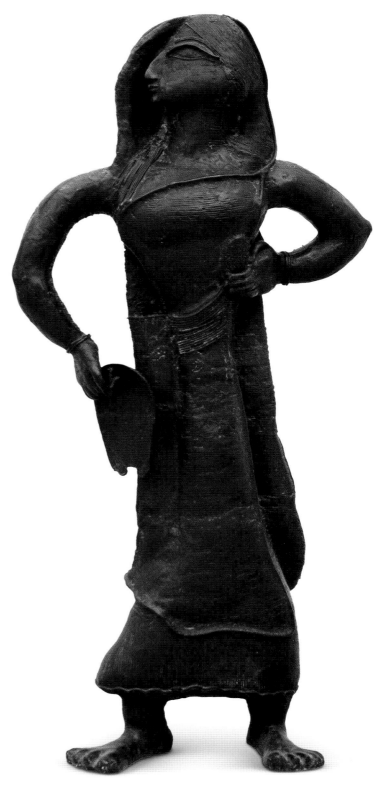

Spirit of Daily Work
Bronze, 68 x 33 x 12.5 inches
Collection: NGMA

mass, and as an open form and vessel. But whilst Stadler's heads with their elongated necks look statuesque and have an archaic effect due to their severe facial expressions and are clearly defined as ideal classical, and also early Greek and Etruscian art, Meera gives life to her bronze head with wavy, flowing lines which describe brows and mouth of the model, thereby filling the "vessel" in her way. Like this, on the one hand, Shilvanti's mind and individuality glow in the sculpture, and on the other, the knowing smile of the friend and her Buddha-like calmness point towards a higher spiritual dimension, animating the bronze and taking away the heaviness.

It is not easy to say which artistic inspiration Meera took back to Kolkata from her time in Munich and her stay in Paris before that. But her portrait head demonstrates that the 30-year old Meera, who had already intensively studied painting in Kolkata and New Delhi, came to Bavaria as a mature artist. Nevertheless, she sought in the West new challenges, and a dialogue with European art. However, she neither lost nor subordinated herself

Untitled
Brass, 14.5 x 14 x 6.6 inches
Collection: NGMA

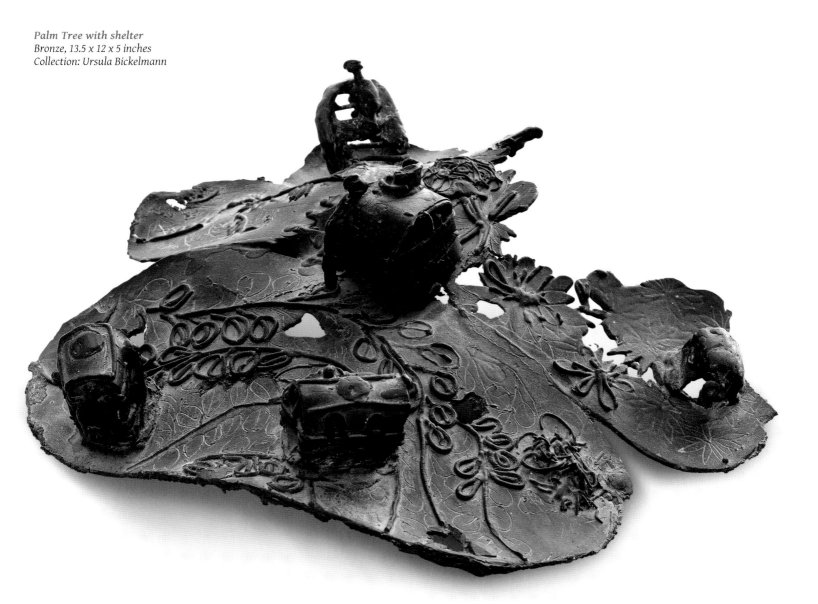

Palm Tree with shelter
Bronze, 13.5 x 12 x 5 inches
Collection: Ursula Bickelmann

to Western criteria; rather, she accepted from the varied stimulations, only the ones she could connect her own artistic ideas to. She did this all through her life as she was always open to new experiences and remained a seeker. Meera once made the following statement:

The realm of the art, however, is without tangible borders. Like an explorer he has to confront himself with new regions of experimentation which he has to mark off and conquer with his own untiring energy and ability. He cannot overcome the problems he encounters thereby with approved and known formulae and recipes. The solution for this has to be found through his own fight for new ideas, materials and tools. This means an endless and lifelong fight for the artist.

Paris and Munich confronted Meera with an abundance of new impressions. However, the stay abroad also strengthened the Indian in her, and being a stranger in another culture made her conscious of her own roots. Simultaneously, the multiplicity of positions and tendencies in art

that she encountered in exhibitions, books and discussions made her realize that the category of "style" which since the 19th century defined in rapid succession as Impressionism, Expressionism, Cubism, Surrealism etc. in the history of European art, is on its own not a lasting constancy but rather, a quality defined by the "inner necessity" (Wassily Kandinsky) with which artists express their own ideas, inner images and visions.

After her return to Calcutta, Meera during the course of decades created complex and manifold works born out of this realization. Although she developed an unmistakable style of her own, she continued with subordinating outer form to content and expressive intention. She never became victim to routine but applied herself to each individual work with great devotion and seriousness.

Sitar Player
Bronze, 10 x 10.5 x 5 inches
Collection: Amrita Jhaveri

The Sculptor's Expressiveness

In the sense of this endeavor for expression, one can assign Meera to those tendencies and forces that through millennia in all cultures positioned realization and manifestation of feelings, innermost emotions and impulses, also ideas, over objective "realistic" depiction of visible reality, and still do so. Out of this impetus, forms are simplified, deformed and stylized as indeed the Brücke painters and other expressionists did. The individuality of characters creates many possibilities of expressions. However, it is understood that German expressionistic contents and themes are different from Meera Mukherjee's as they grew out of a different historical context.

Meera developed her expressive intentions in various ways. The figure of the male *Sitar Player* for instance, who with his instrument merges into an arabesque clef-like ornament, is reduced by her to flat basic forms with long overdrawn arms and upper part of the body. The female *Veena Player* on the other hand is defined by round forms and a block-like grace. Though with works like *The Ecstatic Baul Dancers*, she moves towards abstraction, it is doubtful whether she actually visualized concrete figures by Lehmbruck, Barlach and other European sculptures whilst working. Most probably their works made her aware of creative possibilities which now flowed unconsciously, together with the suggestions she had received from her Munich professor, into the creation of her sculptures. Content and expression of Meera's works, however, are of an entirely different type. Her picture of humanity, for instance, does not correspond to the broken, desperate, lonely and isolated creatures German Expressionism has to show. She never accuses, her works are never defined by pathetic screams or strong protests, not even with her *Empty Bowl* sculpture which simply states the fact.

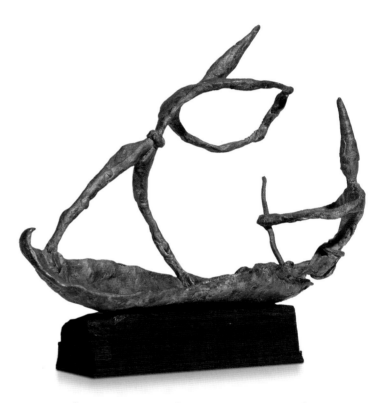

Untitled
Bronze, 8 x 9.5 x 3 inches
Photo courtesy: Sotheby's

Meera's figures are mostly in a swinging and dancing mood, pleasantly animated or entranced, but in any case fatalistic. This is also the case with depictions of people like fishermen or weavers in contrast to European Naturalism or Realism. She often transforms the figures into ornamental structures thus giving the impression, that the people are part of a greater whole and that their existence is defined by causality and higher order.

Meera Mukherjee's world in bronze is full of movement. The viewers' eyes do not only follow the flowing contours of the figures but also the patterns, lineatures and ornamentations animating the surfaces of her bronze sculptures. None of these figures is profane in the Western sense as all of them seem to be imbided with something of the divine, and pulsating with flowing forces

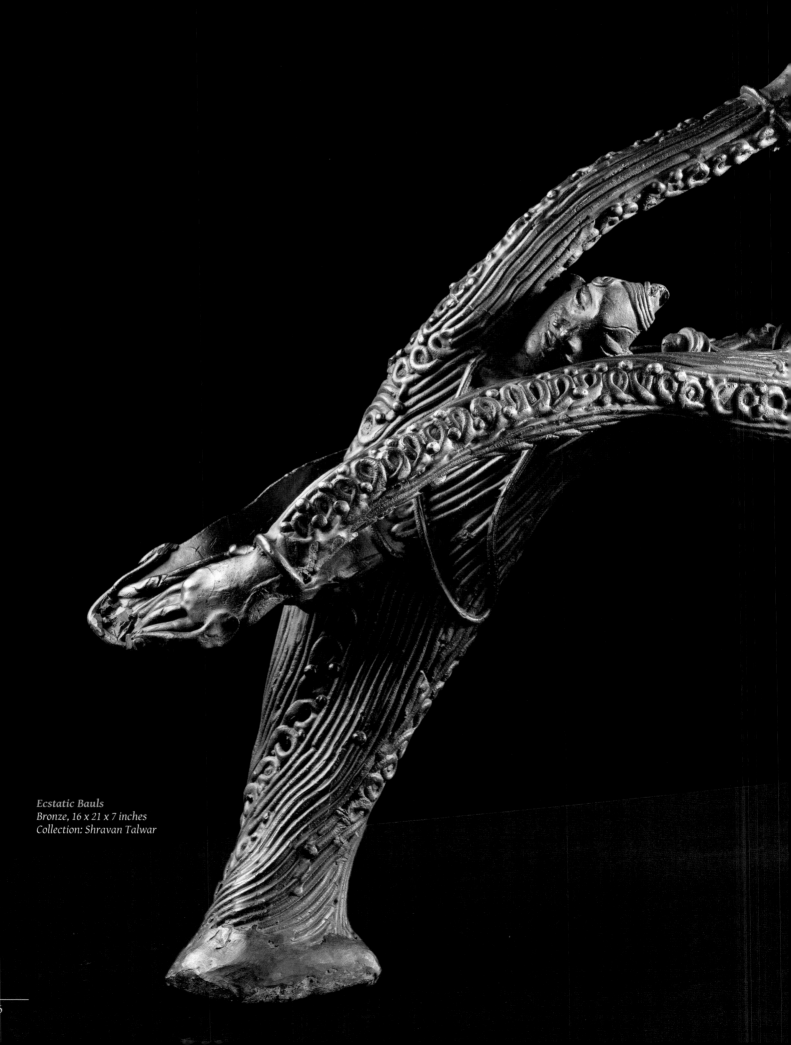

Ecstatic Bauls
Bronze, 16 x 21 x 7 inches
Collection: Shravan Talwar

and energies. They sing and dance, are overcome by self-forgetting ecstasy, and do all this with utmost devotion. Casting into form such volatile phenomenon such as music or spiritual energies, and yet rendering them tangible to give the impression of constant flow and transiency of each shape is one of Meera Mukherjee's great achievements.

That towards the end of her life she chose traditional Indian mythological figures, such as her depiction of *Shiva Nataraja*, the dancing god who reflects the never-ending dynamic process of creation and destruction, shows not only her deep roots in Indian culture but also her need to discover for herself anew their innermost meanings and interpret them in her own way. Like this, the monumental *Buddha of Badamtam* who resides on a hilltop in the mountains near a monastery can be seen both as a sign of faith as well as the sculptor's constant search for identity. She was and remained all through her life a person of two worlds, crossing borders between the cultures of the West and the East. Meera was a highly individualistic, emancipated, modern artist and woman whose roots were 'Indian' and defined by a strong need for spirituality. This longing is evident when she talks about the Gharua artisans from the Bastar region where she worked as an apprentice for some time:

> *I experienced their complete devotion whilst working on sacred pictures which would be venerated and worshipped and I asked myself, could we modern artists not develop the same spirit of devotion and apply to our work? Why cannot we experience the same spiritual devotion on creating a figure that is not any more a depiction of a deity but of other worldly matters?*

Pranabranjan Ray
The Gathering of Experience and the Choice of Tradition

Wave
Bronze, 13 x 8 x 9 inches
Collection: Dadiba Pundole

In the 1950s, when Meera Mukherjee was at the Delhi Polytechnic Fine Arts Department, and after that decade, when she was a student at Munich's Kunst Akademy, sculpture, both in India and abroad, remained strongly wedded to the concepts of modernism. Although at the beginning, at least in Europe, this outlook was born out of a rigorous questioning and understanding of life and art relationship in modern times, by the 1950s it had ossified into a kind of academicism and a set of institutionalised practice. Moreover in India, this strain of modernism had, from the start, been enmeshed in a derivative discourse under colonial hegemony. The worldview based on such a Modernism had, by the late fifties, become defunct in the field of the arts. Axiomatic to that Modern ideology was the belief: even if an individual artist's life experiences and interests influenced their particular way of thinking and training in art, these influences weren't to be very visible in works and hence, were not deemed worthy of consideration.

An artist's worldly experience and vision always should find lateral, not literal, reflection in its art. When these ideas and feelings, born of worldly experiences, find physical manifestation in the materials used to craft works, an object is born that becomes a form of unique artistic self-expression. This equivalence of the final form with the idea that motivated it helps us gain a further insight into the evolving self of the artist and echoes in the words of the philosopher, Wittgenstein, when he points out that a "family resemblance" is created at two levels: firstly between the physical object and the abstract vision which gave birth to it; and secondly between the viewer-customer's understanding and the maker's concept. Such a modernist belief proposes that the body of the artwork be self-dependent, self-complete and self-evident; hence not tied to any other force or factor. It does not

matter whether a work of sculpture is realistic or abstract or moulded according to traditional images and practice; it shall ultimately not be judged on the basis of its faithfulness to the object, reflection, concept or legacy from which it is derived. Instead its immediate physical character, its shape, proportion, height, weight and depth, its lines and balance, its frontal and hind constructions, the structuring of its body and the synergy generated within all these features, shall finally determine its beauty and value. This understanding of the physical form and material may or may not point to the artist's larger worldview and knowledge, but that in itself is not significant. What is more important is the extent to which the artist's own skills and sensory experience are echoed in the viewer's consciousness and approach to the work. It is this assumption that formed the presiding, foundational principle of Modernism in art.

In Germany, while receiving her training in sculpture, Meera was forced to confront the institutions of Modernist art practice and philosophy, but often found that they clashed with the self-understanding and learning she gained through her more personal and visceral visual experiences. In the museums of Europe, as she encountered the ancient sculptures and other arts of the Assyrians, Sumerians, Babylonians, Egyptians and Etruscans, she realised that, contrary to established Modernist beliefs, the ancients did have their own evolved sense of the material and display practices that were integral to the making of art. It is just that they never studied these in a conscious academic manner. The language and skills of art were viewed as a part of a naturally inherited legacy and culture; they were not matters of new discovery and innovations.

From what we know of Meera Mukherjee through her later interviews, through the two main books and several other smaller articles she wrote, and

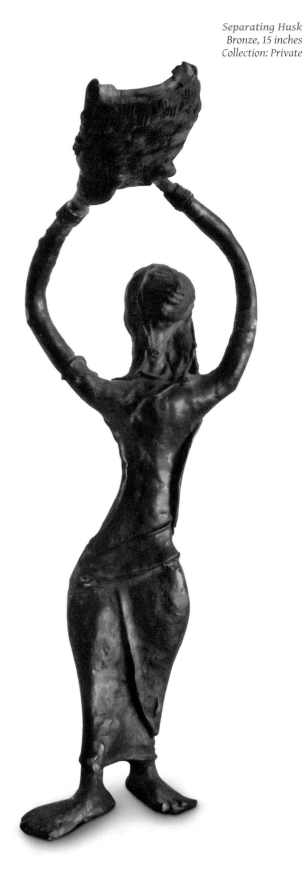

Separating Husk
Bronze, 15 inches
Collection: Private

most importantly through the ideas expressed in her sculptural works, it would not be unwise to make the following conclusions about Meera's own attitude and views regarding the particular subject of sculpture.

At different periods in the history of art, different communities have adopted their own distinct styles and vocabulary to depict worldly and other-worldly subjects. These languages have then formed the basis of new transformational art practices. The spread and consolidation of an artistic language, its absorption, rejection and collation of various sources and resources, and its growing definition and enhancement through certain norms and subjects, then finds reflection in the sculpture produced by that culture. With constant change and diversification of subject matters, there comes about a concomitant transformation in the evolving language of sculpture. At the same time, we must understand that these continuous inclinations towards change are often modified by the desire to have an art language that is commonly

Dharmapuja
Bronze, 12 x 12 x 11 inches
Collection: Reena & Abhijit Lath

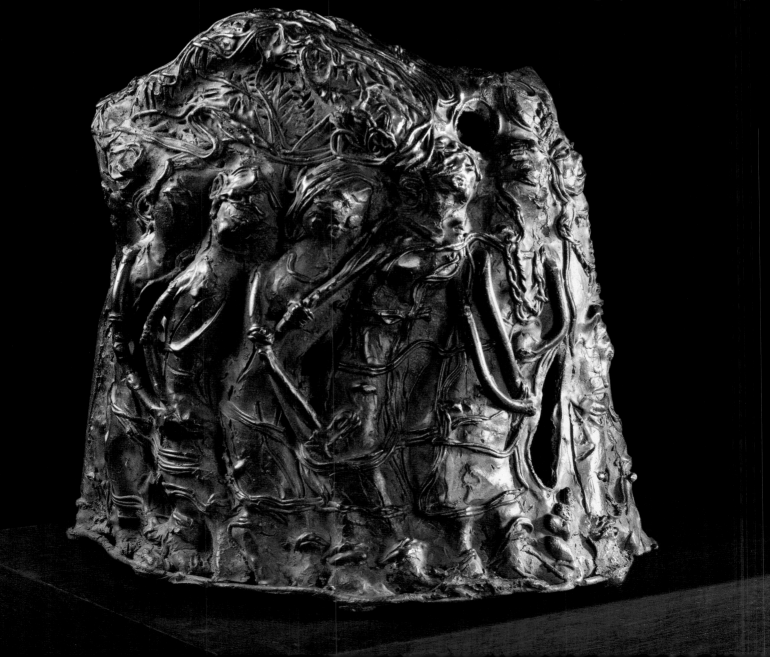

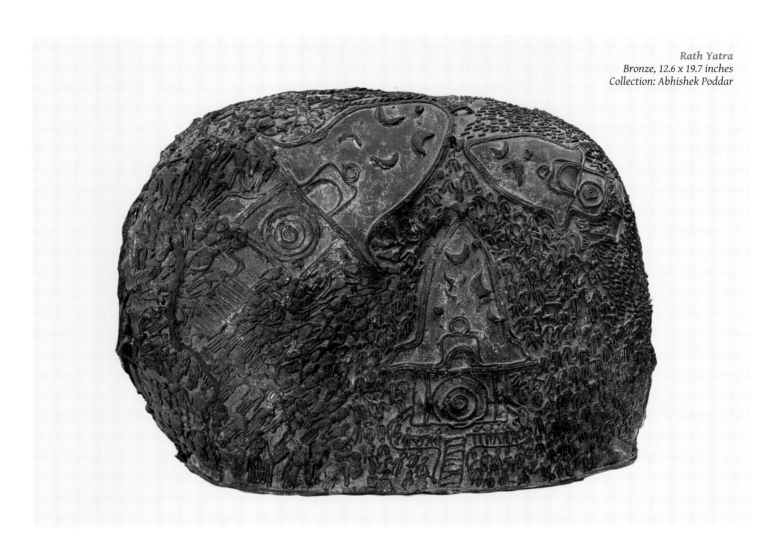

Rath Yatra
Bronze, 12.6 x 19.7 inches
Collection: Abhishek Poddar

acceptable for all within a community and that retains its ties with older, inherited customs. The modernists gave sole predominance to immediate sensory experience and powers in their ideas about sculptural tools, language and practice, but therein Meera discovered a shortcoming. She started recognizing the importance of viewing sculpture as part of greater culturally-determined communitarian practices which in turn significantly influenced the philosophy of art and sensory perception.

Around the same time, Meera also came to recognize the crucial role played by sculptural materials and methods in determining the artistic language of this particular field. The variations in the materials and production techniques resulted in space- or place-specific, time-specific and personality-driven strands of creative output, developing within any one artistic language.

Unlike any other western-educated Indian artist of her time, Meera did not take her western training to be her main guiding star and avoided style of sculpture, based purely on the prevalent European models of the period. Moreover, contrary to the common Indian sculptural practices of

the 1960s, she chose not to follow any tradition that was similar to the western academic school of Modernism, capable of accommodating improvizations which could carry so-called spiritual interpretation.

On returning to India, Meera Mukherjee did something which no other independent urban artist, coming out of an advanced industrial and capitalist democracy, would have dared or dreamt of doing. In the history of western art, we hardly find examples of personalities who consciously went beyond their chosen area of work and made special attempts to learn, support and represent the living arts of an indigenous folk community that had gathered all its sustaining skills from inherited knowledge and practice. From the beginning, Meera felt the need to root her own art practice within a larger tradition and identity. However, she also understood that artistic talent could not be generated solely by inherited values and ideas, and that modern education, instead of hampering, helped to hone and expand creative skills. Furthermore, she realized that tradition often stagnated to become a meaningless burden, at which point it became important to behave selectively in one's dealings and acquisitions from

Right: *Kashiram Das reciting Mahabharata*
(a 16th century Bengali Poet and translator of Mahabharata)
bronze, 10 x 5 x 3 inches
Collection: Nagesh G. Alai

Below: *Kashiram Das reciting Mahabharata*
Bronze, 9.84 x 5.1 x 3.15 inches
Collection: Private

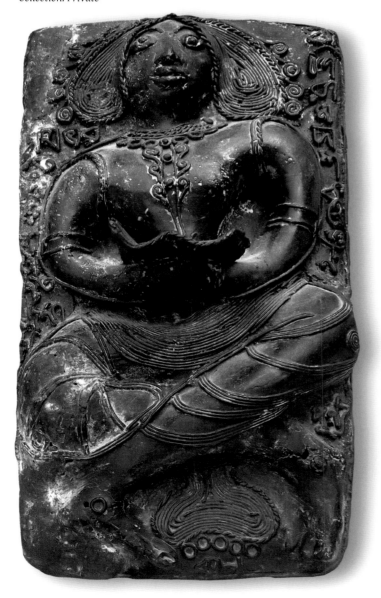

this inheritance. Ultimately a legacy did not stem from inheritance alone. It required that when the need arose, one could ably sift through an older heritage and extract that which was most supportive of valuable, creative restructuring. After coming back home, Meera set forth to discover and create a new identity for the legacy from which she drew inspiration.

Her interest turned towards regional folk art and sculptural forms that had come down the ages. She began to focus on the particular art of creating metal cast sculptures. Her fascination for this possibly stemmed from the fact that this art, in particular, gave priority to material-based techniques sourced from inherited knowledge. Encouraged by the cultural anthropologist, Nirmal Kumar Bose (1901–1972), and with financial assistance from the Anthropological Survey of India, Meera started travelling across the country to research and gather information on the lives and practices of artisan communities devoted to

working with mixed copper metal cast sculptures. Her main research interest lay in the way natural forest ingredients like bees wax, colour pigments and resin could be used to create future forms which would then be given a mud-coating, after which melted bronze could be poured in, and the figure mould extracted following the dissolving of the surrounding wax coating. The bronze, once it took the place of the wax layer, would cool down to replicate the wax outline. For several decades, craftsmen in India had used this wax-drainage process to mould bronze cast sculptures. This practice was better known in English as the 'Lost Wax Process', in French, as '*Cire Perdue*' , and in Bengal, as '*Dhokra*' (since it was mainly *Dhokra*-craftsmen who followed this method). From the craftsmen of the Baghel community in Madhya Pradesh and Chattisgarh, and the Moraal community (known usually as *dhokra* artisans) of the Rarh regions of West Bengal, Meera learnt this art technique and used it for her own needs. From the early 60s, she devoted herself to making sculptures in this lost-wax process. But it would take her another seven or eight years to completely master it and generate her own unique artistic creations through it. Before going into that story, it would be worthwhile to consider the way in which Meera created her own school of thought and legacy for this new style of work.

A number of different kinds of materials and methods are used in the art of sculpture, most of which Meera had already learnt at the academies. Why then did she abandon these familiar practices and get drawn towards the art of the *Dhokra* craftsmen? One reason could be that she found in it a living, vibrant, folk custom which, at the same time, did not necessarily employ resources and techniques that were already steeped in the practices of a particular community. As a result, she could include or reject various elements according to her desires and create out of its resources, an aesthetic that was self-expressive. Moreover, unlike many other folk art forms, closely linked to rigid cultural and ritual beliefs, the school of lost-wax sculpture came devoid of such associations. One-third of the works happened to be divine figurines, based on human, animal, bird and reptile forms. Another one-third consisted of objects related to religious customs and worship. And yet, the community of artisans who created them had no such immediate use for these. Rather

Bou
Bronze, 12 x 6.5 x 5.5 inches
Collection: Private

Lord Ganesha
Bronze, 4 x 2.25 x 1.5 inches
Collection of Reena & Abhijit Lath

they would make them to fulfil the demands of people of other communities who lacked figures to worship for their religious functions. It is this freeing of the sculpted figures from their strict ritual functions that gave Meera her own freedom to experiment with *Dhokra* materials. Furthermore, in opting for the lost-wax method of sculpture, Meera deliberately chose a craft-process that had otherwise no direct or indirect ties with her immediate linguistic, religious, and ethnic community, or with her institutional training. Thereby she could create a new legacy, translating elements from previous traditions into her own, and creating a craft that avoided the trap of trying to emulate other topical and aesthetic lineages. She could finally carve out an identity, subject and art for herself.

She started out with the main intention of generating a new kind of sculpting idiom from this lost wax process of metal-casting, and through this process of innovating, she became involved in an entire folk way of life. She closely acquainted herself with, not just the professions and techniques of these sons and daughters of Vishwakarma, but also with the rhythm of their daily lives and culture and those of the greater village community who lovingly embraced their works. She learnt the secret of how and why they were willing to protect and preserve the works of other communities of artisans outside their own. She also understood the importance of viewing the public acceptance of an art tradition as an integral aspect of creativity.

Left top: Untitled, bronze
Collection: Abrajit Mitra

Man with a Bowl, bronze
Collection: G.B.Singh

But most significantly of all, she discovered that the struggles and celebrations of daily life—its poverty, pain, sadness, and joys—were not just individual experiences for these village folk. Rather these were always collectively experienced by the community as a whole and shared with family, blood relatives, neighbours, co-workers, and the larger village brotherhood. Even in rivalry and enmity, an individual's clan identity mattered more than his personal role. In trying to understand the craft of these folk artists, Meera became deeply involved in their lives and this understanding of their communitarian spirit of harmony and creativity became the main source of inspiration for her work. All their emotions and experiences became hers. Thus, in keeping with the essence of ancient Indian aesthetics, Meera was able to create a kind of art that beautifully interwove itself into the lives of its subjects to achieve a fuller beauty and value.

In trying to underline the main characteristics of western Modern art, theorist Wilhelm Worringer, in 1908, claimed that abstraction (free of worldly associations) was one of the main signifiers of Modernism. However, in a pre-industrial, pre-urban, pre-modern Indian setting, the story of this city-bred, progressive, academically trained woman artist (someone who had willingly left her familial space to search for a new kind of art) could not translate itself into the western Modernist tale of the melancholic artist-traveller: one suffering from a deep sense of urban alienation and seeking to transcend immediate surroundings to pursue art on a global scale. At most, a comparison could be drawn with Paul Gauguin who left his familiar urban

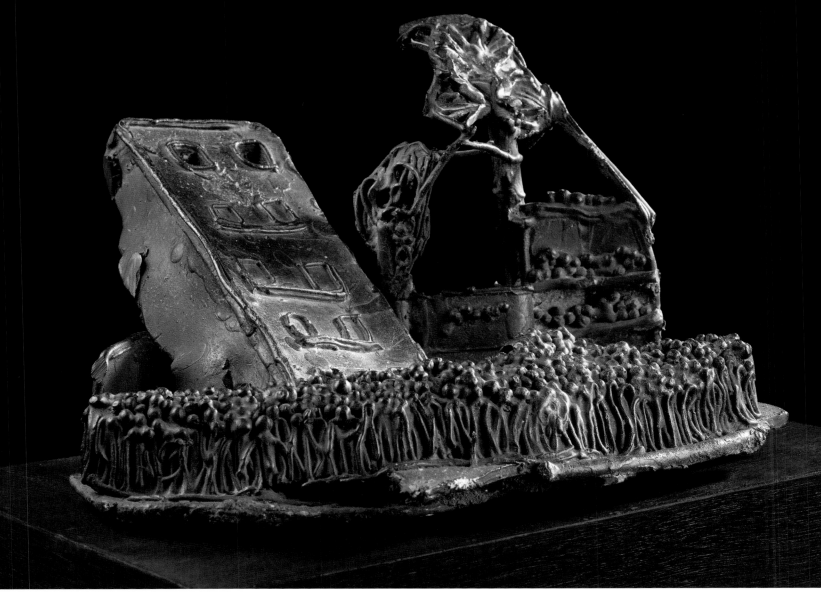

Urban Disaster
Bronze, 12 x 7 x 10.6 inches
Collection: Goodricke group Ltd.

space to seek shelter in a more pristine paradise. But hailing from a country like India, where untouched rural pockets existed side by side with fast developing cities, Meera never had to travel too far to find the paradise she had been looking for. A few steps away from her urban home, she found a new home in the rural heartland of Bengal. Despite their poverty stricken circumstances, these village homes offered her the pure, carefree pleasures of peasant life. The small and simple labours, joys and sorrows of these earthen folk found resonance in her sculptures with their women and children becoming the main protagonists of her works.

To bestow her subjects with a visual flavour, Meera used a descriptive storytelling pattern, picturising intimate scenes and events. These scenes were not purely imaginary but rather born from her close observations of the everyday life of these rural folk. Through this pictorial tableaux Meera wanted to create a new way of looking at this way of life in a style that avoided exaggeration

or over-simplification. In her loving depictions, she captured the dignity of human labour and the happiness, energy, self-respect and optimism that these simple folk continued to derive from their daily lives and struggles. At the same time, the poverty and physical hardships of their sad lives moved the artist, and these struggles found equal reflection in the roughly hewn figures she created. While these differing emotive approaches ultimately did come together to create a synergetic visual vocabulary of rural life, her viewers' ultimate interaction with these figures seemed to go beyond the basic emotions of joy and grief to suggest a deeper, inner feeling of compassion that governed the artist 's work.

The linguist Noam Chomsky refers to the notion of "deep structure" as a force that allows our innermost consciousness to influence the language we speak in. In Meera's case, this sense of empathy proved to be one such force, a fact evident through the other kinds of sculpture she dabbled in. The works from her mid-career i.e. *Ashoka at Kalinga*, *The*

Meditative Buddha and portraits of her music guru, were all infused with this feeling of compassion. Of course, this sense of deep empathy may also be traced to the Buddhist inspired practices in the history of ancient Indian art that placed a great emphasis on giving visual form to non-physical emotions or ideas.

None of the different folk sculptural practices that use the lost-wax process employed their figures to construct a descriptive pictorial method of event-based storytelling. It is not that such a tradition did not exist at all. In Madhya Pradesh and Chattisgarh village homemakers would often create toys that were descriptive of bigger scenes. Some of these examples have been preserved at the Bharat Bhavan in Bhopal and in the Ranjan Ray collection in Bombay. But it was largely left to Meera to create such a descriptive pictorial language for herself. This marked her first step towards moving beyond received folk knowledge and generating a style of her own. Moreover, most folk art sculptures tended to be frontal-facing divine figurines, cast in the

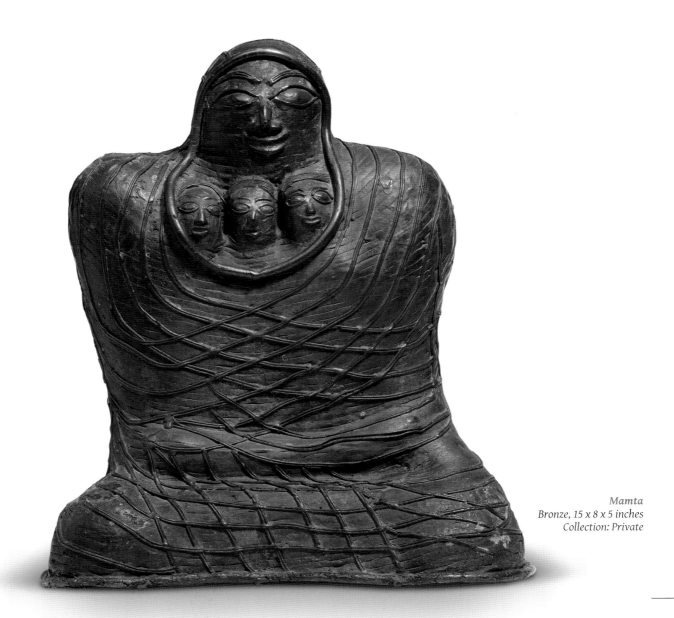

Mamta
Bronze, 15 x 8 x 5 inches
Collection: Private

shape of human beings. The second step of building a self-defined style involved doing away with these limiting characteristics and this involved quite a lot of effort. Even in the early 60s, when she held her first solo exhibition at Kolkata's Chemould Gallery, most of her human figures had still not lost their frontal-facing features. In the third step of departure, Meera worked on enlarging the shape and size of these sculptures. In folk traditions, the figurines were never too big. They had to be of a size, capable of being held in two hands and viewed at the same height as ordinary human vision. By incorporating the method of welding into the lost-wax process, Meera was able to create sculptures of bigger shapes and sizes. Most importantly, folk traditions, even if they made use of conjoined figures, had no custom of using multiple separate figures to create larger sculpted pieces. For the purpose of pictorial storytelling, Meera introduced this usage of multiple figures. Besides this, she did away with the excessive ornamentation typically associated with the folk practices of sculpting bodies. Most traditional folk arts adopted a method whereby wax threads or strips were wound around the basic body framework to sculpt a form that was heavily ornamented. To make her works more attuned to realistic subjects, Meera felt the need to get rid of such ornamentation. Instead of wounding around wax threads and strips, she increased the use of uniform wax layers. Following the melting away of the wax, a richer layer of metal alloys would emerge.

In order to allow her own unique style to keep growing, Meera had to adopt these changes. From her own experiences with the community and culture that had given birth to these art practices, Meera had arrived at certain ideas and beliefs that would never blindly fit the medium's rigid, inherited knowledge structures and techniques.

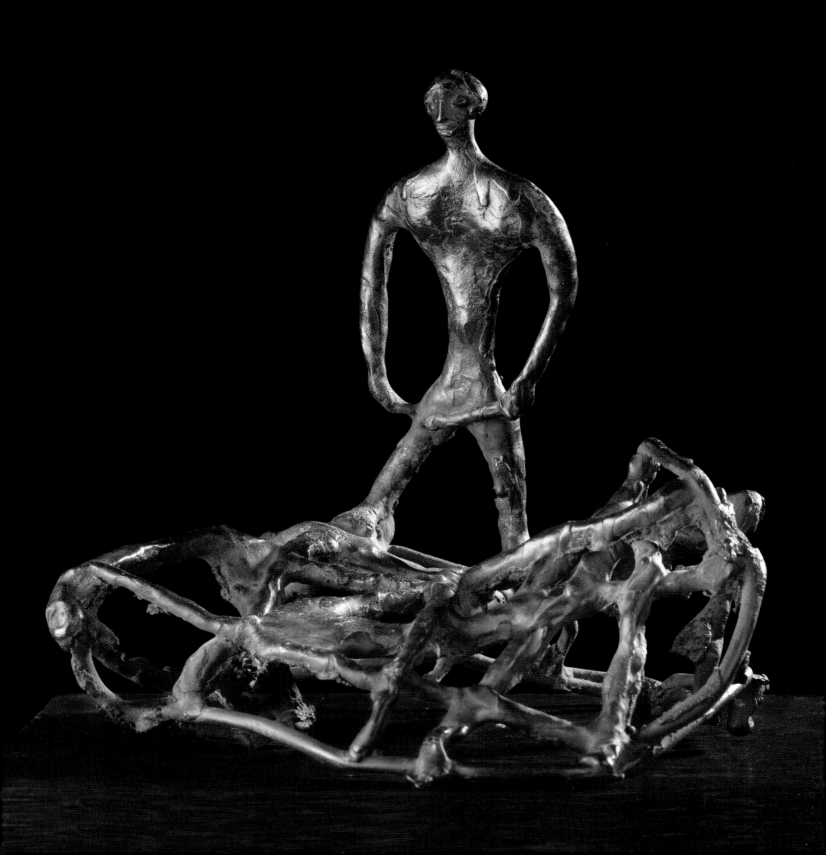

Ashoka at Kalinga
Bronze, 12 x 8 x 8 inches
Collection: Neerja & Mukund Lath

She was, after all, an urban, well-educated Bengali woman who had, at her aid, a stellar academic training, at home and abroad, in her chosen field of sculpture and had gained the courage to question the basic foundational assumptions of these received philosophies.

We have already observed how Meera had set herself the aesthetic task of evoking the myriad emotions of folk voices through her own sympathetic depictions of them in intricately crafted sculptural stories and scenes from village life. We have also seen how she went about trying

Patralekha
Bronze, 4 x 6 x 3.5 inches
Collection: C. Sen

Crossing the River
Bronze, 3.75 x 11.8 x 9.5 inches
Collection: NGMA

to successfully achieve this goal. At this point, it is necessary to mention another contextual detail. Unable to find a suitable pictorial storytelling language in the pre-existing lost-wax folk art traditions of middle and eastern India, Meera had to turn to other sources for inspiration. Here, she sought help in the detailed patterns of woven '*Nakshi Kanthas*'. She discovered a similarity between the signs and line forms created by *Kantha* threads and those of wax threads and was able to translate the storytelling customs of the *Kantha* artisans into a sculptural language for the art of the lost-wax method of metal casting. Thereby, she successfully employed a simple folk method to visually evoke the simple narratives of these common people. This in turn gave birth to a more pictorially evocative form of sculpture.

As a sculptor, Meera Mukherjee will be best remembered for a different group of works. These sculptures—well-defined and elaborately contoured human figures—are often narrative forms in themselves, but at the same time are not purely dependent on these story-telling functions. Most of these works are fairly large in size. Before Meera, nobody had ever experimented with large sculptural forms created through the lost-wax process. Moreover, nobody had tried creating such tall figures by welding different parts together. In these single-figure sculptures, one senses the grand values and depth of the artists' own ideas, experiences and perceptions. The first of her big sculptures was probably that of *Ashoka after the Kalinga War* (this can be viewed at the open lawns in front of the Maurya Hotel, Delhi). Standing on broken knees with his injured elbow placed on a broken sword, this eagerly observant, broad shouldered figure is anything but a victorious emperor. Yet he is also not a dejected, defeated character, since his face remains calm and

composed. Through this pose, the artist sought to bring together several different feelings and forces, such that no one overriding emotion could be segregated and differentiated from other co-existing, greater or smaller sensations. But after repeatedly seeing it from its multiple different angles, the overall impression that the viewer conjures is not one of grief, pain, triumphant joy or regret. Rather it is one of deep compassion and sacrifice. Meera's last great creation, an incomplete work which she finished with the help of two talented young sculptors (Anitya Roy and Adip Dutta), a Buddha statue, three times the average body size (located in Goodricke's Badamtam Tea Estate in Darjeeling), stands as another symbol of peace and compassion. It is easy to see that compassion is the chief driving inspiration behind both these works. But, even in other instances, where this understanding is not so evident, the artist's inner ideas find a unique reflection in the sculptural body that was inspired by them. A good example of this is the standing figure of the farmer's wife. At first glance, it would appear that the sculpture has been imbued with a self-assured strength, determination and resilience. And yet the clothes that cover her are soft and sinuous; the delicate cloth folds and texture transform her into a figure suffused with compassion, and it is this

Platform
Bronze, 13.8 x 14.6
inches
Collection: Abhishek Poddar

very emotion that has hardened her over time and lent her a toughness that goes against her innate nature. These various manifestations of empathy and sympathy typically lend an unusual significance to most of Meera's work, distinguishing her from other artists and sculptors of the time.

A philosophy of art, born from close observations and interactions with her worldly surroundings—a new style created by borrowing elements from tradition and marking them with her own unusual touches—these features gave Meera her own unique identity. Making her distinct from her other contemporary sculptors, this identity placed her in the same league with fellow artists like Kalpati Ganapati Subramanyan and Somnath Hore. In the 1940s and 1950s, Ramkinkar Baij had singlehandedly established a genre of sculpture based on human and worldly subjects. From that period onwards however, artists chose to focus on a more pure form of sculpture that gave predominance to methods and material over subject matter. Working around the same time, K.G. Subramanyan, Meera Mukherjee and Somnath Hore helped bring back the importance of the human being in sculpture. The legacy of describing visual stories through sculptures, which had so far remained largely disregarded, was once again made popular by them. A new attention to subject matter and human content transformed the trends of Modernist sculpture in India. The artists of the 1980s—Krishna Kumar, Rimzon, Soman, Pushpamala, Alex Matthews, Ravinder Reddy, Pritpal Singh Ladi—and those of the '90s—Anitya Roy and Adip Dutta—could not have evolved if the stalwart trio of Subramanyan-Mukherjee-Hore had

not taken inspiration from Ramkinkar Baij and paved the way for them.

However, once in a while, there is a question that arises. Given the kind of importance she is given within the history and study of modern Indian sculpture, was Meera Mukherjee truly that accomplished a sculptor?

In trying to give priority to a description narration-based form of sculpture, Meera sought the help of devices employed by *kantha* artisans and, to a certain extent, those of the Bengali *patua*s. The common characteristic of both these folk art traditions is their two-dimensional line drawing and figure formation. In order to transform this into the three-dimensional language of sculpture, a significant leap had to be taken. The problem was that, on many occasions, Meera tried to make this transformation without adequate finesse, resulting in two-dimensional figure contours that would be sloppily mixed with heavier three-dimensional body structures. The various gaps and discrepancies become evident in such cases.

The adoption of this style of visual storytelling was problematic in other ways as well. In sculpture, the figure requires a definite ground to sleep, sit or stand on. In the case of the two-dimensional figures of *kantha*, there is no such defining ground needed. Four different sides to the same figures can be seen by just turning the piece of cloth around. For every direction, a new base or background is formed according to the viewer's perspective. However in the case of sculpture, the subject has to stand, sit or sleep with the viewer on the same single ground. By shaping her figures using the visual language of *kantha*, Meera ran the risk of depriving her works of real foundational ground.

In Meera's human-shape based sculptures, another weakness is also sometimes visible. The limbs are frequently not proportional or correctly placed and hence the figures seem out of balance, particularly those seen in movement or at work. In other cases, an excess of sentiment takes over the sculpture thus robbing it of a certain delicacy. For example, the sculpture of King Ashoka has an unconventionally elongated neck. If the other limbs had been similarly extended, then this one feature would not have stood out, hurting our overall view of the work. For a more nuanced evocation of empathy, a restructuring of the neck would have helped.

These drawbacks and failings though, are in no way meant to take away from the stature the artist has come to acquire in the field of genuinely modern Indian sculpture. Despite the shortcomings, Meera Mukherjee continues to be celebrated today as one of India's finest sculptors and chroniclers of art and life. Much like the Emperor Ashoka, these skills and frailties have, over time, come together to create the image of a charming historic figure. For after all, the religion of art must finally give way to the religion of life.

Acknowledgements: Abhijit Gupta and Adip Dutta
Translated by Mrinalini Vasudevan

Geeti Sen

Meera's Journey to the Himalayas

During the last fifteen years of her life, Meera Mukherjee went in search of new sources of inspiration. She was a woman obsessed. She travelled long distances into the Himalayas, through the Kumaon hills and up to Lahaul and Spiti, and to remote monasteries in Ladakh. Occasionally, when she was inspired, she would write me a postcard from the mountains.

Why did she journey so deep into the mountains? Travel could not have been easy for a lone woman who had crossed sixty-five years, in search of places mostly inaccessible by road. Her mission remained a secret and few know of it, even today. She wrote a book on her experiences, illuminated

Climbing, terracotta
Collection: G. Ghosh

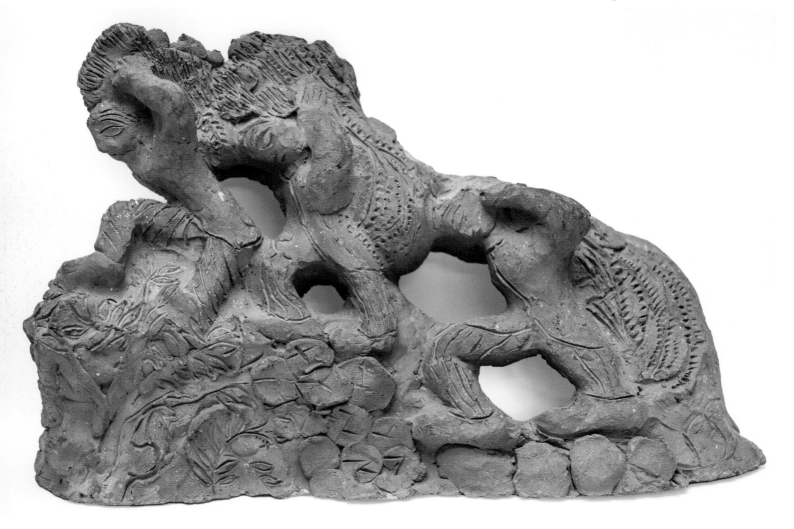

with her drawings, and published it in 1994 with the title *In Search of Visvakarma*. I remember her gifting me this slim volume, before she passed away three years later, in 1997. The gesture was made as though she was giving me a secret treasure.

I opened the book after she was gone, and it was a revelation. The book is her research and views about craftsmen and their skills; but it is also about Meera with a new vision. She writes:

A desire had grown in me to go to Lahaul and Spiti to visit the Buddhist monasteries there. I felt that if the practice of meditation in teaching arts was still in vogue anywhere it must be in these monasteries. With this idea in mind I went first to Keylong and the beautiful monasteries of Kardang, Tabo and Ki.

On my way to the Karddang monastery I met a person called Norbu Tsering, a government servant whose father was a Lama and an inmate of a gumpha (cave) and also an artist who painted Tankas. Norbu had also received training in this art from his father. Norbu told me that in Buddhism, art is regarded as a means of attaining Nirvana. Script writing is also considered to be such an art.

She continued her journeys. On seeing giant images of the Buddha she was mesmerized. She travelled deep into the interiors of Himachal, to Tabo, which remained a small village with an ancient monastery when I visited it in 1993. A new purpose, a new image was born through her travels. And she reflects,

The Tabo monastery is in Kaza. There I came across clay images which were a thousand years old. The images in metal which I found were of recent origin. Among these

Top: **Buddhist Monks in Dharmashala**
Watercolour on paper, 16.5 x 11.5 inches
Collection: Akar Prakar

Above: **Untitled**
Watercolour on paper, 11.75 x 16.25 inches
Collection: Abrajit Mitra

clay images, there was one of a seated Buddha about twelve feet high. They said that this image depicted Buddha...

There are different kinds of journeys. The distinction between travelers and tourists and adventurers is certain, but there are different reasons for travel. Some journey for the sheer thrill of discovery; some for the challenge of reaching inaccessible heights; some to document or reclaim lost heritage; and some to rediscover themselves. For Meera perhaps it was some of all these but most significantly, the last.

Her journeys into the mountains were in the nature of pilgrimage. Only a bunch of water colours remain now, radiant with colours, to tell us of her secret mission. At the end there was the icon himself, *Buddha*, her last image in bronze, larger than life. He is seated in a valley of the Himalayas, near Darjeeling.

Above: Untitled
13.25 x 10.75 inches, 1986
Collection: Abrajit Mitra

Right: Untitled
16.25 x 11.75 inches, 1970
Collection: Abrajit Mitra

Boatman II
Watercolour on paper, 28.5 x 10.25 inches
Collection: Piramal Art Foundation

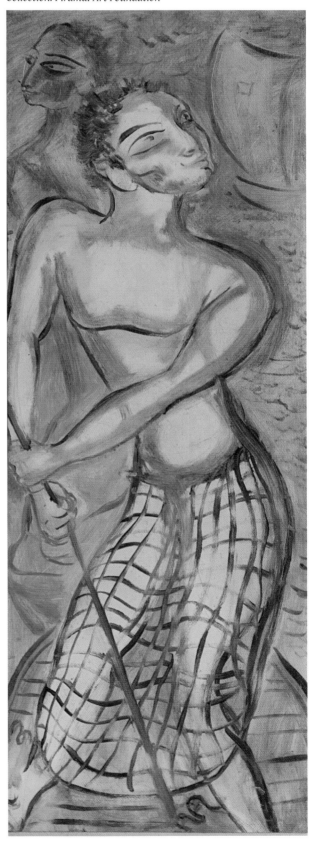

The *Buddha* sits facing Mount Kanchenjunga with his eyes open, his large ears shaped like conch shells hearkening to sounds floating down from the Himalayas. His long arms reach down to touch the mother earth as she bears witness to his overcoming the assault of Mara and his evil forces. This is his moment of triumph – as I interpret it – over the delusions of the mind. His robust frame resonates with a power that is physical as much as it is spiritual. The tea-planters in the vicinity bring offerings and pay him their homage.

How did Meera arrive at this iconic image? *Buddha* marks a milestone in her life with a fascinating story to be told.

She was not a believer, nor a follower of religious rituals. She would protest, "My work is my religion!" From the start her images focused on mortal humans who rise through their actions to heroic stature. The *Boatman* holds his oar as though he was steering through life; the *Archer* pulls his bow taut and by this gesture he frees birds trapped; Three *Fishermen* cast their nets, enmeshed themselves in the web of life ... The *Earth Carriers* are her tribute to labourers who built the underground in Kolkata. These monumental figures, man and woman rising to eleven feet, are now in private collections.

Soon after she had returned from Munich, Meera received a small grant from the Anthropological Survey of India. She chose to go to Bastar to learn the technique of bronze casting from the Gharua image makers. From them she imbibed not just the technique of lost wax process but also a world view of the tribals. In *adivasi* myth and legend of this region, goddesses such as Mayi, Matadevi, Maulidevi and Danteswaridevi were recalled for their heroic deaths while protecting the local people of Bastar.

Mortals such as Gappa Dei and her consort Lakkad Deo, a woodcutter, were deified through their brave deeds. Jaidev Baghel, the master craftsman from Bastar, confirms that deities worshipped by the *adivasi*s were "all born to villagers", and they "dared and lived to fulfill a need in their society, even at the cost of surrendering their lives".

Much of these values have changed now in the iconography of Bastar metal images. But like those ancient *grama devata*s Meera chose to render the boatman, the archer, the flute seller, kite seller and *baul* singers who in local folklore of Bengal are regarded as heroes. Our heroes are archetypal and every act is symbolic. An essential humanism is breathed into the smallest of her images. But she had larger ambitions than the image makers from Bastar.

The ultimate expression of the heroic is conceived by Meera in her monumental image of *Ashoka at Kalinga.* In that remarkable moment when the Mauryan emperor surveys the battlefield and its

Fishing Boat
Bronze, 8 x 23 x 5 inches
Collection: P. R. Ray

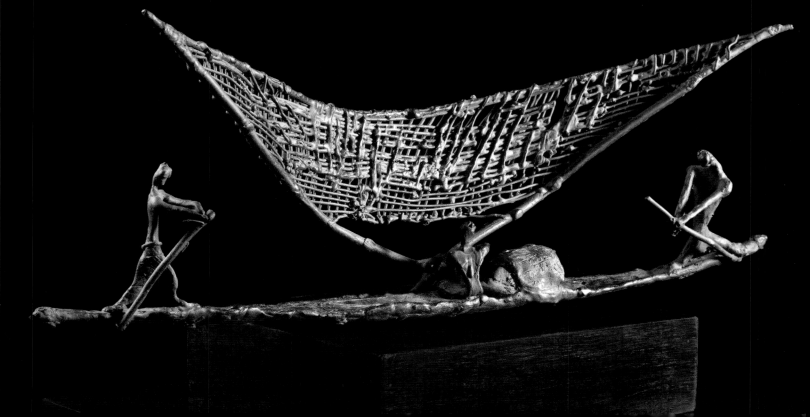

consequences, he rejects his role of
an emperor in pursuit of military
conquest. Meera conceives him in that
moment of his transformation towards
embracing the philosophy of Buddhism.
One arm still grips the sword while the
other goes limp to relinquish power. His
face is illuminated, tilted to one side.
She exclaimed, "He is my hero of all
heroes, he who rejects physical
power!"

Ashoka at Kalinga and Meera's
Buddha stand twenty-five years
apart in their conception and
making, the first in 1972 and
the second in 1997. Yet these iconic
images share remarkable affinities in
inspiration and treatment! Meera came to
her first monumental image of eleven feet
with *Ashoka*, to realize the significance of
Buddhism and its message; and she concluded
her life's work with creating the *Buddha* as her
largest image, towering to a height of fourteen
feet. Both figures are possessed of a robust and
powerful physique, with rough textured surfaces
that retain striations of the original wax models.
Not all figures retain these striations, and those
that do such as the *Guru* and *Thought Streams*
remind us of her inspiration from the technique of
tribal bronzes from Bastar.

Meera's *Ashoka* and *Buddha* belong to a genre
apart from many of her smaller works of
local heroes—of the *Bauls*, the *Kite Seller*
and *Flute Seller*. It is not only the nobility
of bearing that sets them apart but their
mesmerizing presence that is iconic. Their
long powerful arms are exaggerated, with
heads that are small in proportion to the torso

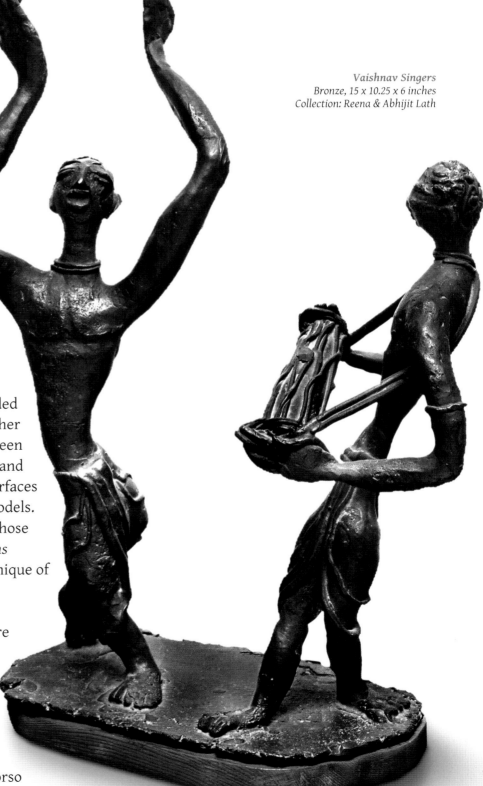

Vaishnav Singers
Bronze, 15 x 10.25 x 6 inches
Collection: Reena & Abhijit Lath

Buddha of Badamtam
Bronze, 168 inches
Collection: Goodricke Group Ltd.

but identical. Both heads are defined with square jaws to signal determination, and large eyes that emit the radiance of inner illumination.

Both images signal Meera's own determination to create images that would remain icons forever. She sketched her *Ashoka* first on a cigarette packet; and her drawing of the Buddha in red crayon tells us that she knew from the start how she was going to build the icon. The only difference is that the *Ashoka* was not commissioned but her own inspired ideal, whereas the *Buddha* was originally created on request. For a long time the *Ashoka* lay like a colossus in a derelict courtyard at the entrance to her flat in Poddurpukur. It finally found its place when the image was purchased by the WelcomGroup of Hotels and placed appropriately in the Maurya Hotel, Delhi.

The *Buddha* has a different history. When commissioned by an Indian to create a powerful icon, she decided to work upon the Buddha – "a god-like being but so very human". It was a daunting task that few sculptors would attempt, to create an image in bronze in sixty-four parts, and rising to fourteen feet. But before these various limbs were cast, the man who had commissioned the work had withdrawn his promise and disappeared.

relieved. Now that the head of the *Buddha* was done, she was done with the image... And she was not wrong. The letter reached me a day after the news of her heart attack. It was followed by a letter from Nirmal *babu*, her life-long companion. The image had still to be cast and welded, the workers to be paid. Both letters left me with a task of finding a home for the *Buddha*.

Many tried. We succeeded by chance, through a man who had never met Meera. He came, saw the icon and he was mesmerized. He thought of a home for the *Buddha* in the Himalayas, which she may have liked. After six more months in Kolkata, the *Buddha* traveled to the tea estate of Badamtam belonging to Goodricke India. Many tea planters are Buddhist. The *Buddha* is installed as their local deity and paid homage. At last, this became Meera's triumph.

Meera was determined and refused to stop the work, sensing perhaps that this may be her last image. She was possessed of a rare instinct for survival. On the day before she passed away she wrote to me, saying that her *Buddha* was almost completed. She was desperately tired, but

Woman carrying child at Kasauli
Terracotta, 9.5 x 6.5 x 4.5 inches
Collection: Premal Sanghvi

Adip Dutta

From Child Art to Stitched Painting

Vivid pictures of country life slowly emerge on humble pieces of cloth in the form of *kantha* design. These *kanthas* again derive their source material from paintings and drawings of a few children at Nolgorhat and its adjoining areas in South 24 Parganas. From the *kanthas* again Abu Taher, a traditional carpet weaver, weaves a pictorial surface which is uniquely exotic. The late sculptor Meera Mukherjee reflects on the craft of *kantha*-making in the lines as below,

Kantha *from children's drawings and paintings and carpet from these* kanthas *are experimentations to show how creativity could be made to flow harmoniously among groups of people. Each person in a group and each group in the project contributing to the entire process make a rich, vibrant and lively language of art evolve.*

Meera's consistent effort to explore creative potentialities of individuals and her ability to effectively direct them to one integrative whole open up some very important avenues enlivening the spirit of a craft form and modification of its purposes. In one of her projects, "Kantha", she leads the way of the collective creative force, from child-art to more pronounced art forms involving traditional pictorial registers and complex technicalities. This creative journey culminated in an experimentation that traced the process of evolution of art forms at the grass-root level and their social commitments. The work is particularly interesting in terms of a study of the pictorial elements of the synthesized language of an evolved art form.

Untitled
Kantha, 17.5 x 32 inches
Collection: Private

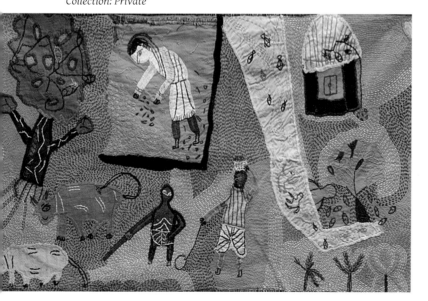

The groups of subjects involved in the project formed a part of the suburban population of Kolkata. They all stood on the lower-most stratums of India's caste hierarchy which is peopled by the majority of the Indian population. This enhances the significance of the project because a part of it deals with the genesis of art traced through development of the artistic faculty in children. This project is considered as the off-shoot of the artist's aesthetic sensibilities and consciousness. The very essence that one gets from the artist's mainstream creative endeavor, i.e. sculpture, can be found in its complete manifestation in the concerned project.

Meera's aesthetic consciousness was intimately linked with the awareness of her country and her great tradition. She says, "It was the heritage, which had in a thousand ways moulded me". Thus, through the revival of age-old indigenous technicalities of metal casting, the sculptor revitalized and enriched the vocabulary of her sculptural compositions and vice-versa. Similarly in the case of "Kantha", the project, the artist enlivened an otherwise traditional art form with fresh, spontaneous, responsive sensibility of children.

Children's circumambulating space-handling and multiple-view perspective through juxtaposition of imageries in visual narration are in common with the space handling of traditional *kantha* artists. Here a new dimension is added when the superbly skilled *kantha* stitches depicting vivid visual images of children are aided by Meera Mukherjee's trained creative perception. Thus a combined, collective effort here creates a language of an entire community that the artist dealt with at different levels, from the late '70s through the '90s till her death.

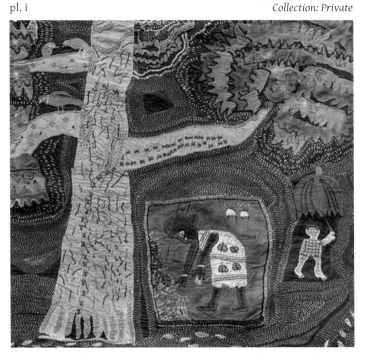

pl. i

Untitled
Kantha, 25 x 25 inches
Collection: Private

The idea of revitalizing the traditional pictorial idiom of *kantha*, through the introduction of children's imagery drawn from their direct visual experiences of day-to-day life, came to the sculptor during the late '70s. "It started suddenly about six or seven years ago at Nolgarhat when she was helping young children learn their alphabets and the numbers" wrote the women's activist, the late Maitreyi Chatterjee, on Meera Mukherjee in her article "New Frontiers of Arts" in 1982. Chatterjee further said,

Every time the children showed the sculptor their hand-writing and sums, she noticed little doodles at the corner of their slates. She was struck by this attempt at self-expression and by their unconscious folk-like approach. The doodles seemed to her woven closely into their life-pattern. Why not encourage them to paint on paper was

113

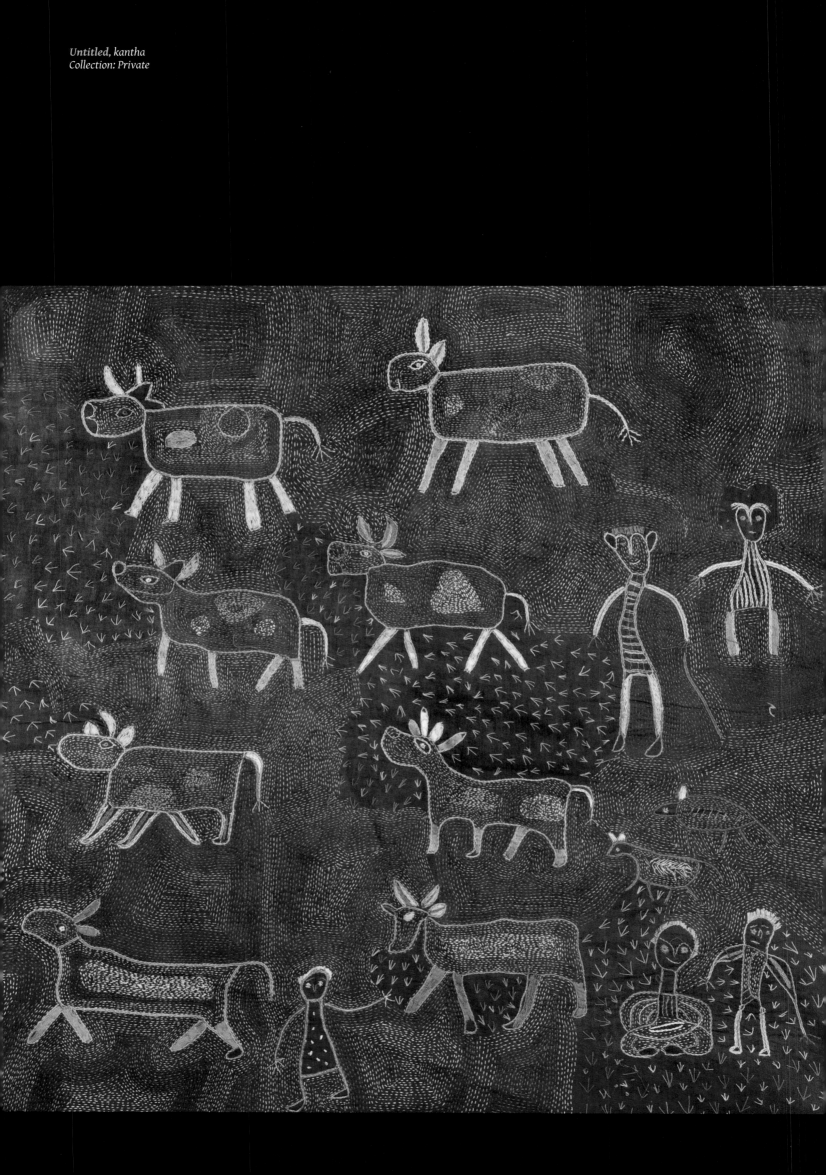

Untitled, kantha
Collection: Private

her thought. There was no ambitious plan in her mind when she decided to give these simple children a part of her Sunday every week except perhaps to instill a feel for beauty.

But her ability to impart "a feel for beauty" largely depended on how pragmatically she was to plan her incipient project, for the parents of the children involved, most of whom were day labourers, rickshaw pullers, landless farm hands, were not enthusiastic about releasing the children even for an hour once a week. Through the sculptor's brainwave came an instant solution to the problem. The grown-up girls who were so far made to stitch *kantha*s with conventional pictorial format and stitched messages as "Dadumonike Pronam" (Salute to beloved grandfather) on them now earned a wage from the artist for stitching *kantha* from children's drawings. These 'stitched paintings', to put it in words of the sculptor's lifelong friend late Nirmal Sengupta, were marketed among friends and acquaintances. Let me take this opportunity to mention that Nirmal Sengupta was instrumental in the formation of many of the projects related to Elachi and Nolgarhat. It includes the artist's casting of the metal sculptures at the Elachi studio space, which actually belonged to Nirmal Sengupta. The foundry for casting metal that was set up by her here led to a whole series of activities culminating in interesting projects. Sengupta's socialist approach resulting in the formation of Dhankhet Bidyalaya, a school for the semi-rural, under-privileged population at Nolgarhat, Narendrapur, initiated the "Kantha" project. Meera Mukherjee's orientation to work with folk artisans located at the lower strata of the caste hierarchy led her to an immediate identification of the potentials of working with and on groups of people in and around the school.

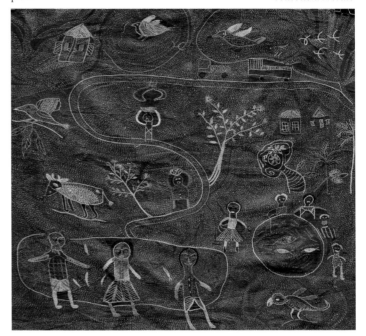

Untitled
Kantha, 20 x 19.75 inches
Collection: Private

pl. ii

Before we go into the formal and elemental details of the blended pictorial idiom we shall look into the two significant interrelated aspects of the entire project. The first one is Meera's aesthetic consideration which primarily concentrates on how art develops at the grass-root level and closely woven with it is the social significance of the work. For a clear knowledge, the first aspect naturally demands a quick look into the sculptor's artistic background and aesthetic consciousness. It all started when her German Expressionist teacher Toni Stadler, who was deeply inspired by Zen Buddhism, asked Meera to look for her roots. Though today it may appear hackneyed, at that time it had a tremendous effect on the psyche of the budding artist who was basically from an upper-middle-class background that handed down a colonial outlook that canonized Renaissance art. Meera's lessons in Germany led her to an 'understanding of one's own turf' or what Gurusaday Dutt meant by saying[1] "sharing the soul character" race language or spirit of a land or region.

It is widely known among art enthusiasts that Meera after coming back from Germany in the late '50s made an extensive study for the Anthropological Survey of India under Professor Nirmal Kumar Bose on the indigenous metal craftsmanship and artisans of India. She went as far as Nepal in the Northeast and Bangalore in the South. But this artistic journey was started in Bastar, Chhattisgarh, in 1961 when she sponsored herself a study on the forms, motifs and technicalities of metal casting practiced by the Gharuas in Bastar. Here, Meera first came across the tribal narrative scroll paintings or *Pats*. These scroll paintings shared in form and content the same spirit found in the Jadu *pats*, Gazi *pats*, narrative Krishnaleela and Ramleela *pats* of Bengal, Chotrakanthi in Maharashtra and Ankasi in Andhra Pradesh. These scroll paintings from different states of the country strongly resembled each other and revealed the universal chemistry of evolution of art form at the grass-root level.

Meera was deeply impressed by the tribal people's capacity to absorb any form of visual experience and transform it into their own language of expression. A similar effortless act of depiction of visual experiences by children prompted Meera Mukherjee to link these art forms at the grass-root level to the works of the children she was dealing with twenty years later. Apart from a physical semblance, she also discovered that 'the motifs were deeply woven into their life pattern'. To both, the act of creating visuals is a surrogate for speech. It was the element of response in the works of the children that brought them close to the narrative scroll paintings Meera came across early in her artistic career. The sociological reasons here are obvious. The group of children Meera was dealing with came from the suburbs of Kolkata. Though Nolgarhat and Elachi fall within the urban periphery today, 35 to 40 years back they formed the city outskirts. The existence of the poor, rural people there, centered over the rudimentary of life. So perhaps similar social elements prevailing in both the societies must have led to a similar perception of forms of surrounding objects especially when form is known to be "social experience solidified". But most importantly it was the physical semblance that led Meera to trace the line of development in the art of children and the artist at the grass-root level.

Let us now try and answer the question why an artist like Meera Mukherjee tried to create art with children. It is likely that Meera was making an attempt to fix for eternity, moments in a child's world. She realized that faith inherent in every act of a child is a temporary phenomenon. So by

Untitled
Kantha, 15.75 x 15.75 inches
Collection: Private

Facing page top:
Untitled, kantha, 21.5 x 30.25 inches
Collection: Private

Below left:
Untitled, kantha, 16 x 18.25 inches
Collection: Private

Below right:
Untitled, kantha, 15.5 x 17 inches
Collection: Private

making these children create painted visuals she was trying to hold on a moment of flux. But here she was doing something more – fighting change. Those who were close to her would know how she resented the concept of globalization most often confused with mono-culturalism. She firmly believed in the development of art through an in-depth understanding of one's own 'race language'. Her sculptures and writings reflect this idea. So here too, with the children she was basically trying to stem the flow of change by making them create a lasting visual diary.

We know that the most unpretentious work from a child's hand holds up a mirror before our eyes. Children usually choose everyday occurrences for their themes. They reveal divine in the most commonplace events around us. At Elachi and Nolgarhat, in the children's doodles Meera not only noticed sparks of the divine, but also strong similarities between the works of the children, who have no tradition of art as such and the *kantha* designs she has seen in many Bengali families and in museums. This realization plays the key role in creating a new language of art by making older girls stitch *kantha*s incorporating the designs and colour schemes from the drawings of kids.

The *kantha*, which basically involves simple vegetal or floral designs and motifs abstracted from the surrounding visual reality, is mostly an ordered art form practiced by the womenfolk of rural Bengal. These designs of profane art bear marks of Neolithic peasant art. Essentially feminine in character, these designs reflect marks of discipline and order.

So to add more vibrancy to an apparently ordered but rigid, decorative pictorial idiom, the artist introduced the grown-up girls, to stitching *kantha*s with motifs drawn by children. In museums Meera had seen old traditional *nakshi kantha*s composed with floral motifs, human and animal forms etc., all narrating a story. This narration was enhanced through the use of stitched scripts appearing in the form of lines and formed a part of the pictorial design. All these together made the pictorial ground throb with life. She wanted to once again enliven and rejuvenate this tradition by including the unaffected spontaneity of children's drawings and colour scheme.

Though the grown up girls composed the pictorial ground of the *kantha* from compositions by children, they had the liberty to alter and improvise the forms, composition, add colour to it, and in the process contribute their own creative sensibility. On a square piece of cloth the girls first used to

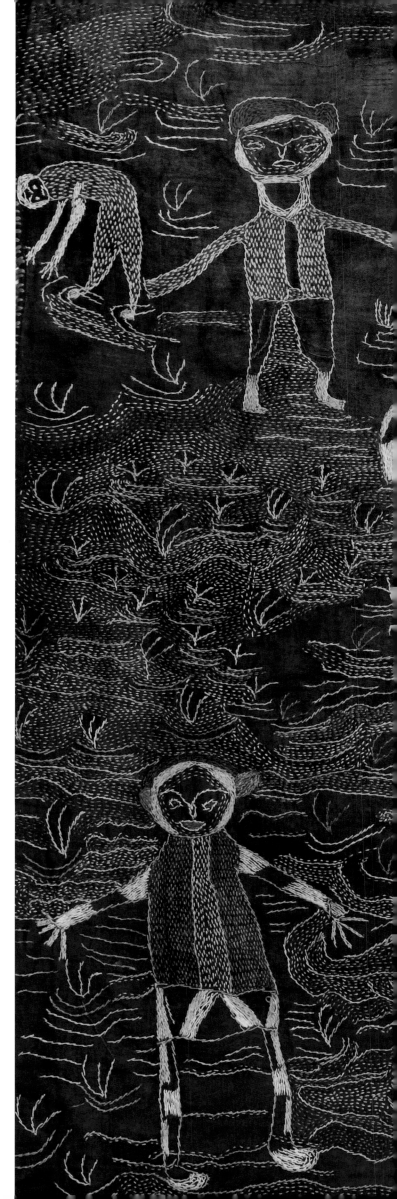

arrange a picture from more than two compositions of different children. On most occasions the artist helped the girls with the arrangement and drawing of the composition on the ground of the *kantha*. So a single *kantha* used to be a combination of images of more than one child, Meera's trained creative perception and the imaginative sensibility, and superb technical skill of the *kantha* makers. Thus, an amalgamation of a number of individual styles here speaks of a collective effort and a language of an entire community. Though there are extremely subtle stylistic differences in the form of motifs of two different children and technical skill of the *kantha* makers, there exists in each a uniform temperament.

Initially during the 1970s at Elachi, Meera Mukherjee made the women-folk, who came as domestic-help, stitch *kantha* with traditional pictorial format consisting of repetitive motifs and decorative designs. These *kantha*s were very difficult to be distinguished from those that were seen in middle-class and upper-middle-class households, especially with the arrival of a newborn in the family. It was only during the late '70s that the artist thought of blending the design of *kantha* and the drawings of the children. By then she was already working with groups of children. Here one may legitimately ask as to what prompted the sculptor to combine the two art forms. The answer is probably a similar handling of space that she noticed, both in the works of the children and in the *kantha*s. A conglomeration of multiple points of viewing a single event in a composition, resulting in a multiplicity of representation of the three-dimensional worldly space on the two-dimensional picture surface, and creating floating effects of the motifs were found both in the paintings of the children and in the *kantha*s. The difference lay in the subject and the colour scheme used. The artist noticed that most

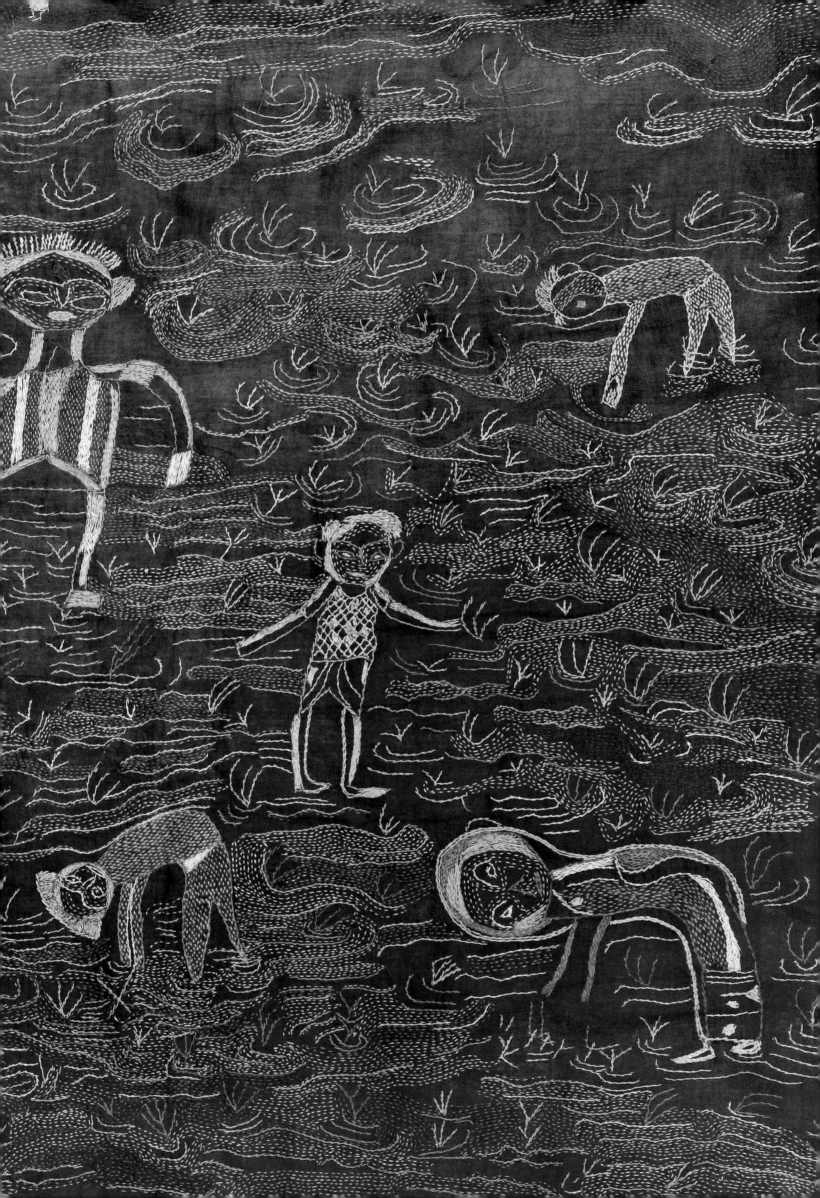

of the children she was dealing with approached art with an air of confidence and unrestrained enthusiasm. They had vivid imagination and keen interest in the world around them. Regarding colour, she noticed that the boys and girls had an inclination towards assembling primary and secondary colours in complementaries. The artist visualized the uniqueness of the picturesque quality that she would create if the precise and refined *kantha* stitches were used to depict the subjects and colours of the children.

To strengthen the ground of the *kantha*, running stitches in the form of flexible, moving, curvilinear lines made up of several uniform hyphen-like small lines and dots were used as common devices. These lines appearing in the form of chromatic divisions in between motifs of the pictorial ground not only served the practical purpose of strengthening the *kantha* with numerous stitches known as *kantha phonr* in common parlance but also activated the space in between the motifs, created rich textural quality, and brought about a fine tonal variation surrounding the figures. This in turn made the motifs vibrate with an enhanced presence on the ground of the *kantha* (pl. iii).

The *kantha phonr* most effectively expressed pronounced movements on the pictorial ground (pl. i). Upward growth of tress, spiral movement of whirlwind, serpentine roads (pl. ii), ripples on the surface of water, and the direction of rainfall, etc., are most common in the works. Apart from movement, the stitches suggested formation of objects too. Occasionally, *kantha phonr* stitched close to each other created the volume of objects, and even human and animal forms. Other stitches most commonly used to enhance the picturesque value of the works were Satin stitches, used to densely fill up wide areas; Dull stitches, used in depicting the

sharp contour lines that enhanced linear dynamism and balance in the composition; and Chain stitches, used to suggest the harvest.

Unlike the traditional *kantha*s, the *kantha*s at Nolgorhat reflect a unique colour scheme. Though here, the children's innate sense of colour found expression, the works went through the process of a chromatic metamorphosis aided by the artist's creative perception. She took care of the even distribution of all colours that were used. This was done by the hyphen-like *kantha phonr*s, which revolve round the images in many different colours used to depict the main motifs. These created an effect of the colours in the motifs being reflected on the ground. The contour lines of the figures were also stitched with many colours that created an effect of the colour being reflected from the ground onto figures. In both the cases the result was a pleasant chromatic division.

The main difference regarding colour between the traditional *kantha*s and the *kantha* at Nolgorhat lay in the background. These *kantha*s are stitched on pieces of cloth coloured chrome yellow, turquoise blue, dark purple, army green, pinkish violet etc. The option of selecting the colour of the cloth on which the *kantha* would be stitched lay with the grown-up girls. The colour of the cloth determined the selection of the other colours to be used to stitch *kantha*. The girls always didn't strictly follow the colour scheme laid down by the children. This was mainly to provide ample opportunities to every individual working in the project to add their own chromatic perception and in the process to build up a rich colour scheme. This was true not only of the colours used but also of the trans-creation of motifs, composition etc. in their medium.

The composition shown in the next column has been derived from the drawing above it. In the painting

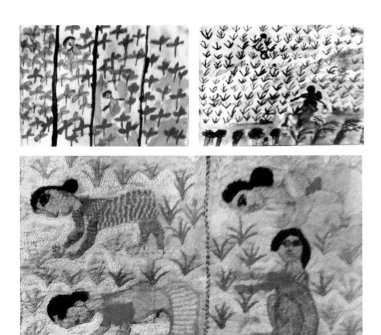

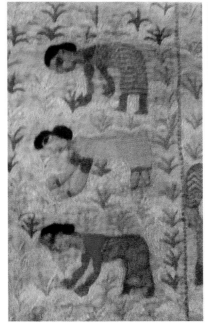

play. A serpentine road fringed by trees, animals, human figures etc. moves up and down the *kantha*'s space creating exotic visual glimpses. The glimpses made on the *kantha* have been appropriately called "stitched painting" by the artist's friend Nirmal Sengupta. Though these stitched paintings rejuvenated the technicalities of an art form, the form in this case got transformed into a pure art form for its own sake, divorced from its practical utilitarian aspect. These are like currents of fresh air and shafts of light that make one breathe in life leading to a keener perception of visual delights of nature. These stitched paintings are a complete aesthetic fulfillment to all those who participate in its making and to those who see them.

we notice a predominance of the colour green. The naïve figures suggest that the women-folk working in the field bend themselves to plant the paddy saplings. Though the compositional arrangement has been directly used by the *kantha* makers with very little alteration, we notice that the colour of the cloth, i.e. chrome yellow here, predominates. On the chrome yellow background the green of the saplings juxtaposed in a row appears more pronounced. The colours red, cobalt blue, grayish blue, muddy brown, and ochre yellow create a vivid and rich chromatic surface. The figures at work on the *kantha*'s pictorial ground derived from the drawings of the children have been executed in graphic detail, suggesting the formal constructional perception of the grown-up girls. This perception results in slight improvization while translating the figures, motifs etc., while translating them from the children's drawings to their own medium.

Specs of yellow ochre create the chiaroscuro effect of shimmering sunlight on a tree, under which children

Facing page:
Reclining Woman
Watercolour on paper, 14 x 20.5 inches
Collection: Piramal Art Foundation

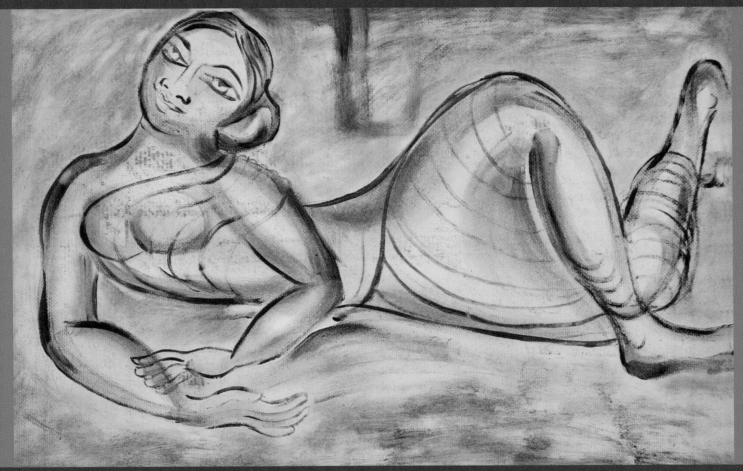

Meera on Art

Meera In
Her Own Words (Part 1)

*"Craftsmen become artists through
their talent but artists seldom become
craftsmen in turn."*

As a child I did not know that I would eventually become an artist, although I had a vague longing for it. That longings can come to fruition was not very clear to me back then. It wasn't as though I knew a lot about the subject. But I did like to paint and I clung to this feeling, that is all I know. For instance, one's mother's teachings – the traditions of home and festivals remained. My mother used to paint *alpana*s not in the style of Santiniketan, but more spontaneously, with greater ease, and fluidity, something that I have maintained to this day because I know there's a certain joy to be had from the uncertainty, and from not knowing where your painting will lead you next. Perhaps you have made something, added vines and leaves to your piece, maybe you have faithfully illustrated all that you have seen in real life, the people, the crowds, everything that has left a mark on you—all that gets identified. This is an important lesson to learn. We have grown from the foundation laid down by our parents.

Later when I was a little older, I got admitted to Abanindranath Tagore's school where I was taught their style of painting. They would give us plates of say, Ajanta, and ask us to faithfully copy the piece. But they would not tell us why we ought to copy it, what point of view ought to guide us when we are copying it. All we knew was that our job was to identically represent what we saw on the plates onto our canvases. So we did our job and copied the plates, but it didn't help us in any way. However, it must be admitted that today has been made possible by the distance and experience of age. These experiences cannot be taught, they have to be acquired through one's life. So if they had taught me about the outlook and points of view of a painting back then, I may not have been equipped to either understand or assimilate

the knowledge of it. I was very young then, all of 14-years old. But I do believe they could have told us, and taught us a little more in order to widen our perspective and our skill of observation.

After this I went to Delhi's Polytechnic. On one hand there was Nihar Chaudhuri from Santiniketan, on the other there were luminaries like Dhanraj Bhagat, Kalyan Sen, and Sushil Sen. Their method of teaching was more West inclined. When I was learning under their tutelage, they must have felt that I would be unsuccessful with what is today called Realistic Art. Even here there is something to be learned. You call something real from your own perspective, which is fine. You teach that to someone, you show them how to view something, how to draw a line – which is something like draftsmanship. Now what one takes away from the piece is something I learnt much later, when I was in Europe. When I saw Impressionist art, or witnessed the work of abstract artists, or for instance, when I interacted with the artists, I automatically learnt what I needed to see in a piece of art and take away from it. My European friends used to tell me that I spoke one language, I thought differently, but my work resembled theirs and they did not understand how that was possible. These questions always came as a shock to me – it came to a point where I became an insomniac; I couldn't sleep for almost six months. I'll admit to blaming our teachers back then. The fact that painting goes beyond measured lines and colouring within expected borders, that paintings can have a specific feeling and outlook, were things our teachers never taught us. Perhaps they did not teach you that either. I don't know if they teach you now like they used to teach us back then. Either way, it remains a crucial aspect of painting.

In the midst of all this I was also learning art from the Indonesian artist Affandi. Affandi taught me to

Top and above:
Pithoo at Kasauli (front and back)
Terracotta, 5 x 6 x 5 inches
Collection: Premal Sanghvi

Mother Earth
Bronze, 15.7 x 16.1 inches
Collection: Abhishek Poddar

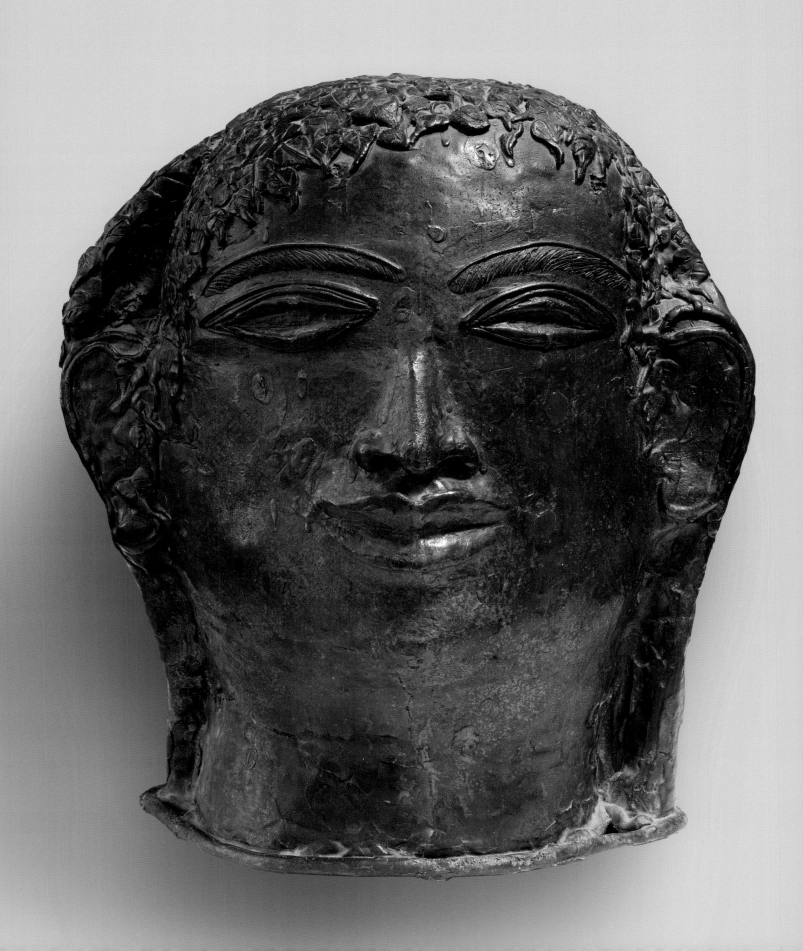

see the ordinary things in life. He used to tell me I worked too much and he advised me not to. From him I learnt how to see and observe, and let myself go amidst nature...

I started to work at home. Regardless of whether I am criticized or praised I want to finish my works. If I am not an intellectual, if I cannot be an artist, no one can make me one. If I am an ordinary man I will do ordinary work. I'll be happy with my lot in life. I never had an ambition. I never wanted to be a grand artist. Therefore, I had no problems. Among them there are so many who built boats, spent the rest of their lives building boats and were none the worse because of it, brilliant sculptors who left sculpting and built boats instead. I spoke to one such man. We had a professor who used to break things, literally break things. Imagine working on a piece for 7 days, 10 days, a month even and he wouldn't even deign to look at it. But I will never criticize his method of teaching. A friend of mine tells me I would never have become 'me' had I not been taught by that professor. However, his treatment didn't always yield good results, we were all sensitive young people after all. I am not that artistic in a way. I always thought of myself as a worker. I keep saying that because I truly believe it. The person who taught me music used to tell me a wonderful thing. He used to say that the ones with the most brilliant minds were often the most problematic. One has to cherish and protect it, any callousness in its use and – imagine dashing a delicate knife against a block of stone repeatedly – what will the outcome be? It's much the same for people. The human mind is so delicate that repeated gashes on it can only lead to frustration.

But eventually I tore away from that school of learning, which in hindsight was the right thing to do. My decision to break away was correct because

I knew I did not want to be an artist – how does it matter if the public calls me grand or insignificant? I will remain who I have always been – I realized this. Regardless of the standard I am boxed under, I will aspire to what I like...

The biggest problem from my time was the decision to go into the line of painting at all. No one understood what I was trying to say. When I tell someone I want to work in such and such place, I was only met with incomprehension from the part of my audience. So I took up a permanent government service at the time. I'm telling you that the decision to not walk the beaten track, to stand by one's decision is always the hardest part. That's how I said "no" to a very lucrative job at the German consulate. My reason for refusing remains the same today as they were back then. I had to fight so many people and so many were disappointed by my decision. How do I explain to them my utter disinterest in becoming a Class I officer? These are the areas where I had to struggle the most. I did not have the backing of an 'ism' back then, I hadn't read much although now I do – I didn't know much back then save for my art. But I have felt a deep love for my country and my people. This love is what motivated me...

I liked working with them. I liked their cooperation and simplicity. When something grows, it does so in its own pace. There is a huge difference between growing consciously while being mindful of the growth, and growing with a oneness and identifying completely with your craft. The latter is always better sustained, livelier, and more potent. Real art can't always be a conscious growth, one needs to invest one's life and soul into it. One could say there's some violence in it because unlike a conscious decision, here you have let yourself go completely – it has a mind of its own – and

therefore by extension it has a better sense of 'you' in it.

I have already commented on the method of the artisans. Their work goes through stages. First comes clay that you mould into a form, then wax, and finally *dhalai*. They don't have to work after the *dhalai* is complete, but I am required to. The artisans are completely invested in the entire process and they make everything with their own hands. Because you are working through so many mediums, matter, and methods, your work will have better longevity.

Recently, these artisans have come into focus and the government too has tried to help them. But I find this method of helping grossly inadequate. The government knows nothing of the artisan's way of life. One cannot help someone while being ignorant of their lives...

As far as my own work is concerned, when I learnt how to become one with it and completely lose myself in it, I no longer thought of it as something that is my doing alone. I get ideas, say I am walking down the road and I hear the sound of the people pulling those wires up, say something strikes me when I hear them and I come home and I try to do something about it. Something wholesome and comprehensive comes to my mind as if in a flash. I can see it completed in my head, and I try to remain faithful to this image and finish it in my painting but there are always obstacles and interruptions that change the original idea. Perhaps that is because of technical shortcomings on my part, and for not having enough skill. Despite this I try to do as much as I can. It's not like I force myself either. Ambition can be of various types and people usually say not having ambition is a terrible thing. Personally, I believe ambition and competition

aren't desirable everywhere. If you truly love something, it will show unbeknownst you. There can't be any gaps and shortcomings there; you will have to be sincere. You have to be honest to your art and to yourself, and you will see paths opening up for you. The obstacles that come your way will no longer feel like interruptions to you. I love my work which is why I do it. Honestly speaking, I try to give as much of myself to it as I can. I stop giving when I am no longer capable of it.

I want to be just another face in the crowd. Only from there will I be able to pick out the truly ordinary audience. Of course, there will always be the ones who understand art. But the ordinary audience! I really feel for them. I feel terrible for the middle class, educated audience who believe they know something. I try and avoid them as much as possible. Forgive me. I dislike those who pore over works of art with the intention of dissecting it. It is infinitely more desirable to look at a work of art and in the act of looking uncovering hidden meanings. Can intellect alone ever be enough?

Endnotes

1. From the compilation *Prabahita jibaner bhaskarja/shilpokatha sakshatkar diary* edited by Sandipan Bhattacharya, Manchasha Prakash Prakalpa, Kolkata, 2005, pp. 11–24 (quoted as being originally published in an art journal *Pat*, Issue 1 & 2, 1982).

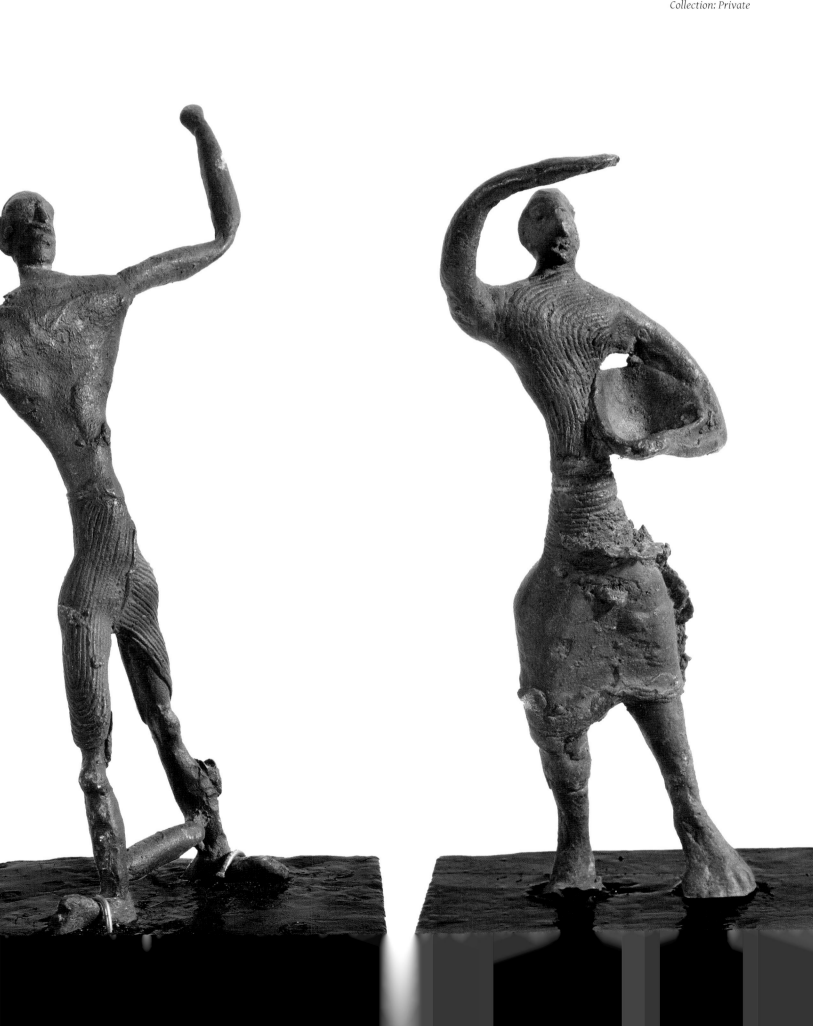

Left: **He**
Bronze, 7.5 x 5 x 2 inches
Collection: Private

Below: **She**
Bronze, 7 x 2.5 x 2 inches
Collection: Private

Meera In Her Own Words (Part 2)

Untitled
Bronze, 10.8 x 8.6 x 7.8 inches
Collection: NGMA

We had to leave our house back then owing to a tumultuous time in our family. My sister and I left for Raajshahi. I must have been 14 or 15 years old at the time and my Shejdi, the sister older to me and younger to the two before, between 17 and 18. We went onwards and upwards from the chaos and emotional upheavals of our home in Boubazar to a calmer world. My sister channeled her grief into academia, I could not. I constantly thought about the secret alleyway in the corner of our garden back home. It had *swarnachampa*s, *kolke* flowers, and so many other trees. I remembered the afternoons spent on the rooftop—the many afternoons where I doodled on the walls of the room of worship. I knew that along with the rain, the moss would eventually cover up my handiwork. Bibha and I had sat in the garden and etched out the village of Purba Bangla (East Bengal). The rail tracks and the river going their zig-zag route, flanked on either side by paddy fields and houses from the village and a large clearing in the middle, flanked on all sides by four houses.

My grief started to encroach upon my health as well as my mental well being. I fell ill and was confined to a bed; the prisoner of a single room. That small bungalow was owned by a potter. With nothing to do in my solitary confinement, and bored out of my mind, I started to observe the potter at work, making bowls and glasses, from my window in the

afternoons. I don't know when, but the potter and his work influenced me deeply. I would stare open-mouthed at the neighbouring children rushing to gather the mangoes torn apart from the trees during the storms. Storms would look beautiful on the Padma river. With my juvenile consciousness, I would be reminded of other, happier memories in connection to these storms. My mother had the habit of making *Shris* during weddings and other auspicious ceremonies that would make us gape in admiration. My mother would paint *alpana*s on the threshold of our house on the eve of Laxmi *puja*. During the *puja*s my siblings and I would be entrusted with arranging the *naibadya* under the guidance of my mother. During the month of Baishak, at the time of the Shiva *puja*, I would be excited since dawn at the accompanying arrangements than the *puja* itself. A shiny copper tumbler would hold a plethora of flowers–hibiscus, kolke–requirements of Shakti *puja*. And for Shiva *puja* we would have white flowers, leaves from wood-apple trees, *durba*, sandalwood paste, rice, all washed and kept ready on the *pushpapatra*. Ma would hand us the clay and it would be our job to mould it into the form of Shiva. I also recall making paper boats and setting them afloat on the water from the sewers. How far those floated away! It would appear as though they were done with play-acting and would be floating away to the Padma.

It is pointless talking about the sorrows of the soul—who would understand that the trees from the garden, the heap of clay that we would play with would be the reason for my tears. I would stare open mouthed at the potter—he never stopped his potter's wheels for any amount of joy or misery. I must have kept some trace of joy hidden inside because suddenly, after a storm, I picked up pencil and paper and started to sketch in secret. But in vain...

Tree
Terracotta
16 x 12 x 12 inches
Collection: Private

I remember Bahadur. I must have been four years old at the time. I used to stay with Bahadur. He had come from Darjeeling – he would sit at the front door with me on his lap. He would hide his paper and pencil in between the four pillars. Sometimes he would take his paper out to sketch. He would sketch noisily; with the scratch of pencil on paper he would make mountains, pine trees, fountains. I would watch him spellbound, wistfully hoping to sketch like him someday! My elder brother Biruda's school had etchings of Jahangir, Shah Jahan, Aurangzeb, Babar, and Akbar on the walls. One could see their faces on journeys up and down the stairway. Biruda too would sketch noisily. Who would have guessed how dear to me all this was! My heart would long for these familiar people. And

that one guy who brought a sack full of rocks to sell. "Do you want a deity?" he would yell. Some aunt or grandmother would order for a Shiva or a Krishna from some upstairs window and the man would start to carve it out right in front of our eyes. I watched the entire process open mouthed from a corner window.

At Rajshahi, confined to my bed I would say to myself, "I would fight with myself that I would paint." I would try from dawn till dusk and show them to my mother at the end of the day when she would come to my room with a glass of barley or buttermilk. That's how my elder brother, Chhorda, came to know about my love for painting and my willingness to learn. My father came to know as well.

The waters in the pond overflowing in autumn, the shadows made by the weeds in its corner, all looked beautiful to me and I was left wondering when I could paint them. My Shejdi was scheduled to return to college after the *puja* break. I took an oath to no longer study. I explained to my

mother that having one illiterate daughter amidst all her other talented, efficient ones would make no difference. My father had come to this realization long ago.

I did have some difficulty leaving as beautiful a place as Rajshahi behind. I had experienced so many things there! The Padma river, the storm in the mango grove, the endless conversations that I had with the potter's wife in their hut! But my brother declared it a necessity to enroll me at the art college in Kolkata. I secretly panicked at the thought of yet another school! I returned to our new flat in Dharmatala with my father—it had four huge rooms!

Once here, I began to plead with my uncle to enroll me at a school that would not be too intent on disciplining me. Somewhere that had the luxury of endless hours to paint to my heart's content. After a long search my younger maternal uncle, Chhoto mama, finally settled on Oriental Society of Indian Art. I got admitted and loved it! Within a few days I was able to copy the Ajanta plates given to me by

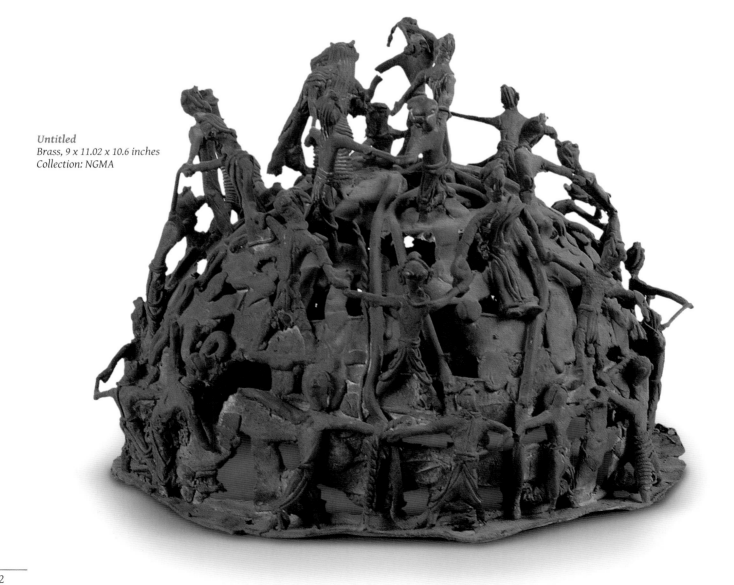

Untitled
Brass, 9 x 11.02 x 10.6 inches
Collection: NGMA

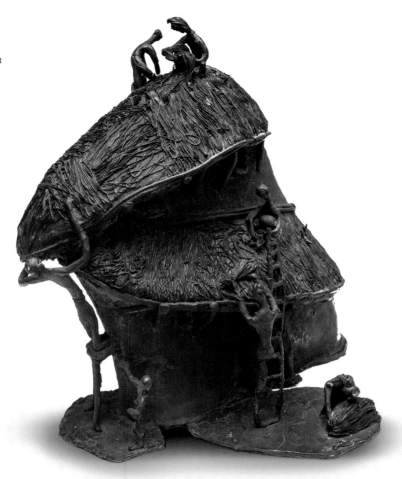

Chalachali ka khela
Bronze, 16.7 x 13.11 x 10.6 inches
Collection: Aradhana Jhunjhunwala

Nanda *babu*. I think I started on colour within two to three months. Back then there were teachers like Kalipada Ghoshal, Shridhar Mahapatra – Abani Thakur's favourite student. They would teach us with a lot of care and with a welcome fondness. I heard so many stories from Kalipada *babu* when learning under him! He used to say that the stories were handed down to him by Abani Thakur. These stories would have such lively descriptions that it would help me evoke their beauty through my paintings. Sometime soon after this the society got dissolved. So a few girls from the class would come to our flat and Kalipada *babu* would come to teach us there. We would paint from the *Ramayana, Mahabharata, Baishnava Padabali, Meghdoot*. We shifted from Dharmatala to Ballygunge in the wake of the war. I painted what seemed to me to be the symbolic representation of war at the time—a sky-high form of destructive force burning everything in its path while it comes closer.

Sometime after this I could not work. A lot of changes, deaths, weddings came and went. Then came a terrible year—my father suddenly passed away. It was a terrible blow because he had been the sole enabler of all my childish whims. Before that wound could heal, my mother was diagnosed with cancer. Her death was painful. To me she was always the epitome of wisdom and sacrifice. Her life doled her many unjust blows. She accepted it all with patience and fortitude. Her death played havoc with me. I could accept her death, but not her pain. I lost faith in God. My life altered completely. A few days before she passed, my mother said to me, "You have a lot of work to do – you will have to do it all." I said, "What do I have to do, mother?" The answer I received was that I had a spirit inside me that would guide me towards a path. I was not to leave this path, nor be afraid. The work that met me on this path would be the work I needed to do.

My Kolkata chapter ended. I went to Delhi. Anil Roy Choudhury came to visit my sister one day. He saw a painting on the wall and asked whose it was. When he heard it was my artwork he could not believe it. He exclaimed as to how that could be, that with a skill like that I was still only sitting at home. After this incident he came to visit once more and made me paint. My mind was clouded by grief. I would be overwhelmed by anything I encountered.

I enrolled at Delhi Polytechnic in a strange turn of events. I faced some troubles initially. I would complete my day's work in a very short time and come here. The more I got involved the more I realized that the only way to escape my misery

Untitled
Marble, 5.75 x 5 x 3.5 inches
Collection: Akar Prakar

would be to get further involved in this. I won acknowledgement within a very short time. Back then our teachers included Shri Bhagat, Kalyan Sen, Sushil Sen, Nihar Roy Choudhury, among others. My initial drawings showed influences of the Indian society. I remember this one time I had sat down to paint a portrait but it didn't turn out realistic enough. Shribhagat laughed and told me I would never be able to paint realistically. Thus I immediately set to work, trying to polish, refine, and measure my images. I was able to paint a realistic portrait within a few days time. I started using water colours and then moved to oil paints. I recall working incessantly in school, and then again once I got back home. Back then the students had immense motivation. I would hang around anyone who seemed great to me. Biren Dey, Atul *babu*'s student, used to teach me portrait painting, still life etc. I would regularly work at home after school as well. Amina Ahmed (Kar) used to work with us. Her drawings were lively and beautiful. Ratan Thakur, Kalyan Sen, and Shribhagat would teach us outdoor water colours. Some of their students earned very good reputations—Kebol Soni, Avinashchandra

Pramukh. The one who didn't earn fame was Kulvant Arora. He would invest a lot of time thinking about the work, and would work at a very slow pace. He tried to explain several things to me about my work but I was certain I didn't have the mind for such high-flown thoughts. That boy would perhaps paint a maximum of two pictures in a year, but those works would be heavy with meaning and far superior to the rest. He and Sejan Pramukh used to read and discuss the lives of Impressionist and Post-Impressionist artists. I would read these biographies too, but was incapable of engaging in a discussion about them.

I never really understood the rewards of my untiring hard work. Perhaps the reward was a lot of practice and the chance to play around with technique. But why? I would often question this but never received a clear answer, or never mustered enough courage to ask anyone. In the meantime, the place had annual exhibitions where I had earned a name. I remember Fabri well. Once he came to an exhibition of mine and was a very gregarious presence. My time at Polytechnic was fast coming to an end. I spent the majority of the last two years dealing in clay and plaster. Nanda *babu* once said to me that if I ever wanted to be a great writer I had to copy the works of other great writers and implement them in my work whenever I could. The same was applicable for artists – one had to copy the great works and apply them in appropriate junctures. Polytechnic taught us the western methodology for painting. They also taught us to replicate the technique alongside. But then what? What was art?

Between leaving Polytechnic and going to Germany lay a gap of a year and a half. Within this time I had the opportunity to meet the renowned Indonesian artist Affandi, and that remained an

Mrs. Affandi
Oil on canvas, 27.5 x 19 inches
Collection: The Savara Foundation
for the Arts, New Delhi

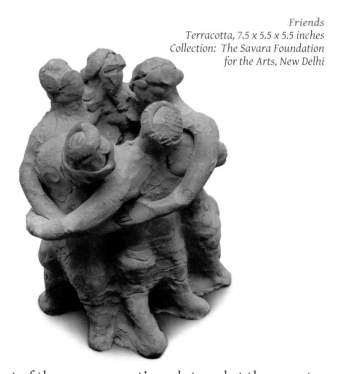

Friends
Terracotta, 7.5 x 5.5 x 5.5 inches
Collection: The Savara Foundation
for the Arts, New Delhi

incident of immense significance in my life. At that time my life was once again full of chaos and I was spending my days with a lot of mental strife. It was Biruda who almost forced me to go along with his friend and him to an exhibition by Affandi. This was because I was in a state of mind that used to make me terrified of being around people and I would actively hide from them. My elder brother was talented and bestowed with an artistic temperament from birth. He was pretty much forced to choose a profession that went against this temperament. Therefore, he was afraid my work would be compromised if I had to abide by the rules of his domestic life. When I think of this today, I am humbled with respect for him. One day he calls me and says, "Meera, if you stay in my family for too long you will be reduced to nothing more than a slave. You stand straight, and remember that you have my full support for the direction you have chosen for your life. Those who want to help you and guide you on your way, be sure to take their help and progress forward." These words helped me a lot at the time. The barbed wire that seemed to be strewn in my path seemed to ease and smooth over. For this I am forever indebted to him.

A friend of mine explained to me that any work that is meant for a lot of people, that helps a lot of people is a noble thing. Back then my life had nothing beyond painting and art, and I truly believed these to be the best work in the world.

Affandi saw my work and told me, "Everything about you is good but there is a fear somewhere that you need to destroy." I went to Santiniketan with Affandi and his family. Back then he was a

guest of the government's and stayed at the resort. The resort was right next to the post office. I delved head long into work. Before this I used to use all kinds of colours but he only had four. He was predominantly using blue, yellow, brown, and sometimes red. I too started using those. Affandi fashioned me an easel out of four thin canes. Besides this I carried with me a board and a box of colours. Armed with just these belongings I walked with him for miles on end. Most days we would leave at dawn after a cup of tea and return between 1–1:30 pm. It was early autumn and the sky seemed to quiver with the oppressive heat and the imprint of one's feet on the red soil brought on by the monsoons solidified into a cracked mass. Affandi was the first one who taught me to see life in all things. The sky, soil, trees, leaves, grass, people, pigs, hens—it was as though he opened up to me their unique liveliness and habits. It was a time when I would complete one painting each day. Suddenly my life was stripped of its fears and a new wave of energy was coming in. On certain days Affandi would say to me, "Don't paint so much Meera, take a break sometimes, see what you have

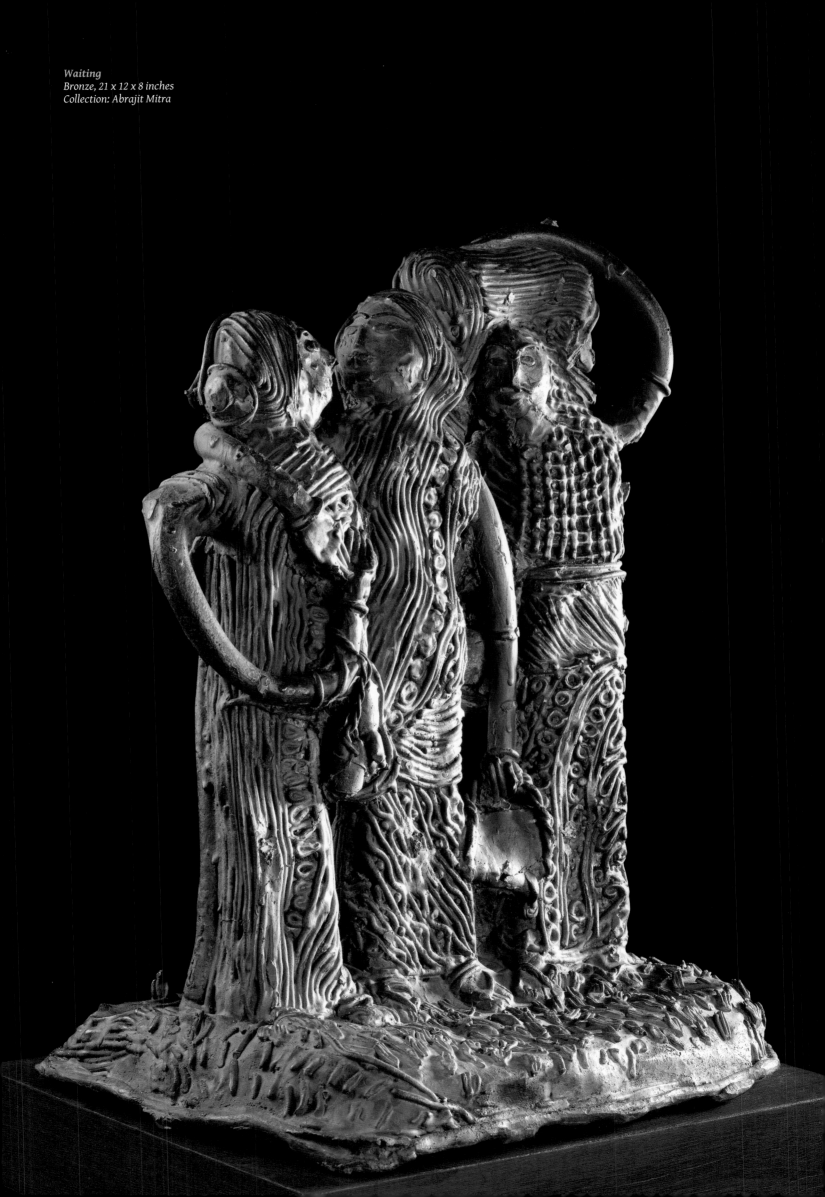

Waiting
Bronze, 21 x 12 x 8 inches
Collection: Abrajit Mitra

painted and reflect on them." This is where I used to face obstacles. I used to reason that I was observing before painting. What more did I need to see and think about? My hands would exercise a will of their own in front of certain subjects. My mind would be left far behind my able hands.

At this time two separate events influenced me a great deal. One day he painted a scarecrow. He observed and pondered over it for several days before painting it. And the other was, at the time I was staying at the resort, a Baul too was staying with us as a guest of his. He used to leave in the mornings with his ektara and returned at dawn or at night. What grains of rice he received through the day he used to give Affandi, and we used to boil that and eat it, all of us. Affandi believed the Bauls to be free people. Once following a bout of rain the skies had cleared up, and the sun was dazzling in the blue sky. I got ready with my cane easel and was standing on the veranda, waiting to go out when suddenly the Baul came out with his *ektara* and began to dance and sing. I watched him, listened to him surprised. Affandi tied a silk cloth on his frame and board, then proceeded to paint on the cane easel. I don't know how long he danced but Affandi painted him for as long as he did. Just as he danced and sang without inhibition, so Affandi's hands went, uninhibited. His dance ended with Affandi's painting. He added a throbbing sun over the Baul's head, a crow, and a thin, black dog at his feet—each one of them free.

Affandi left for a trip to London shortly after our return to Kolkata. My works from that time was showcased at the Chowringee Terrace as part

Dancing Baul-2
Bronze; Collection: ICIA

of my first solo exhibition on 2nd February, 1952. Sometime after that I got a chance to visit Santiniketan once more and stay at Shyamoli, with the help of Pritish Niyogi.

Soon after this I received a scholarship through the Indo-German Cooperation scheme and left for Germany. At first I stayed at a lovely little town over the Rhine that was surrounded by the seven mountains in the house of an elderly watch maker. I would watch him begin his work early in the morning and end not before evening. I would sketch by myself then, especially using oil paints. In the meantime I came to know of an army-artist named Helmut Georg. I went to watch him work one day. I remember some of his paintings and I'm sure I always will. One contained an exhausted piece of an engine, a distorted mouth, fragmented head, hands and feet, and bloody teeth scattered around. And surrounding it lay several sunflowers in bloom. The vast sea of sunflowers seemed to quiver with its own beauty. Another painting showed a dinner plate with a horse's skull. There were several other paintings, the subject for which remained incomprehensible to me. But his colours immediately made one think of some warning sign, and were filled with the anticipation of action. The artist seemed to be devastated by the grief and the horrors of the war, and I too felt deeply when I saw his work.

Enrolling at the Munich academy was another episode in my life. There were so many students there, and I was the only one from India. I was scared out of my wits at the time because of an incident that happened at the town. It was a snowy day, extremely cold, and I had to go to town to fetch my signed documents from the Indian Embassy before leaving for Munich. So I went there, shivering in the cold. I found the door open and

went inside to talk to the relevant authorities. He said, "You have come here, but what if you fail? We will have to send you back in that case." I said, "There is no question of failure, I am certain I will be able to do it." The gentleman kept insisting that the chances of my failing were very high. I tried to stop him a few times but eventually I burst into tears thanks to the combined effects of anger, misery, and utter humiliation. I said, "Have you any idea how difficult it was for me to come here? Why are you intent on scaring me on false grounds when instead you ought to be encouraging me!" In the heat of the moment I also said, "It is our misfortune that people like you occupy offices like these."

After getting admitted to Munich, I was reminded of this conversation. The examination was over. The other students had handed in a single painting each while I submitted three large pieces. The registrar and another professor met me the day after the exam. They said they were left surprised by my paintings, that my drawings were sturdy. I had no trouble getting in. I enrolled for painting classes under a teacher named Glete. At that time I got the company of Rudy Troger. One day he saw my paintings and told me – "you're an Indian, your appearance, personality, way of speaking are all very different from ours. And yet your work looks like they were made by a powerful European artist!" Georg (the army artist) had told me the same thing. Rudy's comment really got to me. I stopped sleeping that night onwards. On the other hand their state of plenty and our poverty always troubled me on the inside. I thought I could hear beggars calling me every night. And then there were clashes between the realistic, busy life in Munich, and my idealistic image of what it ought to have been. Several students, parties, visual and auditory sensations swirled around me at an enormous speed every day.

Rooster
Bronze, 7.4 x 5.7 x 4.34 inches
Photo courtesy: Sotheby's

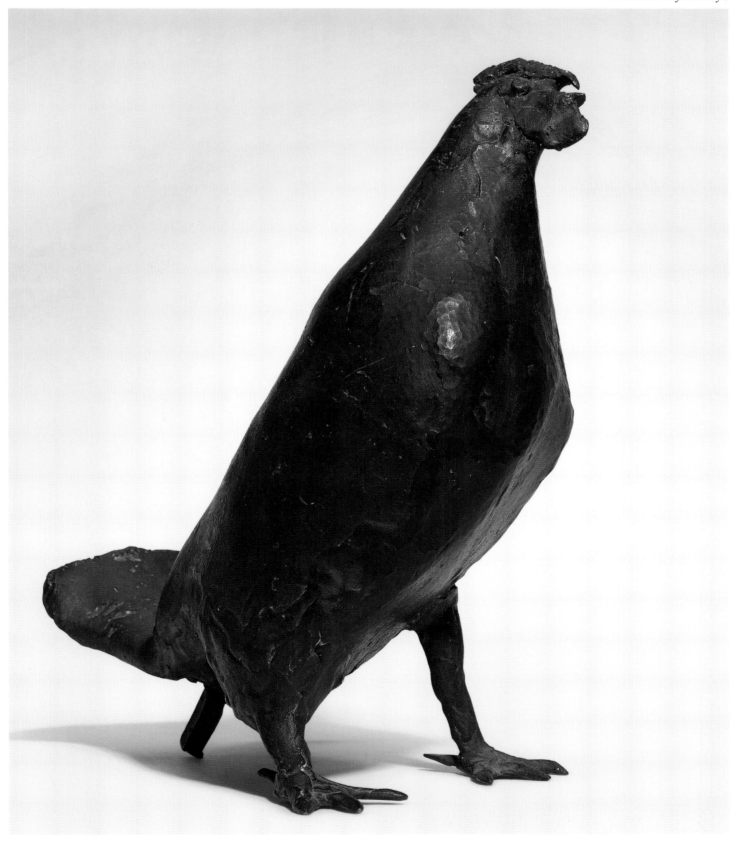

On one summer day I was returning home with Rudy when suddenly a group of giggling little children emerged from the streets, ran up to me, and engulfed me in a playful embrace. I too returned their affection and talked to them. Suddenly Rudy told me, "Meera, did you know that the artist has to give his art all of his love and all of his life-force. In your case it appears that you reserve the residue of your love for art, while distributing the greater part of it among everyone else. It's true that your popularity is soaring, but you are gradually moving away from art." That day itself I returned to the hostel and spread the word that I would be leaving town for the month, and devoted the entire month of break towards working in class. At this time I had the realization that what I had learnt up to this point had failed to teach me the real thing. Whatever I had done till now had been all wrong. I would destroy my hard work at the end of each day. It began to feel as though the ground beneath my feet was slowly crumbling and I cannot clutch onto anything. I would feel so restless! Eventually the holidays ended and the girl who was supposed to be my roommate did not arrive. Instead a note came with the news of her

Nandi, the Bull
Bronze, 6 x 14 x 6.5 inches
Collection: The Savara Foundation
for the Arts, New Delhi

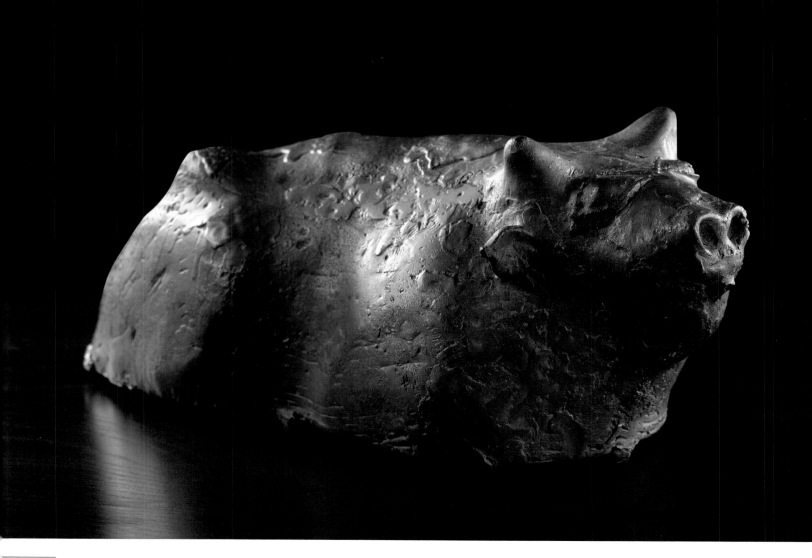

and her father's sudden death. This unprecedented tragedy left me bewildered on my first day of class after the break. Professor Glete came to class and told me, "Why are you so sad when you have all the ingredients of a happy life?" That day I informed Rudy that I would change my class. I told him I needed a break from colours and wanted to delve into physical activity. After some consideration he took me to Professor Toni Stadler's class.

The elderly professor, with a cap on his head, introduced me to the rest of the class. Then he proceeded to ask me several questions about my country. He told me, "Your country is so rich artistically, and yet you work in the style of the West. Why is that?" He stressed his words loudly. Immediately he ordered me to be in class from 7 in morning to 7 at night and to continue working. Initially this was very difficult. He asked me to sketch all day and I did, but he never liked any of them. He used to tear all of them. Weeks went by in much the same way and I began to lose hope. One day out of sheer desperation I asked a classmate for a block of wood to carve something out of. He gave me a piece of wood and sent me to the carpenter's workshop. By then my state of mind had undergone such exhaustion that I no longer wanted anything. My teachers and peers used to work very hard and spoke of nothing but pure art. Their discussions used to be very high flown and all I could do was to listen. I never participated because I hadn't grasped the basic concept back then. My professor was pleased the day I carved the piece of wood. He said, "Finally your soul managed to come out uninhibited." Later he explained that the vessel I had carved out had found true form in that wood and its carved form. It had no trace of me, Meera, but expressed that vessel alone. In other words, art can only ever be truly represented where the artist and the artwork becomes one. Professor Stadler was Renoir's student and he was taught by Myol as well, so naturally we heard a lot of stories about them from him. He never forgave a flaw in one's habits. He would always say that if one wanted to take their art to great heights, they would have to climb higher themselves to attain it. He was influenced by Buddhism. He wanted spiritual development for all his students. After this piece, I worked hard and created another just as good, but he critiqued that harshly. He clearly told me that the detachment

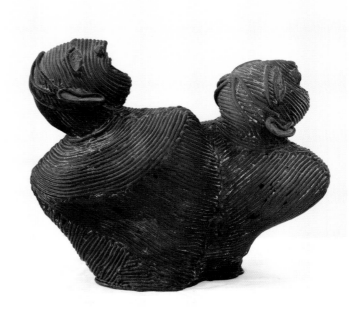

Revolt
Bronze, 16.9 x 18.5 inches
Collection: Abhishek Poddar

shown by the previous piece was missing from the second. A student had to be completely detached, in their mind and their work.

There were no gaps in my efforts in the first year. But I could never summon the kind of qualities he looked for in an artwork. I could never please him, although when he was pleased a couple of times, he would say, "I am getting the essence." Although what essence he got I never quite understood.

We had to bring our own models for nude study. Mostly the models would be from around the university. I remember clearly a senior of mine was studying a female nude. I went to the studio with the professor who said the work was fine, but he seemed to be hesitating. Later he said the model won't do ever again because the girl was too naked. Nudes were a part of nature and were not supposed to be vulgar. The professor would try and make us see these things.

I was leaving for Paris when a professor sent for me. He wanted to know all the pieces I would take a liking to, at the Louvre. However at the Louvre I could only observe a select few artworks every day. I did not have the capacity to observe and

understand the entirety of the museum's vast collection in such short a time. My professor was pleased when I handed him a list of my favourite artworks upon my return. In this list was *Hera* (Greek sculpture) and Brach's ceiling painting. My professor could have easily given me a small studio but he didn't. Instead he told me to be in class for as long as I was in Germany. This, he said, would help me learn from the plethora of artist styles on display. At this point in time I received a lot of assistance from a couple of people – Verner Klingenberg, Maria Natara, and Leo. Verner was extremely sensitive to touch. He would be cruel in his critique of his work, usually resulting in destroying his artwork. My peers and seniors had an incredible aesthetic sense, but they were also extremely demanding towards their art. Like philosophers, they would dissect their work and their thoughts with hair splitting detail. I too got stuck in the midst of all that. I would go out regularly with my friends on Sundays. One of our frequent haunts was the old Pinakothek, which had a vast collection of old Greek sculptures. Besides this, we met a lot of great artists and discussed their work. Maria was a very lively girl. Despite dissecting a piece of work she would tenaciously see it through till the end. The professor's verdict rarely unsettled her. Leo too was a simple guy, always smiling. His work was simple and lucid as well. I really liked it. In my second year at the annual exhibition an artwork of mine received high praise. The exhibition was held once a year, usually during the holidays. I started working on the piece but fell sick due to the cold in two days time. My professor was pleased that my unfinished work received such praise. The same happened in my third year. Meanwhile I had started on etchings and lithographs, and I liked doing them. My professor was usually pleased with my etchings.

The scholarship that took me there was for two years and eight months. After this I won another scholarship from the German academy, which my professor worked hard to get me. By then I was more secure, I had travelled to several countries, been to museums, seen Rembrandt's own paintings, and the paintings by the Impressionists. I had seen the old classical works, Picasso's own paintings and drawings etc. But I never tried to meet Picasso when I went to Paris. This was partly because I did not know French and partly because I hadn't yet worked on something truly commendable, and was thus scared of coming on people's radar. Even though I never went to him, he had a profound influence on my life and works. A lot of his graphic work had influences of ancient Greek styles. These influences can never be superficially summoned, they are usually deeply felt. When I saw the ancient artists' works in the Roman and Ancient Greek galleries of the London British Museum, I realized how rigorous Picasso's training and practice must have been.

While roaming the galleries of the London British Museum, I gained two specific insights. Firstly I understood what Picasso was trying to say, and secondly, it was here that I first felt a longing to return to my country and to seek out and work with Indian artists. This thought dawned on me as I was observing the plethora of clay art pieces. There seemed to me a connection, an innate similarity between these pieces and the rural clay toys of our country.

By then my mind had gone through a sea of change. I didn't feel as overwhelmed by Michelangelo's work as I had felt the first time I went to Rome. I preferred the slightly older, Etruscan work because it seemed to have an infinite touch in its dimensions. Michelangelo and his contemporaries'

artwork had a grandeur that spoke out very loudly. But the same message was conveyed with a natural grace and serenity in the Etruscan, ancient Greek, Roman or even Byzantine art. These had an air of limitlessness about them that made them appear novel and alive each time they were observed.

I knew very little about Modern Art. I used to see Henry Moore's artwork when I was in India, but I never really understood them. I liked watching him at work. Once I was forced to appear on a talk show for BBC at a time of some financial constraint. I spoke about a student's view on these artworks, that was all. I met Moore after this and was surprised to find that my view on his work and his view on the same were almost identical. That's when I realized that when an artist speaks from a personal understanding of an artwork, even if they happen to be as big a simpleton as I am, they are likely to be able to illustrate the point of view of the artwork with honesty.

After this I tried to polish what I had learnt through my stay in Munich. Usually one cannot do this without prior permission from the professors. So I had to do mine secretively, ensuring that I was not found out.

A boy from Yugoslavia used to do this outside the Academy. I got together with him to polish my works, but it was not that great. We did not take the precautions one needs to, to do this kind of work. Despite this, the work ended. I completed it in stealth in the classroom at early dawn. After that I painted a portrait of a friend of mine who lived in the hostel. The memories of my childhood came flooding back to me in the hostel room. I polished a few more of my works. Then one day Verner went ahead and brought a few students of my teacher's choice. Michelle Croars and his wife

were both talented artists. They were happy with my work and encouraged me a great deal. After that I took my works to my professor, rather fearful of his response. He was very pleased. Once he came to my room with a large group armed with bread, butter and wine. Since then I was able to be freer around him. After this he himself took us to the casting factory's chief and instructed him to let me work in the metal casting shop. Since then I started frequenting the room next to the casting factory. Although we were not allowed into the room where the casting took place, we were allowed to work on the works after they had been moulded and cast. We would send in several wax structures to the casting factory where the workers would work on them, perhaps add an air duct. But they would give us the works after moulding and we would repair them. I loved doing that.

By then my four years were coming to an end. My professor called me one day and told that he wanted me to prolong my stay for two more years in order to get my Master Diploma. I wrote about this to the association affiliated to the German Academy. But by then I had made up my mind to return to my country and work with artists all over India who were involved with sculpting. My professor told me I would face tremendous difficulty at first. I let him know that I was prepared to face anything. If I left any later I would be older, and lose my ability to face hardship. Hence the time was ripe for me to go. My professor blessed me upon hearing this.

I returned to India via London and Italy. I recall a black professor encouraging me to stay back in London after seeing some of my sketches and small bronze works.

I had to struggle for a long time to do the kind of work I wanted to do once I returned to India. Back

then, no one would understand what I wanted to say. Within a short time I decided that I had to overcome these obstacles and do the kind of work I wanted to do. Of the first four years, two were spent at a Dowhill School and the other two at Pratt Memorial. The struggle at the time was with my inner self. My surrounding world was chaotic to me at the time, dancing to a completely different tune. I would sometimes wonder whether I was speaking Chinese.

In this time, in 1960, I had a solo exhibition at Max Mueller Bhavan with several of my works. A short while after this, a long term wish of mine was granted. At first I went to meet the Gharuas at Bastar, in Jagadalpur. Within a few days of returning to India, I came across a brass elephant that Dr Surajit Sinha had. Back then I did not recognize or understand these things. At any rate these works were rarely seen around. The work was from Bastar. He read my mind and encouraged me to learn the art. He said, "if you want to learn something, you have to do it no matter what the circumstance." Keeping this in mind, I kept trying and eventually left my job at Pratt Memorial to learn the craft at Bastar.

All the hardship, misery, sadness I had endured throughout my life seemed to mould itself into pure gold all around me and enrich my thoughts. Jagadalpur did not have too many people in 1960. First I tracked them down. Then I began to learn the honest trade of these craftsmen. At first they refused to teach me. They would turn me down with numerous excuses. Once they asked me to dilute the excreta of a goat with water and make it into a paste of sorts. I had a lot of difficulty doing this. They had thought I would refuse to do it. At first I had hesitated, it's true. But they were adamant about the task being crucial to learning

the art. I listened to everything they said and did as I was told. At first I moulded a small idol of Krishna. It turned out beautifully after casting. Next when I tried to mould an idol of Durga, these people began to protest. They asked me for a lot of money which I did not have. Thus I started working from home. Jammuram used to stay in Chilkuthi, as did Manglu. They helped me out.

Once Jammuram was working, and I was working next to him. His work came out so beautifully that I asked him how he did it, how he felt when he worked. He said, "Bai (he used to call me Bai), I myself don't know what I think of when I work. I have nothing on my mind, I think of nothing. Suddenly I see that the work has completed itself." I recalled Professor Stadler's words—his wife Prissy von Stadler was a sculptor too. Once Priska had made a circus horse with a rider. I don't know how but it broke one day. Professor said, till now the sculpture was the work of an artist, but the broken rider and the horse have now become the perfect example of art. This was very true. When an artist creates something with a framework in mind, he or she is bound by that framework itself. She had tried to make the rider beautiful, but had been unmindful of the horse. But with the rider lying broken, the horse finally came into its own and was transformed into art.

After Bastar I started getting a minimal stipend from the Handicrafts Board. Because of this, I was able to go to South India and learn the work of the Acharyas. I saw a different dimension with them. They were greatly involved with spiritual exercises, but with a profound love of their work. Several among them were well versed in scriptures and were extremely virtuous. Their work was intellectual, rational, and time consuming. The hands and mind were skillful and adroit. For

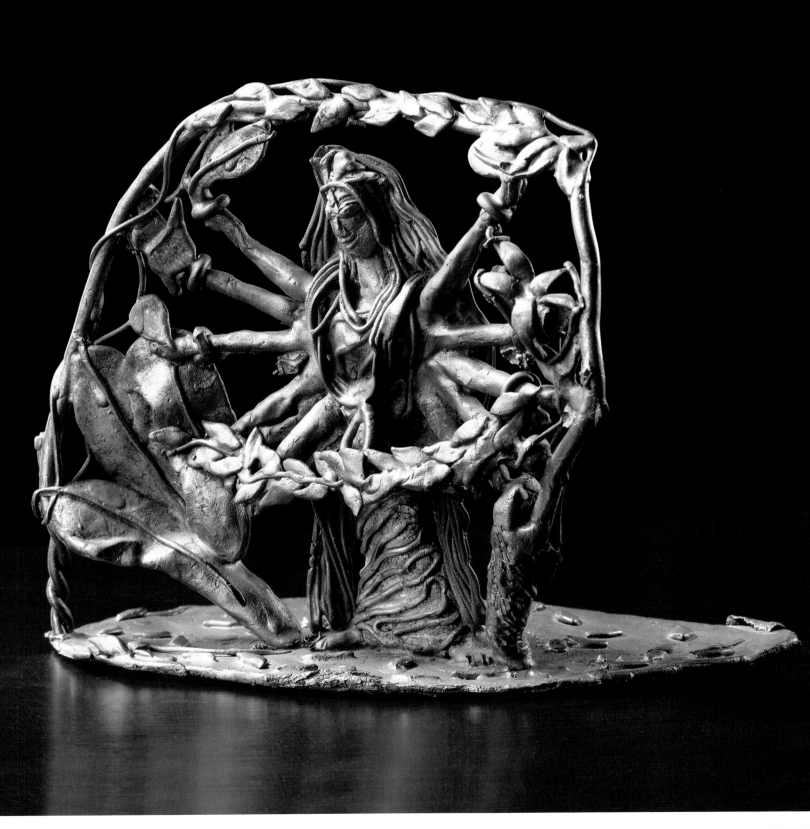

Self Portrait
Plaster of Paris, 6.25 x 8.25 x 8 inches
Collection: Private

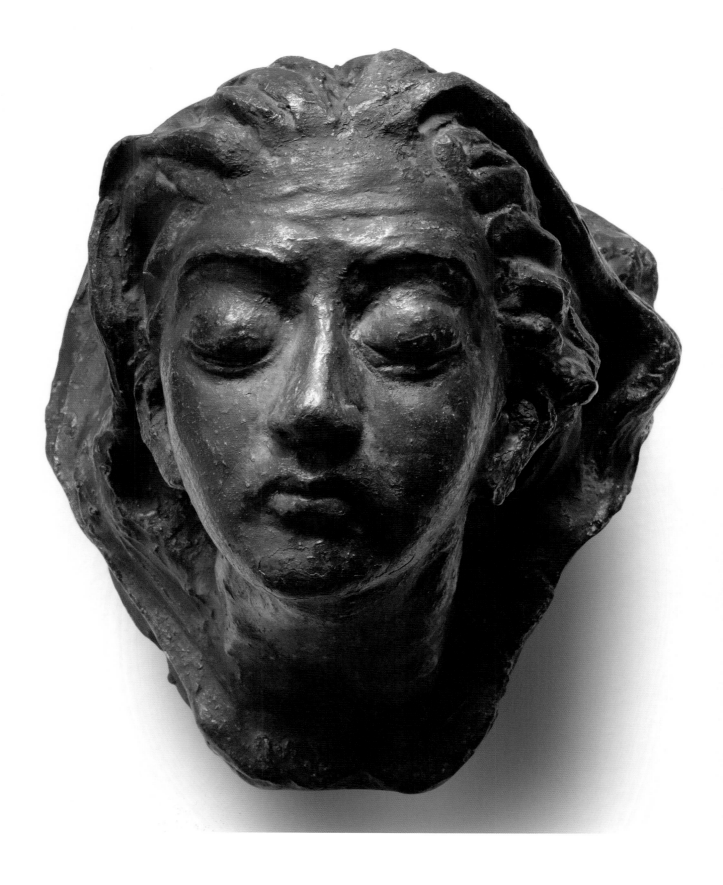

instance, Srinivas Acharya knew how to make a chisel. Generally the tools they worked with were of their own making. Here I saw that it was not enough to just make something of my own choosing and leave it at that. From the beginning to the end of making a work, one was required to think deeply about it. For instance, once one of my works was destroyed while casting. The metal did not flow. When I was working on the wax work, they had noticed flaws in my work but had said nothing. When the work was finally unsuccessful, they showed me where I had gone wrong and gave me detailed instructions. That's when I learnt that the work is one entity, from the beginning till the end, no matter at what stage of construction. One has to think about the end at the very beginning. Of course, this comes naturally after a while.

Small works are made at Bastar, but they don't have much to do after the casting. Sometimes they get distorted, but those cannot be fixed, and even if they are, it's hardly noticeable. But South India has both kinds of work. The wax work is cast after a form has been created. After casting, the work is filed with chisels and hammers in order to be completed. The work runs the risk of becoming too rigid, too constricted if it is filed after casting. Personally, I did not much care for this step of the work. Another thing that did not sit well with me was their rule of pre-ordaining the number of hours each artist had to put in per day, just like a factory worker or a government servant. As a result of this, although the works would be beautiful, they would seem too orchestrated, too manicured. Works like these fail to inspire with their beauty. These works are bought as souvenirs, but that is about all.

The stonework education centre at Mahabalipuram uses a lot of calculation. Their

Dharmapuja-II, bronze
Collection: Abrajit Mitra

calculated method of work guides the worker so well that one no longer runs the risk of stasis. Their methodology is different. I got the opportunity to see their work when I was touring the temples.

Then upon my return to Kolkata I got the chance to work with Maral Karigar, Malhar Karigar, and Nepal's Shakya Karigar. At that time I learnt that the foundation of my thought, which ultimately shaped itself into art, had to be strong. Almost everywhere I went I saw that the artist was actually a workman. He is aware of each step of his work from the start. The reason being, art is not just a product of skill. Both are inseparable.

Endnotes

1. From the compilation *Prabahita jibaner bhaskarja/shilpokatha sakshatkar,* diary edited by Sandipan Bhattacharya, Manchasha Prakash Prakalpa, Kolkata, 2005, pp. 51–62 (quoted as being originally published with a title *"Jibon o shilpobodh"* in the journal *Sharodiyo Pratikshan,* 1396 Bengali era).

Born in Calcutta, in 1923, Meera Mukherjee received her training in arts at the Indian Society of Oriental Arts (1937–1941). She earned a Diploma in Painting, Graphics and Sculptures from Delhi Polytechnic (1947–51). Mukherjee had painted along with the Indonesian master Affandi Koesoema, when he was visiting Santiniketan, and, she went on to study sculpture, painting and metal casting. Her work reflects the essence of daily life, folklore, Bengali calligraphy, music and dance to name a few.

Training & Education in Art

1937–41 Indian Society of Oriental Arts

1947–51 Delhi Polytechnic, Diploma in Painting, Graphics and Sculptures

1952–53 Spent a month painting with the Indonesian master Affandi, in Santiniketan, West Bengal

1953–56 Studied at the Akademie der Bildenden Kunste in Munich, under Prof. Glethe Malerei in Painting, under Prof. Toni Stadler and Prof. Heinrich Kirchner in Sculpture, under Prof. Theirman Radierkunst in Etching and Lithography under Mr. Herrn Lowasser

1960 Metal casting with the Gharuas of Bastar region, now in Chhattisgarh

1961–62 Metal casting with craftsmen of West Bengal, Bihar and Orissa; metal work with Nepal's Shakya craftsmen

1965 Research Fellowship from the Anthropological Survey of India, conducted a survey of indigenous metal artisans in India

1967 Survey of folk metal craftsmen

Solo Exhibitions

1941 Painting in Oriental style in Calcutta

1949–51 Group shows: Paintings, sculptures and graphics at Delhi

1952 Solo show of painting and sculptures at Calcutta

1952–56 Group show of sculptures in West Germany

1960 Sculpture and painting, Max Mueller Bhavan, Calcutta

1966 Sculpture show at Chemould Gallery, Calcutta

1971 AIFACS, New Delhi

1980 Gorky Sadan, Calcutta

1981 Academy of Fine Arts, Calcutta

1983 Retrospective, Jehangir Art Gallery, Bombay

1984 Cosmic Dancer and Other Works, Seagull

1986 New Works of Meera Mukherjee, Seagull

1988 Rainbow and Other Works at the Anthropological Survey of India Gallery at Kyd Street, Seagull

1993 Birla Academy of Fine Arts, Calcutta

1994 Gorky Sadan, Calcutta

1997 Gallerie 88, Calcutta, Art Today, New Delhi

meera mukherjee
1923-1998

2008 *An Exhibition of Sculptures by Meera Mukherjee*, Galerie 88, Kolkata

2010 *Memories of Meera*, Akar Prakar, Kolkata

2012 *Sculptures of Meera Mukherjee (1923-1998)*, presented by Akar Prakar & Welcom Hotel Sheraton New Delhi as a collateral event of India Art Fair 2012; *A World in Bronze: Meera Mukherjee* at the Buchheim Museum by Akar Prakar in collaboration with ICCR and Indien-Institut.

Selected Posthumous Group Exhibitions

2004 *The Margi and the Desi: Between Tradition and Modernity*, presented by Gallery Espace at Lalit Kala Akademi, New Delhi

2006 *Bronze*, organized by Gallery Espace at Lalit Kala Akademi, New Delhi

2008 *3 Masters Briefly*, Akar Prakar, Kolkata
Freedom 2008: Sixty Years after Indian Independence, Centre for International Modern Art (CIMA), Kolkata

2009 *Modern Continuous*, Galerie 88, Kolkata

2011 *Time Unfolded*, Kiran Nadar Museum of Art (KNMA), New Delhi
The Intuitive: Logic Revisited, from the Osian's collection at the World Economic Forum, Davos, Switzerland

2018 *New Configurations*, KNMA, Noida; *Songs of the uncaged bird*, NGMA, New Delhi

Visits

1967 Research papers on design at Regional Design Centre

1975 The Art of Gharuas at Indian Museum, Calcutta

1976 Invitation of German Cultural Exchange to study Contemporary German Art: Visit exhibitions and museums

1977 Metal craft and its Methods in West Bengal, Department of Ancient Indian History and Culture, University of Calcutta

1978 Methods in Creative Sculpture at Maharaja Sayajirao University of Baroda, Vadodara

1982 Commonwealth Institute, London

1983 Invitation of Japan Foundation

Published Works

1961 First report on Gharuas and their crafts, *Dandakaranya Samachar*

1963 'Gods-Goddesses and Brassware in Bastar' in *Forum*

1965 'Art of Gharuas' in *Rooplekha*

1974 'Gharuas and their craft' in *Man in India*

1977 *Folk Metal Craft of Eastern India*, All India Handicrafts Board, Ministry of Commerce, Government of India

1978 *Metalcraftsmen of India*, Memoir 44, Anthropological Survey of India

1982 'Creativity and Picasso's Sculpture' in *Parichay*; four children's books

1992 Four children's book in Bangla: *Kolkatar Ekti Purono Chhata, Dhowne Soi, Konkhanete/Shefali, Baro Haowa, Lep-Maachhdhara, Kalo O Kokil, Chobi Anka*)

1994 *Viswakarmar Sandhane* (In Search of Viswakarma), self-published, Abaad

2000 *Kalo & the Koel & Other Stories*, published by Seagull Books Pvt Ltd

2000 *Little Flower Shefali & Other Stories* by Seagull Books Pvt Ltd

2000 *Catching Fish & Other Stories* by Seagull Books Pvt Ltd

Awards

1953 Scholarship to study at the Bayerische Akademie der Schönen Künste, Munich

1965 Research Fellowship, Anthropological Survey of India

1967–68 President's Award for master craftsmen in metal work

1967 Ladies Study Group Award

1980 Abanindranath Smriti Puruskar, Government of West Bengal

1992 Padma Shri, Government of India

Peace
Bronze, 11 x 11.8 x 9 inches
Collection: Private

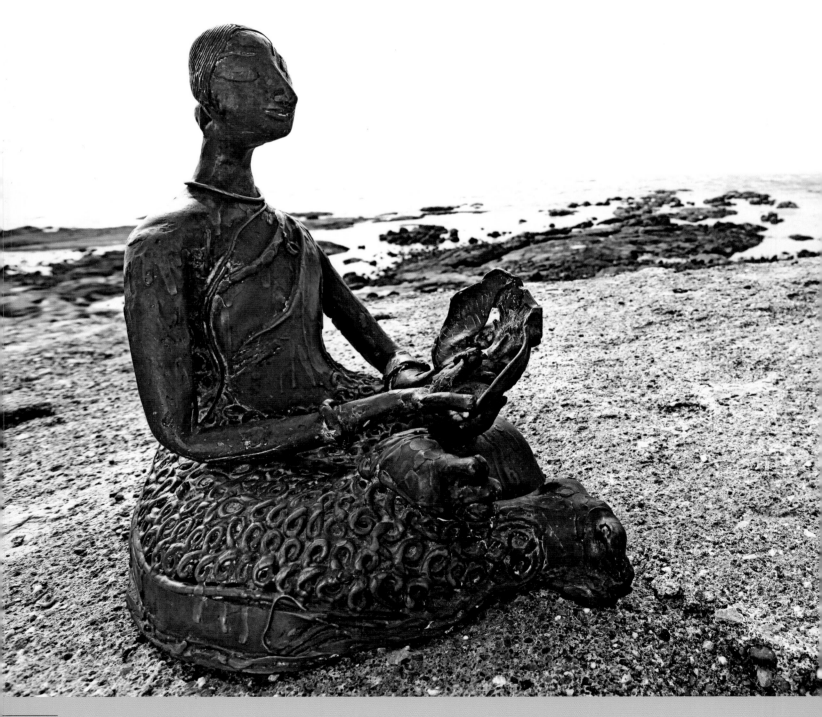